Samuel Cooper
and his contemporaries

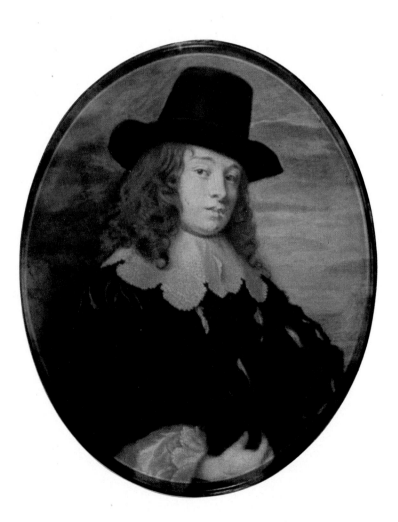

9 MARGARET LEMON
(*Cooper*)

NATIONAL PORTRAIT GALLERY

Samuel Cooper
and his contemporaries

DAPHNE FOSKETT

LONDON HER MAJESTY'S STATIONERY OFFICE 1974

© CROWN COPYRIGHT 1974
TYPOGRAPHIC DESIGN BY
HER MAJESTY'S STATIONERY OFFICE
SET IN MONOTYPE GARAMOND
ISBN 0 11 290174 3*

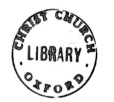

Contents

Acknowledgements

I should like to express my gratitude to Dr Roy Strong for inviting me to arrange the Samuel Cooper exhibition. It has been an exciting experience and one which could not have been carried out without the unfailing help and co-operation of the staff at the National Portrait Gallery. I am particularly grateful to Mr Richard Ormond, Mrs Jenny Haviland and Mr Kai Kin Yung for giving me every possible assistance regarding the details in connection with the Catalogue and the loans. But for the generosity of Mr A. J. B. Kiddell and the Directors of Sotheby and Co, it would not have been possible to illustrate more than one miniature in colour; the fact that they provided the remaining colour blocks has made all the difference to the Catalogue.

I am grateful to Mrs G. E. P. How for contacting private collectors who have kindly lent valuable items of silver, and to Mr and Mrs Peter Manheim for lending four interesting pieces of pottery from their own collection.

I would like to add my personal thanks to all those who have been kind enough to lend exhibits, including the owners who wish to remain anonymous. The late Duke of Buccleuch and Queensberry had generously agreed to lend no less than forty of his miniatures to the exhibition, and we are indebted to the present Duke for his co-operation.

Dennis Brennan and Michael Whalley designed an inspiring setting for the exhibition.

Daphne Foskett

Foreword

SAMUEL COOPER is the fourth in the Gallery's series of exhibitions devoted to leading portraitists practising in this country. The series began with the Tudor painter *Hans Eworth* in 1965 and continued with *Sir Godfrey Kneller* in 1971 and *Daniel Maclise* (organized in association with the Arts Council) in 1972. *Augustus John* will follow in 1975.

The selection of the exhibits has been undertaken by Mrs Daphne Foskett, who has also compiled the catalogue and written an introductory biographical sketch. The enormous enthusiasm and sheer hard work which she has contributed to every aspect of the exhibition, personally approaching many of the owners who have so generously agreed to loan, have resulted in a comprehensive study and showing of Cooper's art and a truly ravishing display of superb and penetrating portrait studies by an artist who, although a miniaturist and comparatively unknown except to specialists and connoisseurs, may fairly be claimed, as Mrs Foskett points out, as one of the greatest portrait painters of the seventeenth century. The Trustees are deeply indebted to her for her dedication and her scholarship.

Thanks are also due to Professor Douglas Stewart for his valuable introduction to the catalogue, in which he has set Cooper within the framework of the portraiture of his age; to V. J. Murrell, of the Victoria and Albert Museum, for his detailed analysis of Cooper's technique; and to Miss Diana de Marly for her essay explaining the value of Cooper's work for the study of fashion, notably in connection with the evolution of wigs and hair styles. Dennis Brennan and Michael Whalley have created a distinguished and wholly appropriate design for the exhibition, and we are much indebted to them for their skill in setting off the miniatures to the best advantage.

Our greatest debt, however, is to the owners who have so generously agreed to part with their treasures for the duration of the exhibition. Her Majesty The Queen has graciously lent thirteen important miniatures, as well as a large portrait, from the royal collection. Her Majesty the Queen of the Netherlands has very kindly lent four miniatures. And we are especially grateful to the Duke of Buccleuch and Queensberry for his generous loan of forty miniatures and several coins. In addition, everyone who has promised to lend has been understanding of the enforced postponement of the exhibition and its consequent extension into June, and the Trustees would like to express their particular gratitude for the way in which owners have so readily appreciated our present difficulties; this response has been a most heart-warming experience, and we trust that the sympathy and generosity extended to the Gallery will be rewarded in the quality of the exhibition.

It remains for me to say how exceedingly grateful I am personally to have inherited this major exhibition from my predecessor, Dr Roy Strong, who planned it.

John Hayes
Director
February 1974

114 BARBARA VILLIERS, COUNTESS OF
CASTLEMAINE, and afterwards,
DUCHESS OF CLEVELAND
(*Cooper*)

Introduction

IT is fitting that an exhibition of works by Samuel Cooper should take place at the National Portrait Gallery, in the heart of London, where this great artist lived and died. The tercentenary of Cooper's death was on 5 May 1972, and this exhibition will, it is hoped, rectify the fact that, at the time, this event passed unnoticed.

The problem of assembling a representative collection of miniatures by or ascribed to Samuel Cooper was not an easy one, as the majority of his works are scattered throughout the world in both private and public collections.

For a variety of reasons a number of very important miniatures were, unfortunately, not available for exhibition, and there are doubtless some in private collections, the present whereabouts of which were unknown.

Taking into account the current value of these works of art and their fragility, a great debt of gratitude is due to the large number of owners who have been so generous in lending their treasures. With their co-operation it has been possible to arrange a comprehensive display of miniatures painted by Cooper and his contemporaries, from which it is hoped that it will be possible to make comparisons and to appraise the whole scope of his art from about 1630–5 to the time of his death in 1672.

Among the many unresolved problems is that of attribution. In the past, a large number of portraits have been assigned to Cooper, many of which are either contemporary or later copies of his works, portraits by other hands or deliberate fakes. The fact that a number of seventeenth-century miniatures have been touched up because of damage, or have had false signatures added, complicated the matter even further. In addition there are undoubtedly some miniatures which were finished by other hands, either in Cooper's lifetime, or after his death. In view of all this confusion it seemed only right to include in this exhibition miniatures by Cooper's contemporaries, including some by his brother Alexander Cooper, and his master and uncle, John Hoskins, as well as a number by Thomas Flatman, the Gibson family and Susan Penelope Rosse. In this way it is hoped that a critical comparison can be made, particularly regarding the early works tentatively attributed to Cooper, painted at a time when he and Hoskins were working together and when the style of the two men is so closely merged. Thomas Flatman was a keen follower if not a pupil of Cooper's, and most people consider his work as a miniaturist second only to

Cooper at this period. A considerable number of his works have been attributed to Cooper, and in certain cases Cooper's signature has been added for good measure. The opportunity of examining miniatures by Cooper and Flatman should help us to arrive at a more serious assessment of their respective styles.

Miniatures painted by or attributed to some of Cooper's other followers—such as the Gibson family and Richard Gibson's daughter, Susan Penelope Rosse—have also been included for the purpose of comparison, as many of their portraits have been and still are attributed to Cooper. Although it is not easy to assign miniatures with absolute certainty to Richard or D. Gibson, as only a small number of their signed works exist, enough is known to separate them from those of Cooper.

S. P. Rosse, who is known to have copied a large number of Cooper's portraits, and may even have been allowed to finish some of his miniatures after his death, presents a more serious problem. Few signed works by her exist, and, as in the case of Flatman and R. and D. Gibson, numerous miniatures possibly by her, and certainly not by Cooper, have been attributed to him. David Des Granges and the artist who signed his works 'F.S.', at present identified as F. Smiadecki, are included as important links in the story of seventeenth-century miniature painting.

Nicholas Dixon carries the tradition forward into the eighteenth century. He succeeded Cooper as King's Limner, and although his works are good, the majority of them lack the panache of Cooper's portraits, and the style is so different that Dixon's works should not be confused with those of the master.

There were undoubtedly other miniaturists working at this period, whose names are not so far known but whose works are worthy of consideration, and for this reason a few miniatures by anonymous artists have been included. No survey of Cooper's art would be complete without including a few large portraits by artists such as Van Dyck, Lely, Hayls and Robert Walker, whose painting of Cromwell can be compared with the splendid miniature by Cooper. The addition of maps of London and such historical material as Cooper's will and his recipe for white lead in the de Mayerne MS, will, it is hoped, all be of interest in connection with the life and background of an artist to whom we in Britain owe so much.

Daphne Foskett

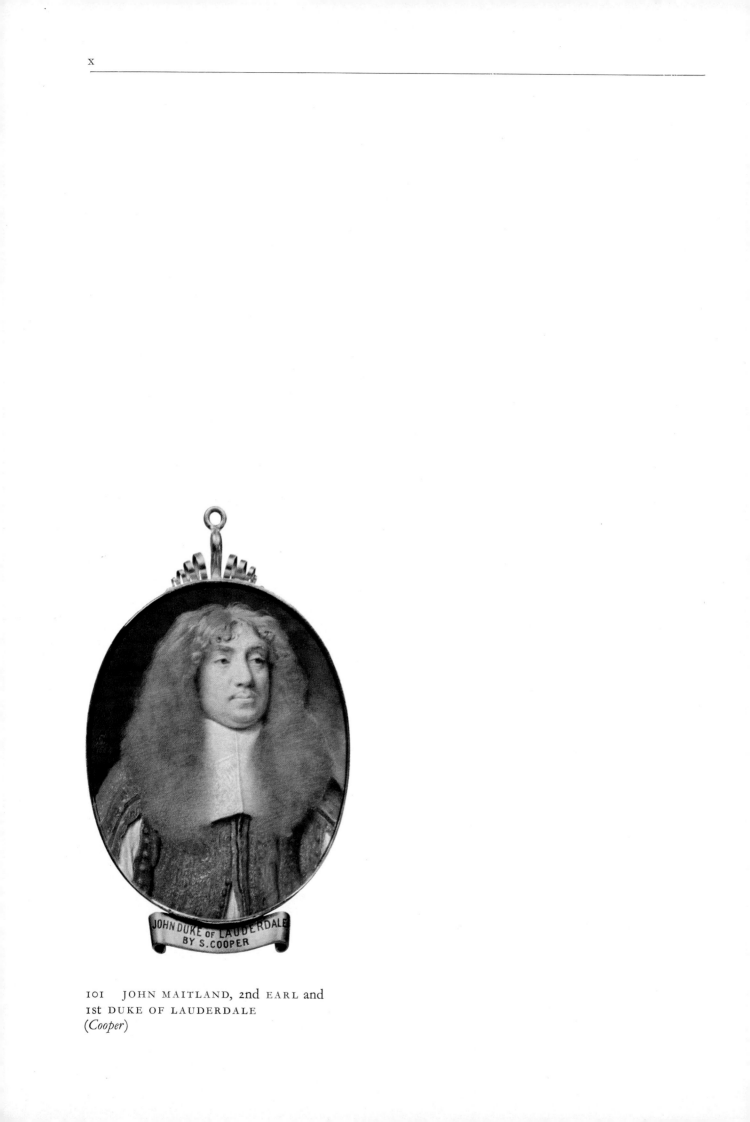

101 JOHN MAITLAND, 2nd EARL and
1st DUKE OF LAUDERDALE
(*Cooper*)

A biographical sketch

JUST over three hundred years ago, Charles Beale recorded in his diary the following words: 'Sunday May 5 Mr. Cooper, the most famous limner of the world for a face died.'

This estimate of Samuel Cooper's ability has never been refuted and his reputation stands as high today as it did at his death. Unlike many artists Cooper did not have to wait for the years to pass before he was appreciated. From the age of thirty and even before, he was acknowledged as one of the best portrait painters in Europe, and was consequently in great demand. Charles Beale's contemporary assessment of his ability has withstood the test of time, and no one has ever doubted his genius.

Throughout the period of the Commonwealth, and after the Restoration of Charles II, he obtained the patronage of the famous and the great, and, fortunately for posterity, many of these portraits have survived.

Lack of biographical information frustrates the student at every turn, for Cooper as far as we know left no diary, notes or lists of sitters from which a detailed picture of his family and contacts can be built up. One might expect that a man who held such an important position, clearly well educated, and with wide interests, would have left behind him some tangible evidence of his life, but all we know has to be sifted out from state papers, early authors, and a few letters from various sitters or acquaintances, discussing his merits.

His family background is no less obscure. Samuel and his elder brother, Alexander, were 'brought up under the care and discipline' of their uncle, John Hoskins, but the reasons for this, like the identity of their parents, are unknown. We do not know at what age they were taken under John Hoskins's care, but it seems reasonable to suppose that the boys were quite young, and a tentative date of 1625 for Samuel's apprenticeship has been suggested, at which time he would have been a boy of sixteen.

Various suggestions have been put forward as to Cooper's possible ancestry, but nothing positive has so far come to light. Based on the fact that Cooper was 'reckon'd one of the best Lutenists . . . in his time', B. S. Long surmised that he might have been the son of John Cooper or Coperario (1570?– 1626–7), a composer and lutanist. Others have pointed out that the name Cooper, Cowper or Kuyper was one commonly met with among the Dutch refugees who were in London at that time. If they had been connected with one of the families of Dutch jewellers who had links with the Continent it would explain Cooper's aptitude for foreign languages, and his friendship with people of importance abroad.

From the inscription placed on his tombstone in Old St Pancras Church, we know that Cooper was born in 1609, and died in his sixty-third year. His brother Alexander pre-deceased him by some twelve years. One of the earliest accounts of Cooper's life is that given by Richard Graham, pp. 338, 339 of the appendix to *The Art of Painting by C. A. Du Fresnoy, Translated into English by Mr. Dryden*, 1695. It confirms his date of birth as 1609 and states that he was:

'Bred up (together with his elder brother Alexander) under the Care and Discipline of Mr. Hoskins his Uncle: but derived the most considerable advantages, from the *Observations* which he made on the *Works* of *Van Dyck* . . . his *Talent* was so extraordinary, that for the *Honour* of our *Nation*, it may without Vanity be affirmed he was (at least) equal to the most famous *Italians*; and that hardly any of his *Predecessors* has ever been able to show so much *Perfection* in so *narrow* a *Compass*. Answerable to his *Abilities* in this *Art* was his *skill* in *Music*: and he was reckon'd one of the best *Lutenists*, as well as the most excellent *Limner* in his time. He spent several years of his Life *abroad*, was personally acquainted with the greatest Men of *France, Holland*, and his *own Country*, and by his *works* more universally known in all parts of *Christendom*. He died *Anno* 1672, and lies bury'd in Pancras Church, in the Fields.'

In view of the fact that this was published only twenty-three years after the artist's death, it is sad that the biographer did not record Cooper's life in greater detail. As it is, his works are left to speak for themselves, and the man himself remains in the shadows.

John Hoskins took up residence as the first occupant of 29 Bedford Square in 1634, in which year Sir Theodore Turquet de Mayerne, Charles I's Swiss physician, met Cooper in his uncle's studio. Details of this meeting are given in the de Mayerne MSS, Sloane 2052, in the British Museum. Sir Theodore was interested in the technical process of painting, and got Cooper to write down for him a recipe for preparing lead white. This recipe is in Samuel Cooper's own hand, and is as far as is known the only example of his handwriting apart from signatures and inscriptions on his miniatures.

The exact date when Cooper left his uncle and set up on his own is not known, but the most likely time is between 1634 and 1642 and it may well be that it was

during this time that Cooper did most of his travelling. It is a cliché that older artists become jealous of their protégés, but according to an appendix in De Piles's *Art of Painting*, 1706, this was the case with Cooper: 'He so far exceeded his Master, and Uncle, Mr. Hoskins, that he became jealous of him, and finding that the Court were better pleased with his Nephew's Performances than with his, he took him in Partner with him; but still seeing Mr. Cooper's Pictures were more relished, he was pleased to dismiss the Partnership, and so our Artist set up for himself, carrying most part of the Business of that time before him.'

According to J. J. Foster, Cooper was paying rates to the vicar and churchwardens of St Paul's Covent Garden in 1642 whilst living in Henrietta Street. *The Survey of London*, XXXVI (1970), however, records him as paying rates in King Street in 1643, and in Henrietta Street from about 1650 to 1672.

The date and place of Cooper's marriage to Christiana Turner are unknown. Her father was William Turner of York, whose family were landowners in Yorkshire, and Christiana was one of seventeen children; her sister, Edith, was the mother of Alexander Pope, the poet.

As far as is known, the Coopers were childless, or, at any rate, had no surviving children. When Cooper made his will, he appointed his wife as his sole executrix. She was fourteen years younger than her husband, and survived him by twenty-one years. The only known portrait of her is the superb unfinished miniature in the collection of the Duke of Portland.

It seems reasonable to suppose that Cooper was no longer working with his uncle from the time that he moved into his own house around 1642, and, indeed, his earliest known dated miniature, of the Countess of Devonshire, was painted in that year. From this time onwards, until his death, there are signed and dated works from which the student can assess his work as a miniaturist.

Of Cooper's home life, day to day activities and intimate circle, we know parctically nothing. Only a handful of close friends are named—John Aubrey, Samuel Butler, Thomas Hobbes and Sir William Petty. His contacts through his art must, on the other hand, have been numerous, and Cosimo III of Tuscany gives us a glimpse of his character and way of life when he describes him as 'a tiny man, all wit and courtesy, as well housed as Lely, with his tabel covered with velvet'.

Cosimo had heard a great deal about Cooper before he came to England in 1669. He was informed that no one visited England without endeavouring to obtain a portrait from this artist, who was held 'in the highest degree of estimation, both in and out of the kingdom'.

Cooper's early work must, of necessity, have been influenced by Hoskins. While he was working with and for his uncle, he would have had to conform to the technique and style of the older man. As time passed he undoubtedly came under the influence of Van Dyck, and absorbed and adapted the Baroque sense of design and full direct modelling more akin to the work of an oil painter but skilfully adapted to suit the size and medium of a miniaturist's art. This technique was a complete break with anything known to his predecessors, Hilliard, Oliver and Hoskins, whose work stemmed from the tradition of book illumination. The flesh tones of pink over white, so typical of the early miniaturists, were superseded by a warm reddish brown, which Pepys thought a little forced, but which is now thought of as typically 'Cooperish'.

The superb miniature of Margaret Lemon in male costume, formerly in the Pfungst collection and now in the Institut Néerlandais (Lugt collection), Paris, is a key piece in the development of Cooper's style, as it was presumably painted in *c.* 1635–40, and shows clearly how Cooper had already developed a mature style of his own. The composition and breadth of handling are far more ambitious than anything hitherto attempted, and the sitter is presented to the world as a living person whose character Cooper portrayed in a remarkable way.

John Aubrey rightly surmised that when Charles II returned to England in 1660 he would lose no time in commissioning Cooper to paint his portrait. Writing to his friend, Thomas Hobbes, Aubrey urged him to be in London before the King arrived, as he felt sure that, being a lover of painting, Charles would be certain to sit to Cooper as soon as possible, and that this would give Hobbes the opportunity of 'renewing his majestie's graces to him.' Aubrey's prophecy was correct, and a week after the King's return to London he visited Cooper's studio, where 'as he sate for his picture he was diverted by Mr. Hobbes' pleasant discourse'.

For the remaining twelve years of his life Cooper was accepted as premier miniaturist, and he was appointed King's Limner some time before 1663, when he was receiving a salary of £200 per annum. This salary soon fell into arrears and a considerable sum was still owing to him when he died.

It is interesting that Cooper's reputation as an artist placed him above any political intrigue, and the fact that he was patronized by Cromwell and his followers made no difference to the royal and court patronage he received after the Restoration. As was to be expected, Cooper painted a number of miniatures of Charles II, the largest and finest of which is the one in the Goodwood collection.

The period of the Restoration and the ensuing years gave ample opportunity for Cooper to develop and expand his style. He had more patrons than he could attend to, and the miniatures produced during the last twelve years of his life are among his finest works. Unlike the fashionable portraits of ladies painted by Lely, Cooper's portraits of women are much more individual, painted in colours that are perfectly blended and harmonious. The faces of the sitters are beautifully modelled and the character of the sitter is at once apparent. Cooper's portraits of men are no less inspiring, and the superb miniature of James, Duke of York, in the Victoria and Albert Museum (1661), and the fine series in the collection of the Duke of Portland, which includes portraits of Sir Thomas Tomkins (1661), Henry Sidney, Earl of Romney (1669), Sir Frescheville Holles (1669) and Archbishop Sheldon, are all proof of Cooper's ability to portray his sitters with sympathetic understanding.

Although the majority of Cooper's miniatures were painted against a slightly sombre background, and the costume of the sitters executed in subtle and somewhat subdued colours, this never detracted from the portrait, but rather enhanced it, as may be seen on the miniature of the Duchess of Cleveland at Windsor, where the sitter's dress is painted in a beautiful harmony of silver, grey and white, as is the miniature of Jane Myddelton in the collection of the Earl Beauchamp.

When he was called upon to paint his sitters in more elaborate dress—as in the case of the Duchess of Richmond in male attire at Windsor, the 2nd Earl of Shaftesbury at the Victoria and Albert Museum, and the large portrait of the 1st Earl of Shaftesbury at St Giles's House—he painted the accessories with great panache.

Only a small number of signed and dated miniatures are traceable for the years 1642–5, and it is possible that Cooper was at this time still travelling abroad. From 1646, the number of known portraits by him steadily grows. By 1650 or earlier, Cooper was working for Cromwell and his family, and he was evidently so busy on this account that other patrons

found it difficult to obtain sittings. Evidence for this is to be found in the *Calendar of State Papers, 1650* (1876), p. 420. In a letter to Lord Conway, Miles Woodshawe writes: 'I spoke to Mr. Cooper, the painter who desires you to excuse him one month longer, as he has some work to finish for Lord General Cromwell and his family.' Woodshawe wrote several times to Lord Conway on the matter, and, on 9 October 1651, informed him that: 'Mr. Cooper assures me that on the lady's return, he will not fail to do the picture for the credit of himself and of her. Col. Ashburnham has promised that on her return from the West Country, she shall sit a week together.'

Dorothy Osborne had similar difficulties in obtaining sittings, and in her correspondence to her lover, Sir William Temple (around 1653), she tells Sir William that she will try to get a large portrait of herself copied by either Hoskins or Cooper, in order that he may have her likeness by him. She later decided to get Cooper to paint her from life. In a letter to Sir William of 13 June 1654, she writes:

'I shall go out of town this week, and so cannot possibly get a picture drawn for you till I come up again, which will be within these six weeks, but not to make any stay at all. I should be glad to find you here then. I would have one drawn since I came, and consulted my glass every morning when to begin; and to speak freely to you that are my friend, I could never find my face in a condition to admit on't, and when I was not satisfied with it myself, I had no reason to hope that anybody else should. But I am afraid as you say, that time will not mend it, and therefor you shall have it as soon as Mr. Cooper will vouchsafe to take the pains to draw it for you. I have made him twenty courtseys, and promised him £15 to persuade him.'

The miniature was presumably painted, but, sadly, its present whereabouts are unknown.

Few records have survived regarding the prices Cooper obtained for his miniatures. We know that in 1650 Robert Dormer paid Cooper £12 for his miniature; Pepys paid £30 for the portrait of Mrs Pepys (also missing); and Cosimo III of Tuscany paid £150 for his portrait in 1670. The latter miniature was on a larger scale than usual. From these scattered references, it is clear that Cooper made as much as, if not more than, the leading oil painters.

The set of five unfinished heads at Windsor, representing Catherine of Braganza, the Duchess of Richmond, the Duke of Albemarle, the Duchess of Cleveland and the Duke of Monmouth, were all un-

doubtedly painted as prototypes from which replicas could be taken. Unfinished as they are, the portraits are by any standards masterpieces; the faces are finished and the remainder of the figures are suggested by broad fluent brush strokes. In addition to the sketches at Windsor there is the unfinished portrait of Thomas Hobbes at the Cleveland Museum of Art, Ohio. Here again only the face is finished, and the area behind the head partially painted in broad wash. Only an artist as great as Cooper could depict a sitter's character in such a remarkable way and with such economy.

Until just over fifteen years ago only two drawings by Cooper were known, the sketch of Charles II at Windsor, and that of Thomas Alcock at the Ashmolean Museum, Oxford; since then four more have been identified. As a result it is now possible to see what Norgate meant when, in his *Miniatura* of about 1650, he mentions Cooper's ability as a draughtsman:

'The very worthy and generous Mr. Samuel Cooper, whose rare pencill, though it equall if not exceed the very best of Europe, yet it is a measuring cast whether in this i.e. crayon he does not exceed himself . . . Those crayon drawings made by the Gentile Mr. Samuel Cooper with a white and black Chalke upon a Coloured paper are for likenes, neatnes and roundnes *abastanza da fare stupire e marvigliare ogni acutis simo inegno*. With like felicite he hath made a picture of a noble Cadet of the first noble family of England, that for likenes cannot be mended with Colours.'

Cooper continued to paint without any loss of power up to the last few days of his life, when he still had more commissions than he could cope with. Proof of his ability at this stage in his life may be seen by examining the miniature of Lord Clifford of Chudleigh, signed and dated 1672. His illness was evidently sudden, and he made his will only four days before his death, which took place on 5 May 1672.

This is not the place for a more detailed assessment of the artist. This I have tried to do in my biography, *Samuel Cooper*, which is to be published by Faber and Faber to coincide with the exhibition. There are still many problems of attribution and comparison to be resolved, and it is hoped that this exhibition will provide an opportunity for collectors and students of miniature painting to examine and compare the works of Samuel Cooper and his contemporaries, and that it will be a fitting tribute to one who was undoubtedly one of the greatest portrait painters—if not *the* greatest—of the seventeenth century.

Daphne Foskett

Samuel Cooper: an English Baroque 'Man for his Century'

THE study and appreciation of British portrait miniatures has always been to some extent a specialist affair, detached from that of painting 'in large'. This is understandable, and to a degree inevitable. The small scale of miniatures presents its own peculiar problems to the artist, and creates its own special attractions for the patron and the viewer. The techniques used by miniaturists also differ from those of other painters. Moreover, since the example given by Charles I, miniatures have often been collected together, mounted in exquisite frames and housed in cabinets, more like jewels (to which they are often so akin in scale, refinement and colouristic brilliance) or rare coins, than oil paintings.

Yet such collecting removes the miniature from the ken of the casual viewer. Another isolating factor is the historical one. Miniature portrait painting, like miniature book illustration, or illusionistic ceiling painting, is an art of the past. Thus it has no direct connection with the present, no continuous tradition, as does portrait painting in large. Further, although the technical level of British miniaturists remained high well into the nineteenth century, in terms of new ideas the pace had for long been set by painters in large. There are no artists of the stature of Gainsborough, Reynolds or Lawrence amongst the later miniaturists.

But for earlier centuries any divorce of the work of the 'limner' from that of the painter of large-scale portraits is certainly a dangerous one. For in the sixteenth and seventeenth centuries the English miniature was still an independent art form, and thus capable of developing exciting relationships with other art forms. It could attract great artists, like Nicholas Hilliard, or Samuel Cooper. Indeed, in the case of Hilliard, miniature painting actually led the way for all English portrait painting for a time.

It is easy to see how readily adaptable the miniature is to the neo-medieval fantasy world of Hilliard and his contemporaries. It is less easy to see why the form continued to present a great challenge to British artists in the seventeenth century—the age of 'realism'—or why it no longer did so in the eighteenth. Perhaps one reason is the continued 'daily' use of the miniature in the Stuart period as a token of affection actually worn on the person. (As late as 1690, Sir Godfrey Kneller's mistress, Mrs Voss, is portrayed wearing a miniature of her lover in a band around her wrist.) Such miniatures required an intimacy and warm-blooded quality which was unnecessary in the hermetic world of the miniature collector.

Miniatures were also still presented as gifts of state from one sovereign to another, and here perhaps the Baroque passion for grandeur provided a challenge for the miniaturists to compete with the painter at large.

A more potent factor in the survival of the miniature in the seventeenth century, and indeed in its final great flowering in the work of Samuel Cooper, lies in the nature of the Baroque period itself. It was an age of paradox. It demanded 'realism' of the most down-to-earth kind, instead of the 'bloodless' fantasies of the Mannerist period. Yet it also required nobility and grandeur. Consequently, what it was frequently given by its best artists was consummate illusionism, of which the great Baroque ceiling paintings are such superb examples—ceilings in which the gods seem humanized, and humans have become godlike, yet all are flesh and blood.

These factors—grandeur, naturalism and illusionism—are brilliantly brought out by Horace Walpole in his famous comparison between the miniatures of Isaac Oliver, the Jacobean artist, and those of Cooper: 'Oliver's works are touched and retouched with such careful fidelity that you cannot help perceiving they are nature in the abstract; Cooper's are so bold that they seem perfect nature, only of a less standard. Magnify the former, they are still diminutively conceived: if a glass could expand Cooper's picture to the size of Vandyck's they would appear to have been painted for that proportion.'

Samuel Cooper was born in 1609—three years after Rembrandt, ten after Van Dyck and eleven after Bernini. It is not idle to associate the Englishman with these continental giants, and not merely because of the proximity of their birth dates. Shortly after his death Cooper was designated the 'Van Dyck in little'—high praise, but praise which tends to obscure his individuality and achievement. Indebted though he was to Van Dyck, Cooper generally painted his portraits with a sturdy honesty and directness which is closer to the approach of the great Dutchman (whom he outlived by only a few years) than to the fragile grace of the Fleming.

Of this group of artists, the Italian Bernini lived the longest, dying in 1680, eight years after Cooper. Nor is it presumptuous to compare Cooper, in his sphere, with Bernini. Like Bernini, Cooper seems to have been something of a youthful prodigy. Just as the period, with its great admiration for the 'ingeniose', was intensely excited by Bernini's masterly handling of marble, so also it praised the skill of Cooper. Bernini continued in high official capacity in spite of

changes in the papacy, and Cooper too worked successively, without apparent difficulties, at the court of Charles I, for the Cromwellian regime, and finally for Charles II. Like the Italian too, he was, although not intellectual, still very much the well-rounded 'liberal' artist of the Renaissance tradition, one who played the lute with great skill, was well travelled, a linguist, and the friend of writers and philosophers such as Samuel Butler, Aubrey, Sir William Petty and Thomas Hobbes. What has been said of Bernini's works by Howard Hibbard—that they are 'not simply autobiographical . . . but the autobiography of the age itself'—could also be applied to Cooper and his miniatures. He was in every way, to transmute a phrase applied to another great Englishman of an earlier age, 'a man for his century'.

Cooper's reputation and pre-eminence in his field were European-wide. Richard Graham, writing shortly after his death, said that 'for a Face . . . his *Talent* was so extraordinary that, . . . he was (at least) equal to the most famous *Italians*'. In 1669 the Grand Duke Cosimo III of Tuscany assiduously sought him out, to obtain an example of his work, as he had just previously sought out Rembrandt in his Amsterdam studio.

Yet Cooper was English as well as Baroque. In fact his mature style represents a personal amalgam of traditional English features, together with some of the most characteristc ideas of the Baroque style which developed on the Continent in the early part of the century. But just how and when he came by some of these features is not easy to say, since his earliest, and some of his later, years are obscure.

What seems to be his earliest signed work is the portrait of Margaret Lemon, Van Dyck's mistress, in male dress, from the Lugt collection. It probably dates from about 1635, and is already astonishingly mature in its boldness of modelling. The tonal qualities and the grace betray the influence of Van Dyck, but the strong sense of pattern (at this stage not altogether successfully integrated with the artist's feeling for mass, especially in the lower part of the piece) can be seen as an English feature, as is the reticence of expression. Yet Cooper has certainly moved well beyond the work of his first known master, John Hoskins, in both expressive and technical power.

Earlier miniatures by Cooper must have existed (and may exist) which would show his development to the maturity of the Lemon portrait. But they are not easily identified. One candidate is the *Queen Henrietta Maria* in the Royal Collection. It has Cooper's

initials on the back, and this has been read as a signature. But the problem is that the miniature is very close to an entry in Abraham Van der Doort's contemporary inventory of the collections of Charles I: 'Don by the life by Haskins [Hoskins] . . . upon the right lighte [i.e. the left] the Queenes Picture in liming with a white feather and in a white laced dressing about her breast in a—blewish purple habbitt and Carnacon sleeves—and a part of a goulden Tissue Curteine . . .' Certainly the methodical Van der Doort is unlikely to have misattributed this miniature. But as has been observed by Sir Oliver Millar, '. . . the exceptionally high quality makes it tempting to consider at least the possibility that it was painted by Cooper when he was working with his uncle Hoskins.' One might add that there is a possibility that we are really dealing with two different miniatures here. The existing miniature does not appear to have the 'carnacon sleeves' cited by Van der Doort. On the other hand it is a little surprising that the Dutchman did not mention the prominent stars on the Queen's dress in his otherwise detailed description.

There is another large gap in our knowledge of Cooper from the late 1630s until the early 1640s. Early sources claim that the artist visited Holland, France and possibly Germany, and it seems plausible to place at least some of these travels in this period. Exposure to continental ideas would also help to account for the complete maturity of Cooper's work from the 1640s, and also for at least one feature of his designs, viz. his use of varied and unusual angles for his poses, generally giving them an 'arrested' and informal character.

Cooper's liking for unusual angles can be seen even in the *Margaret Lemon*, but it is not until such works as the *Unknown Man* (formerly called Robert Walker) of 1645 in the Royal Collection that one sees him using this sort of motif successfully. Here the figure seems to have turned towards the spectator, and his mouth is open as though about to speak. Also, because of the high viewpoint one senses that he is in a chair, an impression heightened by the pose of the arm, as though resting on a chair back.

Neither the problem Cooper faced nor its solution is new. Indeed it is a peculiarly Baroque problem—how to give animation and 'realism' to the truncated human form. Bernini was perhaps the creator of the first truly successful Baroque portrait bust with his marble of Cardinal Scipione Borghese of 1632. But the idea was to some extent 'in the air' in the 1630s, and the northern painter who became the master of

the informal portrait bust was the Dutchman, Frans Hals. Perhaps the earliest portrait by Hals of the sort that could have influenced Samuel Cooper, directly or indirectly, is the *Unknown Man* (1633) in the National Gallery. But as early as 1626 Hals had evolved a rather similar formula, but using the full arm and hand, in his great portrait of Isaac Abrahamsz. Massa, now in the Art Gallery of Ontario.

Hals in fact generally employs the full arm and hand in portraits of this type, features which Cooper almost invariably eschews in his mature bust portraits. There is a good reason for this. In spite of his tremendous feeling for Baroque mass and psychological penetration, Cooper remains English. As such he is more reserved in expression than his continental contemporaries, and also has the feeling for linear, two-dimensional forms, which is part of the English tradition. Thus to Cooper, a projecting arm or hand would break both the form and the content of his images. Even in his three-quarter-length miniatures, such as the 1642 *Countess of Devonshire*, this strong feeling for pattern comes across, not only within the figure itself, but also in the relationship between the figure and the background accessories. The design of this miniature derives from Van Dyck. But with its straightforwardly posed, fragile figure, its delicacy of sentiment and lack of overt sophistication, it is closer to the spirit of Cornelius Johnson and Marcus Gheerhaerts the Younger than to Van Dyck.

Although he had been closely associated with the first Caroline court, Cooper received much employment from Cromwell. From this it has been deduced that he must have had an especially diplomatic personality. One might also conclude that Cromwell was shrewd enough to recognize his genius. At any rate Cooper worked for Cromwell and his family from about 1650, and in his famous 'unfinished' miniature of the Protector in the collection of the Duke of Buccleuch and Queensberry, he produced not only the most memorable image of one of the greatest Englishmen, but surely one of the great portraits of all time.

As with all great works of art, it is impossible to define its greatness adequately in words. But part of the potency of the *Cromwell* surely derives from the subtlety of Cooper's choice of a squarish oval format, which seems perfectly suited for the blunt but majestic head. And the 'realism' and honesty of the *Cromwell* are amazing. He is rendered with the '... pimples, warts and everything as you see them'

which, according to George Vertue, writing in 1721, Cromwell told Lely to paint when he sat to the latter. But Vertue may have been misinformed, because Lely's portrait of Cromwell seems based on Cooper's, not *vice versa*. Moreover, at this stage it is Cooper, not Lely, who dispays a greater feeling for volume and mass, features usually regarded as part of Lely's Dutch inheritance. Did contact with Cooper also perhaps influence him in this direction? With the Restoration, Cooper became King's Limner and was tremendously popular at the new court. The prices he could command were higher than those of Lely (who succeeded to Van Dyck's post of Principal Painter), an indication of the high status of the English artist, and the miniature. Of the King, he painted a number of compelling portraits. The one now at the Mauritshuis, of 1665, shows the Monarch in Garter robes, his head turned nonchalantly to one side. It is a rich, grand, yet strangely fresh and intimate image, conveying much of that Stuart charm which the 'Black Boy' possessed in such abundance.

The new, decorative grandeur one notices in the *Charles II* is part of a general tendency in English painting from the 1660s. Indeed it is a pan-European phenomenon, part of the growing richness and complexity of the Late Baroque style. One sees it in the works of Lely, and also in those of the French emigrant painters like the Vignons, Gaspars or artists like Simon Verelst, who worked in a Frenchified style. Yet, significantly, Cooper avoids French court-portrait features like the stiff back and exaggerated *contrapposto*. Also, much of the simplicity and directness (if not the heroism) of Cooper's Cromwellian miniatures, like the *Cromwell* or the *Sir John Carew*, carry through the Restoration period, in such pieces as the so-called *Duke of Lauderdale* and the *Earl of Romney*. However, both the latter show something of the softness and sensuality of Lely's new courtly style.

Lely seems generally to suffer when comparisons are made between his work and that of Cooper, but to some extent this is unjust. Psychological penetration was, it is true, not always Lely's strong point, but it is hardly the only point of interest in portraiture. Moreover, it is remarkable how close in interpretation Cooper and Lely can be when confronted by the same sitter. One may compare, for example, Cooper's miniatures of the Duchess of Cleveland and Jane Myddelton with the three-quarter lengths of the same sitters in Lely's famous series, the Windsor 'Beauties'. It is interesting to see how, in the case of

the former, both artists have caught a kind of strong, dark, pouting sensuality, and both employ bold, upright poses and dramatic contrasts of light and shade. With the latter, who was known as a great beauty but also something of an *ingenue* (she is said to have put some of her lovers to sleep with her talking), they both use more relaxed postures and more delicate light effects. And both show her as a soft, voluptuous, feminine type. Of course, Cooper is, in the *Jane Myddelton*, altogether more English than Lely in his delicacy and refinement. And the superbly decorative character of the costume, although in line with contemporary trends, can also be seen as reversion to a purely English tradition. Indeed, the marvellous abstract patterning of the costume in this miniature seems like an echo (albeit unconscious) of such masterpieces of Tudor portraiture as Master John's great *Lady Jane Grey* in the National Portrait Gallery, of about 1545.

Yet oddly enough, in spite of his essential Englishness, there is one national tradition in painting which Cooper avoids—the use of symbolism. This had been a frequent ingredient of the Elizabethan and Jacobean 'icon'. It had lived on into the Baroque in the works of native artists like Dobson and Michael Wright, and Van Dyck had been deeply influenced by it during his stay in England. With the Restoration the use of symbolism and disguise received fresh impetus because of its popularity at the French court. Lely made great use of it—in the Windsor 'Beauties' (where the Duchess of Cleveland appears as Minerva and Jane Myddelton is shown with the cornucopia, the emblem of Ceres) and elsewhere. Cooper's reason for avoiding the use of symbolic accessories is, I believe, readily determined. It is related to his avoidance of hands in his portraits. Both would detract from that concentration on the head from which Cooper's miniatures derive so much of their breadth and grandeur. It has been said that the work of Gerard Soest provides the closest parallel in large-scale Stuart portraiture to Cooper's miniatures. To the extent that both artists are fundamentally honest in their approach to individual character this is a correct assessment. Yet Soest possessed a bizarre, mannered streak which Cooper never shows. On the other hand, Cooper was capable of a courtly grace which is not part of the Dutchman's personality.

Cooper's only serious follower was the amateur, Thomas Flatman, who produced works good enough to be confused with those of Cooper. With Flatman's death in 1688 a great age of English miniature painting ended. Yet Cooper's kind of painting did not die; the desire for it was too deeply embedded in the English character. And it is fitting that the latest item exhibited here should be the 1689 portrait of John Evelyn by Sir Godfrey Kneller. It was Evelyn who had proudly held the candle for Cooper to draw Charles II's head for the coinage. And in Kneller's portrait one finds a directness, simplicity and boldness, in both presentation and technique. These are features which Evelyn and other English patrons must have found refreshing after the artificialities and mannerism of much Restoration painting. Yet they were the very qualities they must have learned to appreciate in the works of '. . . the prince of limners of this age', 'the greate, (tho' little) limner, the . . . famous Mr Cooper'.

J Douglas Stewart

Cooper's painting technique

IT is important to remember that Cooper lived in an age when the artist was intimately concerned with the choice and preparation of his own materials. True, most of the pigments could, by then, be bought prepared, but the artist had to be able to judge their quality when making his purchases, and they still had to be ground finely and mixed with a binder; and there were some colours which painters preferred to make up themselves. The artist would also prepare the support, or tablet, on which he painted, and sometimes make his own brushes (or pencils as they were then called), although the London brushmakers had a reputation for making very fine pencils for miniature painting. These may seem very mundane activities by modern standards, but at the time artists were well aware that their choice of materials and the care with which they prepared them would be reflected in the excellence and durability of their works. The fine condition of most of Cooper's miniatures, other than those which have suffered actual ill treatment, is testimony to the scrupulous care which he took over all aspects of his craft.

Cooper worked in a modified version of the English tradition of miniature painting on vellum, which originated in the methods of the medieval manuscript illuminators and was developed by artists such as Holbein, Hilliard and Oliver into a fine watercolour technique, well adapted to the exacting task of painting very small portraits. It was not a watercolour technique as we know it today; neither was it true gouache, although by Cooper's time so much white was being added to the colours that the end results are almost indistinguishable. In modern terms a watercolour is a transparent painting carried out in a water-soluble medium, whereas a gouache is a painting in a water-soluble medium which is completely opaque, those colours which are not naturally opaque being rendered so by the addition of white. The Elizabethans painted large areas of their miniatures with fairly thick layers of pigment mixed with just enough binder to hold the colours together. These areas would be completely opaque. However, other areas of the miniature would be painted in transparent colour, either directly on the vellum, or on opaque underpainting. The method should, therefore, be correctly described as a mixed gouache and watercolour technique. Cooper worked in the same basic technique with the difference that he would work over the transparent areas again, with opaque colour, giving his paintings a more solid, gouache effect.

Cooper painted on thin sheets of fine vellum attached to card supports. Edward Norgate, who wrote an excellent treatise on miniature painting, *Miniatura* (*c*.1650), gives detailed instructions for the preparation of a vellum: by pasting it on to a playing card, and varnishing the back to make it smooth. Early miniatures in watercolour were almost invariably painted on the type of support which Norgate describes. Because of the increase in the size of miniatures, which in Cooper's time were generally upwards of three inches in height, this method was modified by coating the back of the card with a thin layer of gesso. This was made of a mixture of glue size and chalk, and its purpose was to counter the pull of the sheet of parchment, which might otherwise have caused the card to warp. This was not done in every case, but many of Cooper's vellums were prepared in this way.

The preparation of artists' pigments is too complex a subject to discuss here. Suffice to say that it was a tedious business, which had to be carried out with meticulous care. Colours were divided into two categories: those which were prepared by grinding to a very fine powder, and those which had to be separated by washing because grinding would have destroyed their hue. Miniaturists were very careful in their choice of pigments, and, although many used lakes which faded when exposed to light, they avoided pigments which they thought could cause disastrous chemical reactions, such as orpiment, verdigris and the artificial copper blues and greens. Powdered gold and silver, which had figured so prominently in the palettes of the Elizabethans, were not used in Cooper's time to anything like the same degree. The early miniaturists had delighted in the use of metallic pigments, which they burnished to a high polish to represent armour and jewellery. They also used gold powder for their elaborate inscriptions. Cooper sometimes used gold for his signatures and occasionally for representing gilt buttons, but armour and other metallic objects he generally rendered in ordinary pigments. In his miniature of a gentleman, possibly Sir R. Henley, in the Victoria and Albert Museum, can be seen a rare use of powdered gold for rendering the unusual quality of the highlights in satin.

It is evident from the relative lack of fading in Cooper's miniatures that he largely eschewed the impermanent colours such as sap green, pink and the lakes, and used a fairly limited palette of earth and mineral colours. In the seventeenth century it was difficult to avoid using white lead because there

were few acceptable substitutes. This colour has the serious disadvantages that in the presence of atmospheric hydrogen sulphide it turns black, and the frequent occurrence of this phenomenon in Cooper's miniatures points to the fact that he used it extensively. The only authenticated piece of writing in Cooper's hand is a note written for Sir Theodore Turquet de Mayerne, the physician, about the preparation of colours. It is a general directive for the preparation of white lead, bice, massicot, red lead and vermilion. Although the note was written while Cooper was working in his uncle's studio, there is no reason to doubt that he continued to use these colours in his mature works. The complete palette would, of course, have included several more colours. Dr G. C. Williamson, who wrote a number of books on miniature painting around the beginning of this century, repeatedly stated that Cooper used sepia. That colour, although known in antiquity, was not rediscovered in modern times until the late eighteenth century.

When the pigments had been ground or washed to a fine consistency, they had to be mixed with a binder. The binder normally used for miniature painting was gum arabic or, more correctly, gum senegal, which is the clearest and most easily soluble of the acacia gums. The gum would be dissolved in water to make a weak solution and then mixed with small quantities of colour to make a thickish paste. A test patch of colour was then painted out to ensure that the paint had the correct amount of binder. If the colour was shiny when it dried, it had too much binder; if it rubbed off on the finger, then it had too little. The necessary adjustment was then made by either adding more pigment and water, or more gum solution. This was a very essential procedure because some pigments have the ability to absorb more binder than others; the proportion can also vary according to how finely the colour has been ground. When the colour was judged to be correctly bound it was smeared around the sides of a mussel shell or a small, turned ivory box, and was allowed to dry there. When the painter wished to use the colour he would wet it with a brush in the same way as one would with modern watercolours in pans.

Some colours, such as the lakes, tend to crack if bound with gum alone, so it was common practice to add a plasticizer to them, such as sugar candy or honey. We do not know with absolute certainty that these were Cooper's methods, but they were the methods of the artists preceding and following him, and there is no evidence to the contrary. How-

ever, when an original genius presents himself on the artistic scene there is usually a controversy, after a safe interval of a century or so, over the composition of a 'secret' medium which would account for such unparalleled virtuosity. This has happened to many great painters, and Cooper is no exception. At various times it has been suggested that he painted with honey, with starch, or with a kind of dextrine made from sugar, while one journal that frequently reproduced his works described them as being painted in oil on vellum! Williamson advanced his own theory that laevulose was used. Space will not permit a full investigation of these claims, but the weight of evidence suggests that Cooper used exactly the same traditional methods as his contemporaries.

It is not unlikely that Cooper's working methods were the same as Hoskins's, whose equipment is described in some detail by de Mayerne. The bound colours were kept in small, turned ivory dishes. A turned ivory palette was used, about four inches in diameter, which was slightly concave. Small amounts of wetted colour were transferred from the ivory dishes to the edge of the palette, and were then mixed in the centre. White and blue, which were used in fairly large quantities, Hoskins kept separately in ivory pots. Some artists preferred to mix their colours on a large piece of mother-of-pearl.

The brushes, or pencils, used were most probably made from squirrel hair, taken from the tip of the tail and bound together in small bundles, with the hairs curving in to form the tip. These bundles were then set in goose quills, which were subsequently mounted on sticks. Contrary to a popular notion, brushes were not exceedingly finely pointed. The legendary 'brush with one hair' would be literally impossible to use. It is difficult to work in any medium with a brush that does not have a full body of hair, because it will not carry sufficient colour to make a mark. Miniature-painting brushes usually have a full body of hair tapering to a slightly rounded tip. If the brush is too finely pointed the results tend to have a scratchy appearance. Cooper appears to have painted with rather larger brushes than his contemporaries.

In England it was customary to paint the flesh on a pale ground, rather than directly on the vellum. The method was to sweep over the area that the head would occupy on the vellum with a large brush loaded with somewhat liquid colour. This colour was basically white, with small amounts of red, yellow and brown, and occasionally blue, accord-

ing to the complexion of the sitter. The tone was kept very light so that this ground layer could serve as the highlight of the modelling. This flesh ground was called the 'carnation' by the early limners, and the method persisted in England from the time of Holbein until the eighteenth century, when vellum was superseded by ivory as a painting surface. The outline of the features was sketched in lightly over the carnation with a pale brown or red colour. Any excess ground which extended beyond the contours of the features was taken off with a damp brush, so that it would not 'pick up' when other colours were painted on those areas.

At this period miniaturists painted in a strictly observed procedure. Once the outline of the face had been established, the 'dead-colouring' was done. This was effected by lightly hatching on the carnation the various tones of the face: red in the cheeks and lips, blue tones around the eyes, and so on. Then the shadows which formed the modelling of the features were gradually hatched in. The idea was to tone down the carnation to form the shadows and modelling of the face, leaving islands of bare carnation to stand for the highlights.

Once the dead-colouring was done, the middle tone of the hair was washed in, and the basic tone of the background established. Although the effect relied on the colours being semi-transparent, white was added to most of the flesh tones in small quantities to give them body and make them blend well. Norgate says of painting the features '. . . in alle or most of the shadowes white is ever a dayly guest, and seldome absent but in the deepest shadowes.' The dead-colouring and laying-in of the tones of the hair and background would be accomplished in one sitting. In later sittings the modellings of the features would be deepened and 'sweetened' by working over with finer brush strokes, blending the shadows and giving subtlety to the blunt statement of the dead-colouring. The shadows and folds of the drapery would be hatched with darker colour on a middle tone already laid, while the highlights would be added with opaque light tones. The hair and background would be worked over in the same way. For a clear demonstration of the stages in painting a miniature at this period, the reader is urged to study the series of unfinished miniatures by Susan Penelope Rosse in the Victoria and Albert Museum.

There is a tradition which originated with Williamson and has been fostered by Colding (*Aspects of Miniature Painting*, 1953) that Cooper painted experimental miniatures on bone. Only two examples have been cited, one of which is identifiable and has been for a long time in the Victoria and Albert Museum. This miniature is an obvious fake and has been regarded as such by the Museum for many years.

In his brushwork Cooper was an innovator and although many of his miniatures conform to the procedures set out above, most of his best works are painted in a very free manner. In some of his miniatures the carnation is not visible, because he has worked over and over the flesh with free, broad strokes, so that the highlights have an impasto quality. Williamson asserts that Cooper used a green underpainting. There is absolutely no evidence to support this. In all the Cooper miniatures which I have examined where the carnation is visible, it is of a very pale, cream colour, and the dead-colouring of the shadows over it is in a rich red brown. As mentioned earlier, he occasionally used gold for rendering metallic objects or for highlighting costume, but usually he painted armour and gilt objects using colours in an illusionistic technique. His backgrounds occasionally depict a landscape or a stormy sky, carried out in an improvised mixture of transparent and opaque, wash and stipple.

There is one other tradition which should be treated with reserve, and that is that Cooper painted by candlelight. This derives from a statement of Evelyn's that he held the candle for Cooper while he drew the King, 'he choosing the night and candlelight for the better finding out the shadows'. This drawing was intended, not as a study for a painting, but for the new coinage. A study of this kind would need to have very simplified shadows to enable it to be carried out in low relief. It is quite possible to draw by candlelight, but almost impossible to use colour with any judgement. The miniatures themselves look as if they had been painted by daylight in a room with a high window or skylight. Pepys would almost certainly have mentioned it had his wife sat to Cooper at night!

V. J. Murrell

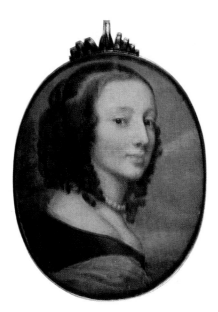

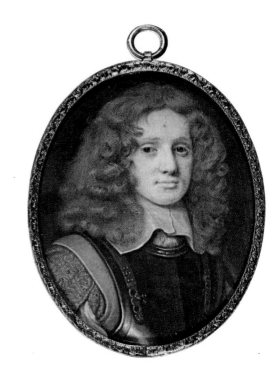

1 PORTRAIT OF AN UNKNOWN LADY
(*Cooper*)

93 PORTRAIT OF AN UNKNOWN
MAN IN ARMOUR
(*Cooper*)

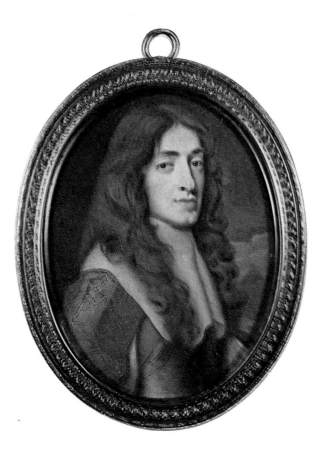

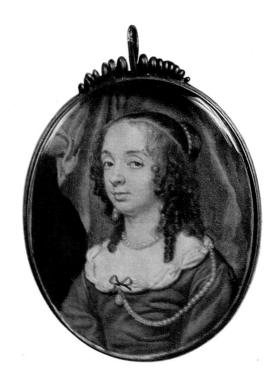

96 JAMES II as DUKE OF YORK
(*Cooper*)

17 PORTRAIT OF A LADY IN A BLUE DRESS
(*Cooper*)

Fashion

FASHION is an illustrator of social division, distinguishing the privileged from the under-privileged, and the 'up to date' from the provincial and the conservative. This was very obvious in the seventeenth century, when fashion was the prerogative of court circles and the aristocracy. Samuel Cooper's oeuvre is valuable because it not only depicts the intimate changes of fashion among the rich, but also includes the occasional soldier or bourgeoise, who could neither afford, nor dare to imitate, the fashions of their social superiors. Thus Cooper shows General Ireton with a decidedly un-fashionable full beard, and country ladies in their traditional caps and kerchiefs, as well as scholars and divines in their black caps and white collars.

The portrait miniature offers much information on changes in hair styles and necklines. From Cooper we have a closely packed range of dated portraits that is especially important. Whilst women's hair-dressing did not undergo any dramatic changes during his career (it was, rather, a series of variations on the style established in the late 1620s), the artist does show every subtle alteration of the fringe, the ringlets growing longer and wider, the movements of the partings, and the shifts of the bun from high to low. For men, hair fashion demanded no more than growth. At the outbreak of the Civil War, the Royalists' hair was already shoulder-length, against which the Puritans launched such attacks as T. Hall's 'The Loathsomeness of Long Hair'. The Iron-sides kept their hair a few inches shorter, and Cooper shows Cromwell with hair down to the base of his neck, even when going bald on top. By the time of the Restoration in 1660, men were wearing their hair as long and as full as nature could provide, but fashion was to demand even more. In Cooper's work we can trace the development of the solution to this demand: the introduction of the periwig. These cost from £3, the equivalent of about two months' wages for a labourer, and were another means of social distinction. Those who wore wigs were 'gentlemen'; those who wore their own hair 'vulgar fellows'.

Cooper shows us the early wig, flat on top and wide and frizzed at the sides, in imitation of the fashion-able tangles of curls. Towards the end of his career, we can see the wig becoming more disciplined into ringlets and sausage curls, and being more obviously 'artificial', although constructed out of human hair. Pepys thought Charles II adopted a wig because he was going grey. Neither of them could have imagined that this new fashion of theirs would en-dure to the end of the eighteenth century, continue in the Church into the mid-nineteenth century and still be worn by judges in the twentieth.

Samuel Cooper also gives us a picture of the evolu-tion of the male collar for over forty years. When he began to paint, the wide lace collar of the Caroline court was still part of male flamboyance, but it was reduced in the 1640s to a linen collar edged with lace. During the Civil War it was a plain collar, reflecting the need for more practical wear in that grim time. The same may be said of the glimpses of the doub-lets that one sees in miniatures: they, too, sobered up, replacing silks with military buff coats. With the Restoration came a flood of French fashions, in youthful exuberance, and the new collar was the *rabat* of extremely expensive *gros-point de venise*. This began to be replaced after 1663 by a short scarf tied in front with a black ribbon. The *rabat* became official dress, to be worn with the Order of the Garter or with state robes. Many a fashion becomes frozen in this way, once it has been accepted as respectable, and can last for several generations in its official form, as the legal wig demonstrates.

The glimpses of the doublets in the 1660s show the new vogue for leaving the sleeve seam open, allow-ing the shirt to balloon out. Cooper's portrait of the 2nd Earl of Shaftesbury illustrates this as well as the one major English innovation of the period: Charles II's introduction of the vest, or waistcoat, which the English court launched in October 1666. According to Pepys, the French response was to put their footmen into vests, which he considered 'the greatest indignity ever done by one Prince to an-other'. Despite the French action, the vest was to prove successful, for the three-garment male suit had been created.

The miniatures also provide a chronology for the changes in men's shaving habits. The trim chin beards of the Cavaliers yield to the moustaches of the 1640s and 1650s, which shrink in their turn to the thin moustache associated with Charles II, al-though he shaved it off later in his life.

It will be noted how little women's necklines changed throughout Cooper's career, most of them being painted in *décolleté*. Such exposure was very much confined to the court, and it tended to increase. In the 1640s the shoulders were still covered, but by the 1660s the neckline is off the shoulder altogether. This was a fashion followed by Cromwell's daughters, as peeresses of the realm. The favourite jewel for the whole period was the pearl, worn as a single strand necklace, with matching earrings, and

xxiv

sometimes as ropes in the hair.

Two of Cooper's works point to the great love for masquerades in the seventeenth century: Margaret Lemon in male attire, and the Duchess of Richmond in Cavalier dress, painted thirty years apart. The former wears a man's shirt, buff coat, and cravat. This adoption of male dress was particularly marked in riding costume, for practical female dress is often taken from more business-like male garments. It was

also enormously popular in the Restoration theatre, for 'breeches roles' gave men in the audience a rare opportunity to see a woman's legs. No doubt a similar reason explained their popularity in the masquerade.

Thus, within the small frame of the miniature portrait, Samuel Cooper has left us a survey of his times, showing how clothes reflect and epitomize the character of the age, and of the people who lived in it.

Diana de Marly

Samuel Cooper
Miniatures

Whenever possible, miniatures throughout
the catalogue are reproduced actual size

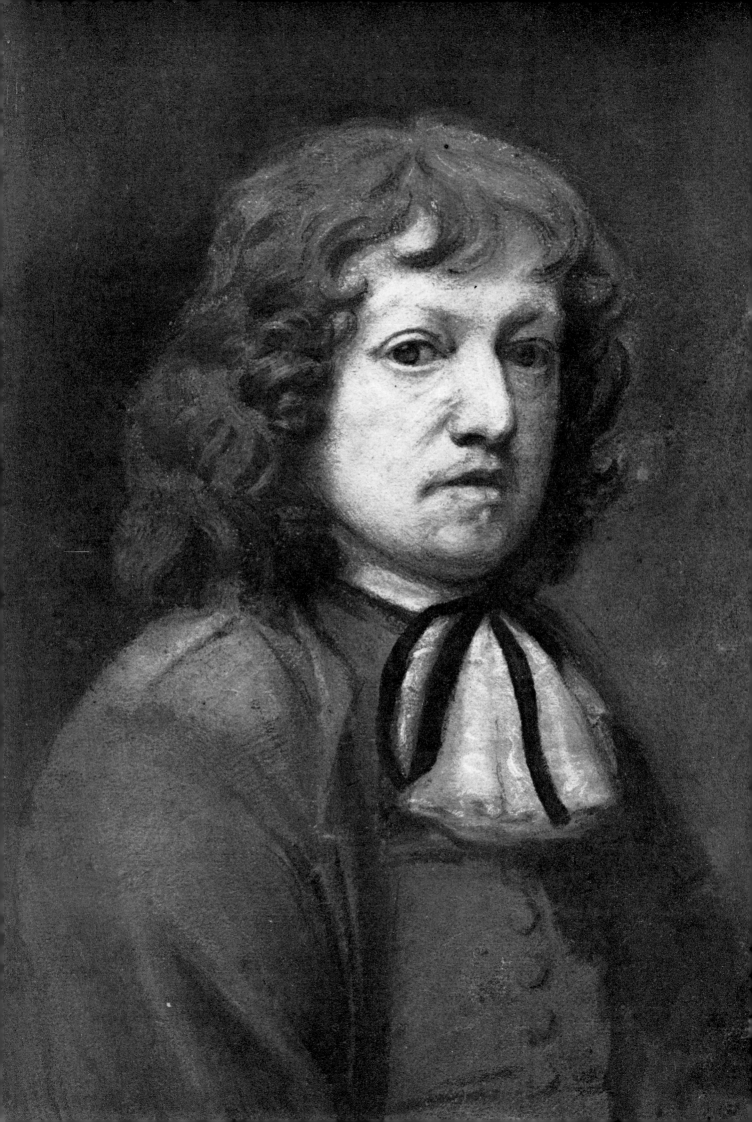

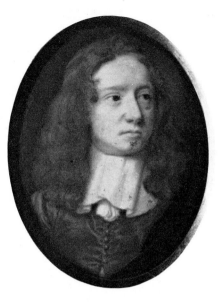

I

SELF-PORTRAIT(?)

Watercolour on vellum, oval:
2 3/4 × 2 3/16 in.

Signed in monogram: *SC* and dated: | *1657*

This miniature, together with the chalk drawing (no. 2), was among the large collection of items bequeathed to the Victoria and Albert Museum by the Revd Alexander Dyce, who died 15 May 1869. The miniature has no earlier provenance than the Dyce bequest, and is identified as of Cooper only by an eighteenth-century inscription on the reverse which reads: *Sam¹ Cooper | by Himself | dated 1657| On Card prepared as | Ass's skin | £100.* The sitter seems too young to be Cooper, and the image is quite unlike no. 2.

The Victoria and Albert Museum

2 (*opposite; enlarged*)

SELF-PORTRAIT (?)

Pastel on paper, rectangular: 9 5/8 × 7 5/8 in. Attributed to Cooper.

This portrait of Samuel Cooper is thought to have been the one once in the Royal Collection at Kensington, and, as in the case of no. 1, was bequeathed to the Victoria and Albert Museum by the Revd A. Dyce. According to Walpole it was drawn by Jackson, a relative of Cooper, about whom nothing is known. Basil Long and others accepted it as a genuine self-portrait, but David Piper doubts the attribution. Although the matter is still in dispute, the work is very much in Cooper's style. It may be the crayon drawing referred to in Mrs Cooper's will, and which she left to her 'cousin John Hoskins'.

The Victoria and Albert Museum

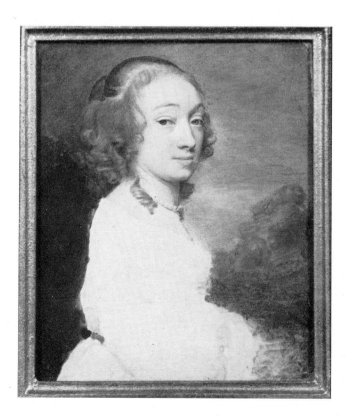

MRS SAMUEL COOPER, *née* CHRISTIANA TURNER (1623?–93)

Watercolour on vellum, rectangular:
3 1/2 × 2 7/8 in. Unfinished.

The sitter, who was the wife of the artist, was a daughter of William Turner of York and sister of Edith Pope, mother of Alexander Pope, the poet. The date of her marriage to Samuel Cooper is unknown, and this miniature, which is one of the artist's outstanding works, appears to be the only known portrait of her.

Reproduced by kind permission of The Duke of Portland, KG

[*Not in the exhibition*]

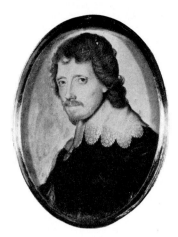

3
JOHN LESLIE, 6th EARL OF ROTHES
(1600–41)

Watercolour on vellum, oval:
2 1/16 × 1 1/2 in. Painted *c.*1635–40.

Succeeded to the Earldom on death of his
grandfather, Andrew, 5th Earl of Rothes.
Married in 1614, Anne, daughter of John,
Earl of Marr. The Earl was an opponent of
Episcopacy and took a prominent part in
organizing the movement against it. His
son, John, held office as Keeper of the
Privy Seal, 1664, and as Lord Chancellor,
1667, being created Duke of Rothes in 1680.
The miniature, although unsigned, appears
to be very close in style to other early works
by Cooper.

The Earl of Haddington, KT

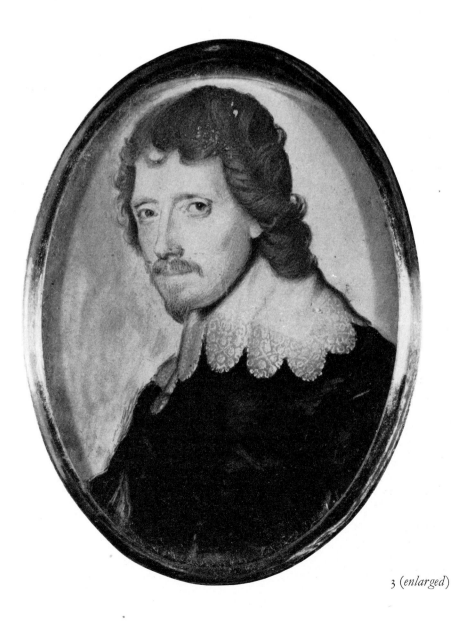

3 *(enlarged)*

4

SIR JOHN HAMILTON (b. 1605)
Watercolour on vellum, oval:
2 1/4 × 1 13/16 in. Attributed to Cooper.
Painted *c*.1635–40.

Son of Sir Thomas Hamilton, 1st Earl of
Haddington, and brother of Thomas, 2nd
Earl of Haddington.
This miniature, like that of John, 6th Earl
of Rothes (no. 3), is attributable to Cooper
by reason of its style and modelling.

The Earl of Haddington, KT

5

PORTRAIT OF AN UNKNOWN
MAN

Watercolour on vellum, oval: 2 3/8 × 2 in.
Painted *c*. 1630–5.

The sitter was formerly thought to be
Robert Devereux, 3rd Earl of Essex
(1591–1646).

Her Majesty The Queen

6

PORTRAIT OF AN UNKNOWN
MAN

Watercolour on vellum, oval:
4 1/2 × 3 1/2 in. Painted *c*. 1630.

Signed: *S.C.*

Although some repainting is visible on the
face and parts of the background, Graham
Reynolds considers that the miniature is a
good example of Cooper's early work,
painted *c*.1630.

Her Majesty The Queen

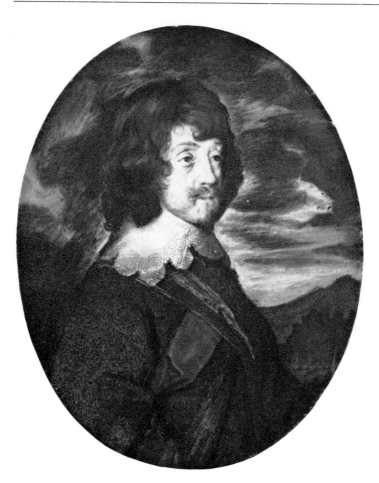

7

HENRY RICH, 1st EARL OF
HOLLAND (1590–1649)
Watercolour on vellum, oval:
4 5/8 × 3 7/8 in. Painted *c*.1630.

On the reverse of the miniature is an
inscription, in an eighteenth-century hand,
identifying the sitter and ascribing the
miniature to 'old Hoskins'. The boldness
of the style suggests that it is an early work
by Samuel Cooper and painted in the
manner of the 'Unknown man' (no. 6) in
the collection of HM The Queen.
The sitter was the son of Robert, 1st Earl
of Warwick, and his wife, Penelope (Sir
Philip Sidney's 'Stella'), daughter of
Walter Devereux, 1st Earl of Essex. Henry
Rich changed sides frequently between the
Royalists and Parliamentarians, and was
beheaded in July 1649.
The miniature comes from the collection
of the Earls of Dysart and was bought with
the contents of the house.

The Victoria and Albert Museum
(*Ham House*)

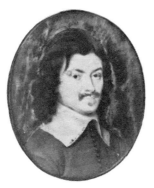

8

SIR WILLIAM FAIRFAX (1609–44)
Watercolour on vellum, oval:
1 3/4 × 1 1/2 in.

Sir William was the second son of Sir
Philip Fairfax of Steeton, and his wife,
Frances Sheffield. In 1629 William married
Frances, daughter of Sir Thomas Chaloner
of Guisborough in Cleveland, and sister of
James and Thomas Chaloner, the regicides.
He was knighted by Charles I on 1 June
1630. Succeeded to the family estates of
Steeton and Newton Kyme in 1636. Was
given the command of a regiment under
Essex in 1642; commanded detachments
at Nantwich and Marston Moor. In the
relief of Montgomery Castle, 18 September
1644, Sir William was mortally wounded
and died the following day.
The sitter is identifiable as Sir William by
the mark over his right temple.

The Hon Mrs Johnston

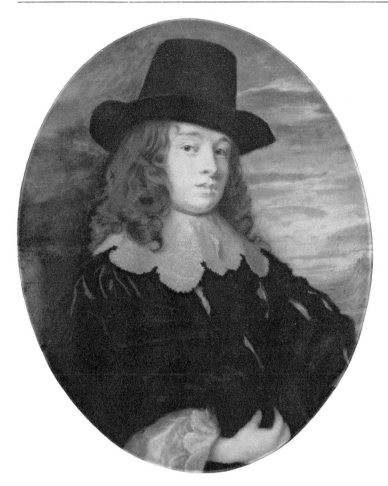

9

MARGARET LEMON

Watercolour on vellum, oval:
4 3/4 × 3 3/4 in.

Signed in monogram: *S.C.* and inscribed with the sitter's name: *MARGARET* and *LEMON*. Probably painted *c.*1635.

This important miniature is at present the earliest known signed work by Cooper. The sitter, who was Van Dyck's mistress, is dressed as a young cavalier. The liaison between Margaret Lemon and Van Dyck was broken off in 1639, in which year he married Lady Mary Ruthven (d.1645). According to W. Hollar, Margaret Lemon was 'a dangerous woman' and a 'demon of jealousy who caused the most horrible scenes when ladies belonging to London society had been sitting without chaperone to her lover for their portraits'. On one occasion, in a fit of hysterics, she is said to have tried to bite Van Dyck's thumb off so as to prevent him from ever painting again. A portrait of her by Van Dyck is in the Royal Collection at Hampton Court (no. 242), and a drawing by Van Dyck, said to be of her, is also in the Frits Lugt collection. The miniature is a key piece, as it shows that Cooper had by this time reached a mature style and breadth of handling that was far in advance of anything produced by his predecessors and contemporaries. It is indicative of the profound influence that Van Dyck had exercised over him. Assuming that this miniature was painted as has been suggested, *c.*1635, and that the artist must have continued painting during the seven years that elapsed between this portrait and the earliest dated one of the Countess of Devonshire in 1642, one is left wondering what has happened to the miniatures executed during the intervening years.

The Fondation Custodia (collection F. Lugt), Institut Néerlandais, Paris

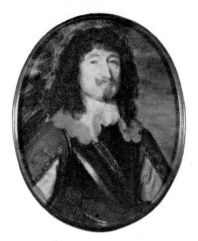

10

GEORGE GORDON, 2nd MARQUESS
OF HUNTLEY (d.1649)

Watercolour on vellum, oval:
2 1/4 × 1 3/4 in.

Signed: *S:C* and dated indistinctly: *1640*

The miniature is based on a portrait by
Van Dyck, of which the best-known
version belongs to the Duke of Buccleuch.
Eldest son of George Gordon, 6th Earl
and 1st Marquess. Succeeded his father,
1636. Supported Charles I, was captured
by Colonel Menzies in 1647, and was
beheaded in Edinburgh, 1649.

The Mauritshuis, The Hague

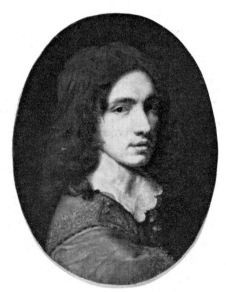

11

PORTRAIT OF AN UNKNOWN MAN

Watercolour on vellum, oval:
2 7/8 × 2 1/4 in.

Signed and dated: *S: Cooper | fe: 1645* and
incised on the reverse of the gesso base:
*Samuel Cooper | fecit feberuaris | 1644 | ould
stile.*

This miniature was formerly thought to
represent the artist Robert Walker (d.1658),
but the likeness does not accord with the
self-portrait of Walker in the Ashmolean
Museum.

The miniature is a superb example of
Cooper's ability to portray his sitters as
living persons, and the effect is almost
three dimensional. The rich tones used on
the dress and the general effect place
Cooper on a higher plane than any other
miniaturist of the British school.

Her Majesty The Queen

12

ELIZABETH CECIL, COUNTESS OF DEVONSHIRE (1620–89)

Watercolour on vellum, rectangular:
6 1/8 × 4 5/8 in.

Signed and dated: *Sa: Cooper | pinx A° 1642*

Lady Elizabeth was the second daughter of William Cecil, 2nd Earl of Salisbury, and wife of William, 3rd Earl of Devonshire (1617–84), whom she married in 1639. She was the granddaughter of Treasurer Burghley; mother of Anne, wife of John Cecil, 5th Earl of Exeter, to whom she left this miniature in her will.

The portrait is of the utmost importance, being the earliest known dated work by Cooper. The composition and breadth of handling show the influence of Van Dyck used on a miniature scale, whilst the competent modelling of the features and use of colour are all indicative of Cooper's ability at this stage of his career.

The Marquess of Exeter,
Burghley House Collection

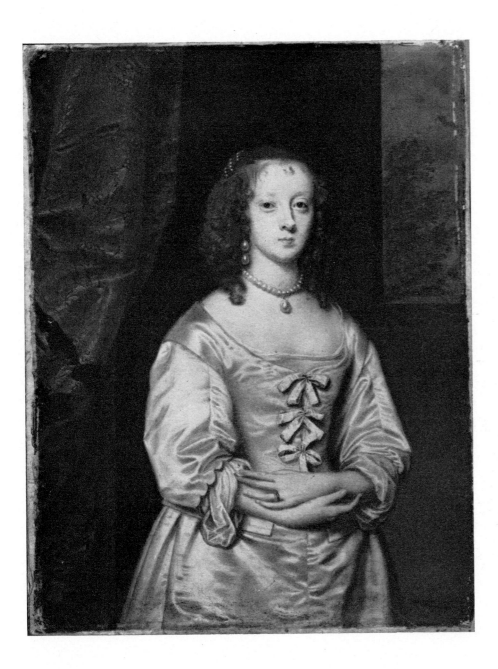

ELIZABETH CECIL, COUNTESS OF DEVONSHIRE

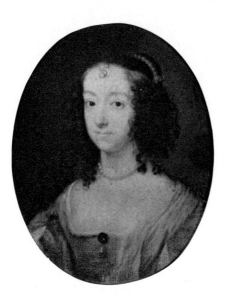

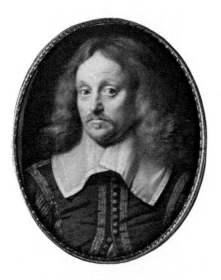

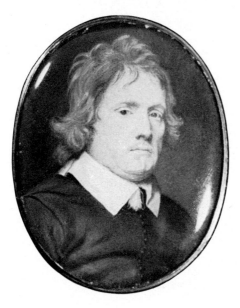

13
PORTRAIT OF AN UNKNOWN LADY
Watercolour on vellum, oval:
2 3/4 × 2 1/2 in.
Signed: *S.C fe / 1643*
The Mauritshuis, The Hague

14 (*opposite*)
WILLIAM CAVENDISH, DUKE OF
NEWCASTLE KG (1592–1676)
Watercolour on vellum, rectangular:
13 5/8 × 9 1/2 in.
Son of Sir Charles Cavendish, of Welbeck,
Nottinghamshire; created Viscount
Mansfield, 1620; Earl of Newcastle, 1628;
Marquess of Newcastle, 1643; and Duke of
Newcastle, 1665. Married as his 2nd wife,
in 1645, Margaret (1624?–74), youngest
child of Sir Thomas Lucas.
After the original portrait by Van Dyck in
the collection of the Duke of Portland at
Welbeck. The late Basil Long suggested
that the miniature might possibly have been
painted by Hoskins, and not Cooper.
The Duke of Buccleuch and Queensberry

15
PORTRAIT OF AN UNKNOWN MAN
Watercolour on vellum, oval: 2 1/2 × 2 in.
Painted *c*.1645.
This unsigned work by Cooper is a fine
example of his ability to portray
character.
Her Majesty The Queen of The Netherlands

16
JOHN PYM (1584–1643)
Watercolour on vellum, oval:
2 3/4 × 2 3/16 in.
Signed in gold: *S.C.*
Eldest son of Alexander Pym of Brymore,
near Bridgwater, Somerset. Parliamentary
statesman. Served in the Short and Long
Parliaments; was one of the five members
whose attempted arrest by Charles I in
1642 was the immediate cause of the Civil
War.
*The Administrative Trustees of the Chequers
Trust*

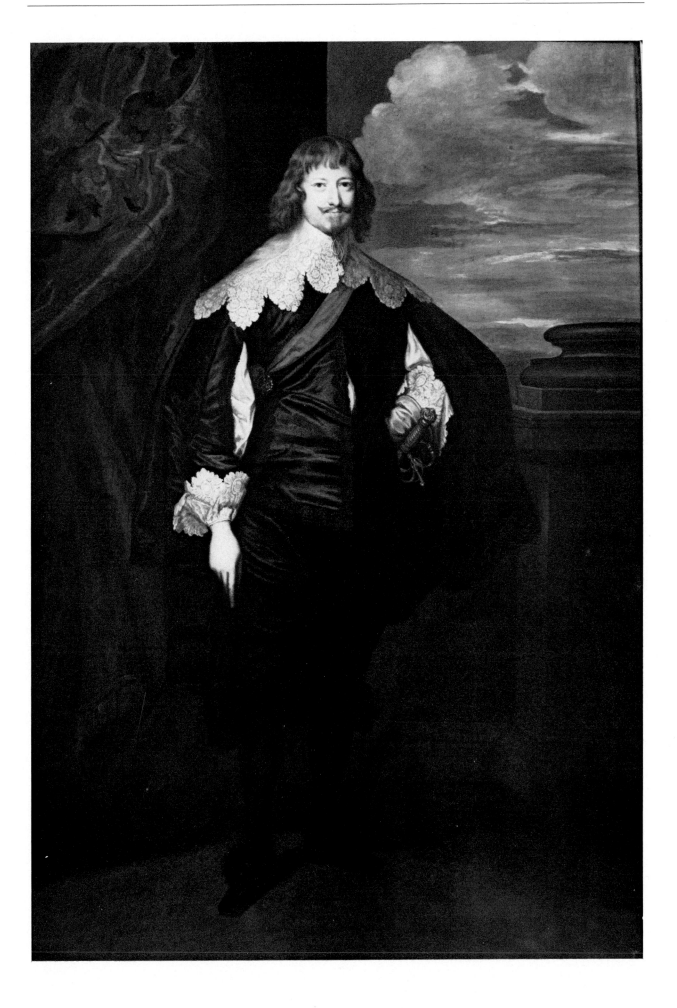

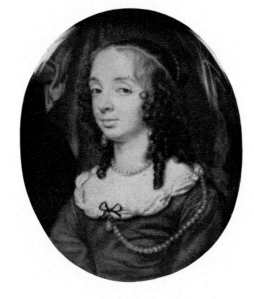

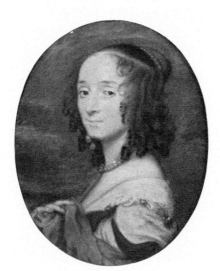

ALGERNON PERCY, 10th EARL OF
NORTHUMBERLAND (1602–68)
Watercolour on vellum, oval:
1 27/32 × 1 17/32 in.
Signed: *SC:*

Algernon Percy, son of Henry, 9th Earl of
Northumberland, was made Lord High
Admiral in 1637, but dismissed in 1642.
Took an active part in the Civil War, sided
with Parliament against the King but did
not take part in his execution. Married
Elizabeth Howard, daughter of the 2nd
Earl of Salisbury, by whom he had a son,
Joceline, 11th Earl. Favoured the Restora-
tion. Described by Clarendon as 'the
proudest man alive'.
The miniature is almost certainly based on
the portrait by Van Dyck at Petworth
House (no. 244). Another version,
attributed to Hoskins, and also after the
Van Dyck portrait, is in the collection of the
Duke of Northumberland.
The Victoria and Albert Museum

[*Not in the exhibition*]

17

PORTRAIT OF A LADY IN A BLUE
DRESS
Watercolour on vellum, oval:
2 7/8 × 2 3/8 in.
Signed and dated: *S.C. | 1646*
The Cleveland Museum of Art
(*Edward B. Greene Collection*)

18

PORTRAIT OF AN UNKNOWN LADY
Watercolour on vellum, oval: 2 5/8 × 2 in.
Signed and dated: *S.C. | 1646*
*The Fondation Custodia (collection F. Lugt),
Institut Néerlandais, Paris*

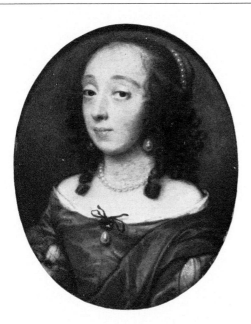

19

ELIZABETH SLINGSBY,
VISCOUNTESS PURBECK (1619–45)

Watercolour on vellum, oval: 3 × 2 3/8 in.

Inscribed in full on the reverse: *Eliza Villiers | Viscountess of Purbeck and Baroness of Stoke | only Daughter of Sr Wm | Slingsby of Kippax Knight | who was second son to Sr | Francis Slingsby of Scriven | and Lady Mary Piercy only | sister to Thomas and | Henry Piercy both | Earls of Northumberland | S. Cooper.*

The inscription appears to be in the artist's own handwriting.

Elizabeth Slingsby married, as his second wife, John Villiers, Viscount Purbeck of Dorset (1591?–1657), who suffered from intermittent insanity.

The Earl Beauchamp

20

JOHN, 1st BARON BELASYSE OF
WORLABY (1614–89) (?)

Watercolour on vellum, oval: 4 5/8 × 4 in.

Signed and dated: *S. Cooper f. 1646*

Second son of Thomas, 1st Viscount Falconberg; Royalist; created baron, 1645; fought for Charles I at Edgehill, Newbury, Naseby and Selby. Was Lord Lieutenant of the East Riding of Yorkshire, Governor of Hull, and subsequently Governor of Tangier; first Lord Commissioner of the Treasury.

The identification of the sitter as Belasyse has been questioned by Oliver Millar, who considers it incorrect after comparison with a large portrait of Belasyse as a younger man.

A smaller version of this miniature, but with the arm holding the baton omitted, is in the Fitzwilliam Museum; it is dated the same year (no. 21).

The Duke of Buccleuch and Queensberry

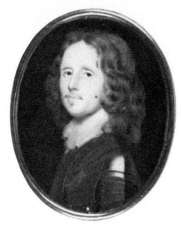

21

JOHN, 1st BARON BELASYSE OF
WORLABY (1614–89) (?)

Watercolour on vellum, oval:
2 1/8 × 1 3/4 in.

Signed and dated: *S.C. | 1646*

This portrait, supposedly of Belasyse, is a
smaller version of one by Cooper in the
collection of the Duke of Buccleuch (no.
20), and painted in the same year. The scar
on his forehead and the arm holding the
baton have been omitted, and the painting
not as strong as one would expect from
Cooper.

The Fitzwilliam Museum, Cambridge

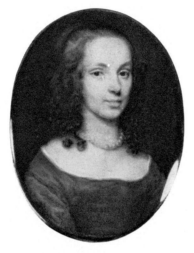

22

Mrs GRAHAM (?)

Watercolour on vellum, oval:
2 3/8 × 1 7/8 in.

The identity of the sitter is unknown, but
it is tempting to consider the possibility of
her being the wife of Richard Graham,
author and collector, who had in his
possession miniatures by Cooper.

Robert Bayne-Powell, Esq

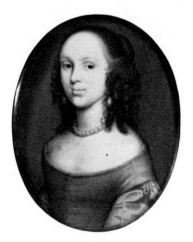

23

PORTRAIT OF A YOUNG GIRL

Watercolour on vellum, oval: 2 1/4 × 2 in.

Signed in monogram: *SC.* and dated: *| 1656*

From the collection of Humphry W. Cook
and Sir Frances Cook, Bart, sold at
Christie's, 16 February 1949, from the
Harry Seal collection.

*E. Grosvenor Paine, Esq., Oxford,
Mississippi*

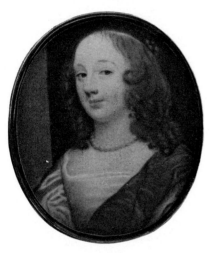

24

PORTRAIT OF AN UNKNOWN LADY

Watercolour on vellum, oval:
2 3/4 × 2 1/4 in.

Signed and dated: *S.C. | 1647*

The sitter has been erroneously identified as Elizabeth Vernon, Countess of Southampton (d. after 1625). For another version, see no. 25 below.

The Duke of Buccleuch and Queensberry

25

PORTRAIT OF AN UNKNOWN LADY

Watercolour on vellum, oval: 2 3/8 × 2 in.

Signed and dated: *S.C. | 1647*

The sitter, whose true identity is unknown, has been called Alice Fanshawe and Elizabeth Vernon, Countess of Southampton. For another version, see no. 24 above.

Nelson Gallery-Atkins Museum (Gift of Mr and Mrs John W. Starr), Kansas City, Missouri

26

PORTRAIT OF AN UNKNOWN LADY

Watercolour on vellum, oval:
2 3/4 × 2 1/4 in.

Signed and dated: *S.C. | 1647*

The sitter was formerly identified as Mary, Princess Royal (1631–60), later Princess of Orange, but the features do not resemble the known portraits of the Princess. For another miniature incorrectly identified as her, see no. 28 below.

The Duke of Buccleuch and Queensberry

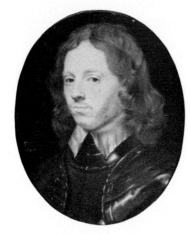

27

GENERAL GEORGE FLEETWOOD
(*c.*1622–d. after 1664)

Watercolour on vellum, oval:
2 1/4 × 1 3/4 in.

Signed and dated: *S.C. | 1647.*

Regicide; raised a troop of dragoons in
1643 in the Parliamentary cause; served as
a member for Buckinghamshire; was one
of the commissioners for the trial of
Charles I, and signed his death warrant.
Condemned to death at the Restoration,
but never executed.

National Portrait Gallery

28

PORTRAIT OF AN UNKNOWN LADY

Watercolour on vellum, oval:
2 3/4 × 2 1/4 in.

Signed in monogram: *SC.*

The identification of the sitter as Mary,
Princess Royal (1631–60), later Princess of
Orange, appears to be incorrect. For
another miniature called Princess Mary,
see no. 26 above.

The Duke of Buccleuch and Queensberry

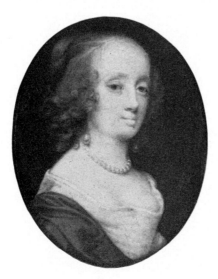

29

ANNE St JOHN, COUNTESS OF
ROCHESTER (1614–96)

Watercolour on vellum, oval:
2 5/8 × 2 1/8 in.

Signed and dated: *S.C. | 1647* and inscribed
on the reverse: *The Lady Rochester don by
S. Cooper in London.*

The sitter was the daughter of Sir John
St John, Bart; married, as her first husband,
Sir Francis Henry Lee (d. 1639), and
secondly, Henry Wilmot, 1st Earl of
Rochester. She was the mother of the poet,
John, 2nd Earl of Rochester (1647–80).

The Earl Spencer

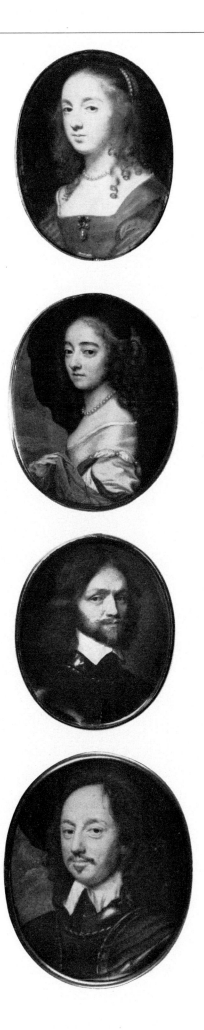

30

A LADY *called* SARAH FOOTE

Watercolour on vellum, oval:
2 1/8 × 1 3/4 in.

Signed and dated: *S.C. / 1647*

The sitter is possibly Sarah Foote, wife of
Sir John Lewis, Bart, whom she married
in or before 1644.

The Hon Felicity Samuel

31

LADY MARGARET LEY

Watercolour on vellum, oval:
2 3/16 × 2 3/4 in.

Signed and dated: *S.C. / 1648*

The sitter was the daughter of Henry, 2nd
Earl of Marlborough (d. 1638).

The Fitzwilliam Museum, Cambridge

32

GENERAL HENRY IRETON (1611–51)

Watercolour on vellum, oval:
1 31/32 × 1 9/16 in.

Signed and dated *S.C. / 1649*

Regicide; BA Trinity College, Oxford. The
sitter was one of the leading
Parliamentarians and one of Cromwell's
most able commanders. In 1646 he married
Bridget, Cromwell's daughter, whose
portrait was also painted by Cooper. Served
Cromwell in Ireland as Lord Deputy. Died
of fever.

This miniature was used by Robert Walker
as a basis for his portrait of Ireton, now in
the National Portrait Gallery.

The Fitzwilliam Museum, Cambridge

33

MONTAGUE BERTIE, 2nd EARL OF
LINDSEY (d. 1666)

Watercolour on vellum, oval:
2 5/16 × 1 7/8 in.

Signed and dated: *S.C. / 1649*

The Fitzwilliam Museum, Cambridge

32 *(enlarged)*

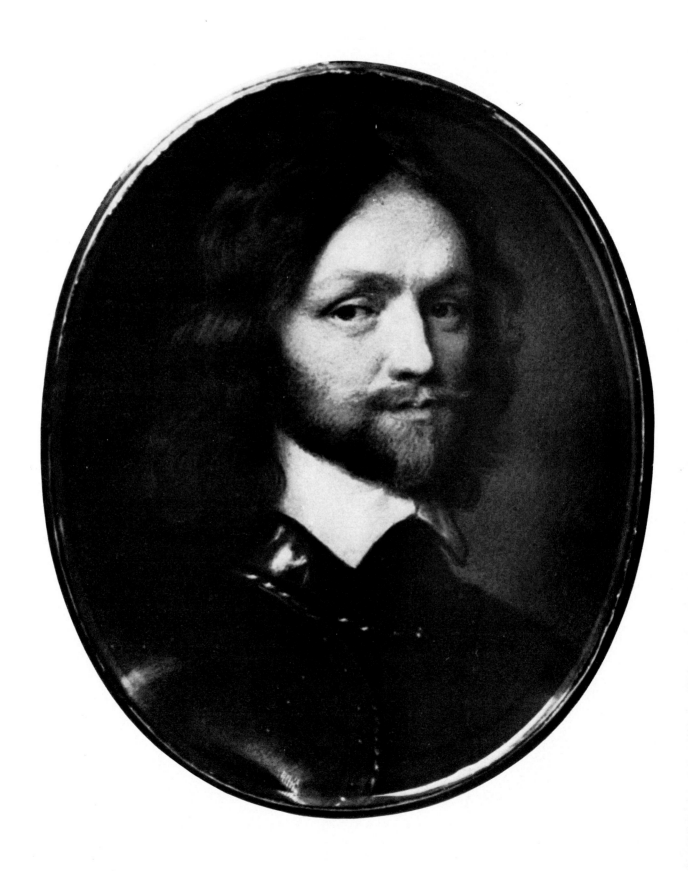

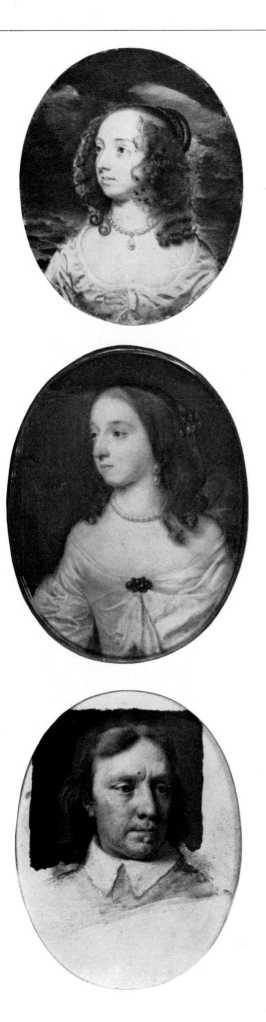

34

LADY ELIZABETH PERCY, *née* HOWARD

Watercolour on vellum, oval:
2 7/8 × 2 3/8 in.

Second daughter of Theophilus, 2nd Earl of Suffolk (d. 1640), and his wife, Elizabeth, daughter and heiress of George, Earl of Dunbar. Lady Elizabeth married, 1 October 1642, Algernon, 10th Earl of Northumberland. This miniature is among those mentioned in the Countess of Devonshire's will and on an indenture dated 18 April 1690.

The Marquess of Exeter,
Burghley House Collection

35

FRANCES MANNERS, COUNTESS OF EXETER (1630–69)

Watercolour on vellum, oval:
3 1/8 × 2 1/2 in.

The daughter of John, 8th Earl of Rutland (1604–79). Married, 8 December 1646, as his first wife, John, 4th Earl of Exeter (1628–77/8), by whom she had a son, John, who succeeded as 5th Earl of Exeter.

The Marquess of Exeter,
Burghley House Collection

36

OLIVER CROMWELL (1599–1658)

Watercolour on vellum, oval:
3 1/8 × 2 1/2 in.

Unfinished sketch, probably painted *c.*1650.

This unfinished sketch of the Protector is one of Cooper's most famous portraits, from which numerous finished versions, copies and derivations have been taken. As in the case of the five large sketches in the Royal Collection, this was probably left unfinished as a study from which replicas could be produced, as and when required. Horace Walpole said of it: 'If a glass could expand Cooper's pictures to the size of Van-dyck's they would appear to have been painted for that proportion. If his portrait of Cromwell could be so enlarged I don't know but Van Dyck would appear less great by the comparison.'

The exact date on which the portrait was painted is unknown, but Cooper was working for Cromwell and his family as early as 1650.

The Duke of Buccleuch and Queensberry

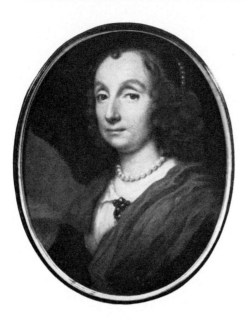

37

Mrs OLIVER CROMWELL, *née*
BOURCHIER (d. 1665)

Watercolour on vellum, oval:
2 3/4 × 2 1/4 in.

Signed and dated: *S.C. | 1651*

Wife of Oliver Cromwell (1599–1658), the
Protector, whom she married on 22 August
1620. Her father was Sir James Bourchier
of 'Tower Hill', a city merchant. Elizabeth
survived her husband by seven years. After
Cromwell's death she lived at the home of
her son-in-law, John Claypole, in
Northamptonshire.

The Duke of Buccleuch and Queensberry

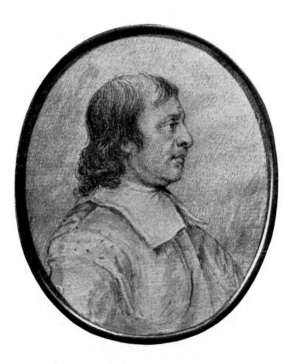

38

OLIVER CROMWELL (1599–1658)

Portrait sketch on vellum, oval:
3 1/8 × 2 5/8 in. By or after Cooper.

This profile sketch of the Protector shows
him slightly older than the full-face version
in the Buccleuch collection. The
authenticity of this drawing has never
been fully established. It has been
suggested by David Piper that a prototype
by Cooper may still exist. A copy by S. P.
Rosse is in a private collection. Vertue
records seeing a profile sketch of Cromwell
that belonged to the Duke of Devonshire,
and which 'was borrowed to coppy by Mr
Richter who has done it very justly for Mr
Howard in whose hands I see it'. (*Walpole
Society*, vol XX, p. 44)

*Devonshire Collection, Chatsworth,
The Trustees of the Chatsworth Settlement*

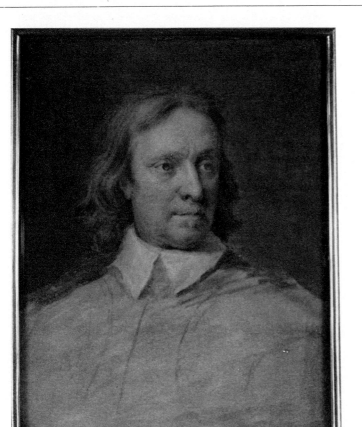

39

OLIVER CROMWELL (1599–1658)

Watercolour on vellum, rectangular:
4 1/4 × 3 1/4 in.

This miniature by or after Cooper is close
to the unfinished oval portrait in the
Buccleuch collection. Copies exist in other
collections, some by Bernard Lens, one of
which is in the collection of the Duke of
Portland. Finished versions by C. Richter
also exist.

*Devonshire Collection, Chatsworth,
The Trustees of the Chatsworth Settlement*

40

ELIZABETH CLAYPOLE, *née*
CROMWELL (1629–58) (?)

Watercolour on vellum, oval: 2 × 1 1/2 in.

Signed and dated: *S.C. | 1652*

The identification of the sitter as Elizabeth
Cromwell is uncertain.

The Duke of Buccleuch and Queensberry

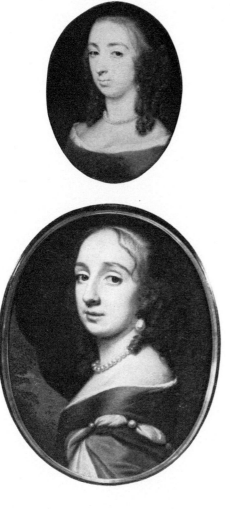

41

ELIZABETH CROMWELL (1629–58) (?)
or FRANCES CROMWELL (1638–1720)
(?)

Watercolour on vellum, oval:
2 3/4 × 2 1/4 in.

Signed in monogram: *SC* and dated: *| 1653*

The sitter has been identified as either
Frances Cromwell, Lady Russell, or her
sister Elizabeth, Mrs Claypole, both
daughters of Oliver Cromwell.

The Duke of Buccleuch and Queensberry

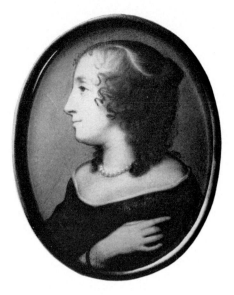

42

ELIZABETH CLAYPOLE, *née*
CROMWELL (1629–58)

Watercolour on vellum, oval:
2 5/8 × 2 1/4 in.

Signed and dated: *SC | 1653*

Second daughter of Oliver Cromwell;
married in 1646 to John Claypole (d. 1688),
Parliamentarian, who was made Master of
the Horse to the Protector. Elizabeth is
said to have interceded for Royalist
prisoners; she died at Hampton Court in
1658 at the age of 29 years and was buried
in Westminster Abbey.

Devonshire Collection, Chatsworth,
The Trustees of the Chatsworth Settlement

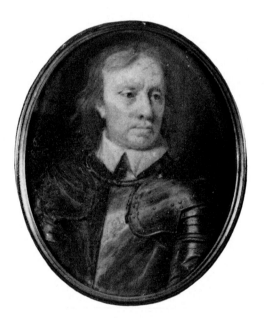

43

OLIVER CROMWELL (1599–1658)

Watercolour on vellum, oval:
2 3/4 × 2 1/4 in.

Signed in monogram: *SC.* and dated: *|1656.*

This miniature is one of several based on
the unfinished portrait in the collection of
the Duke of Buccleuch (no. 36). A number
of these miniatures were commissioned as
gifts and date from *c.*1653 or earlier.

National Portrait Gallery

44

RICHARD CROMWELL (1626–1712)

Watercolour on vellum, oval:
1 3/4 × 1 1/2 in.

Signed: *SC.*

Third son of Oliver Cromwell; Lord
Protector; sat in Cromwell's House of
Lords; recognized as his father's successor,
1659. Retired to the Continent, 1660, under
the name of John Clarke; returned to
England, *c.* 1680, and lived in retirement.

Mr and Mrs John W. Starr, Kansas City,
Missouri

45
RICHARD CROMWELL (1626–1712) (?)
Watercolour on vellum, oval: 2 × 1 1/2 in.

The identification of the sitter as Richard Cromwell is uncertain, and the portrait may represent his brother, Henry (1628–74).

The Duke of Buccleuch and Queensberry

46
HENRY CROMWELL (1628–74) (?)
Watercolour on vellum, oval:
2 3/4 × 2 1/4 in.

The identification of the sitter as Henry Cromwell is uncertain, and the portrait has also been said to represent his brother, Richard. From the manner of the painting it appears to be a fairly early work.

The Duke of Buccleuch and Queensberry

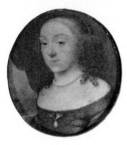

47
ELIZABETH CLAYPOLE, *née* CROMWELL (1629–58)
Watercolour on vellum, oval:
1 5/16 × 1 1/8 in.

Inscribed on the reverse in ink: *S. Cooper / P(inxi)t.*

This miniature was mentioned by the late Basil Long, *British Miniaturists*, p. 89. For other miniatures of the same sitter or said to be her, see nos. 40, 41, 42.

The Administrative Trustees of the Chequers Trust

48
ROBERT DORMER (1629–94)
Watercolour on vellum, oval:
2 3/8 × 1 7/8 in.

Signed and dated: *SC / 1650*

This miniature of Robert Dormer of Rousham is by family descent. In a MS at Rousham it is recorded that Dormer paid £12 to 'Mr Cooper' on 8 September 1650.

Private Collection

49

PORTRAIT OF AN UNKNOWN MAN
Watercolour on vellum, oval: 2 × 1 1/4 in.
Unfinished. Painted *c*.1650.
Mrs Daphne Foskett

50

GRACE PIERPOINT, LADY MANNERS
Watercolour on vellum, oval: 2 × 1 3/4 in.
Signed in monogram: *SC* and dated: */1650*
The sitter was the second daughter of Sir
Henry Pierpoint, KG, and wife of Sir
George Manners.
The Duke of Rutland

51

ROBERT LILBURNE (1613–65)
Watercolour on vellum, oval:
2 1/8 × 1 3/4 in.
Signed and dated: *SC. / 1650*
Regicide; brother of John Lilburne, a
political agitator. Parliamentarian, and one
of those who signed Charles I's death
warrant. Condemned to life imprisonment
in 1660.
The Fitzwilliam Museum, Cambridge

52

SIR ADRIAN SCROPE, KB (d. 1667)
Watercolour on vellum, oval:
1 3/4 × 1 1/2 in.
Signed and dated: *S.C. / 1650*
Sometimes confused with his distant
kinsman, Adrian Scrope or Scroope
(1601–60). Served in Charles I's army
during the Civil War. Was the eldest son
of Sir Jervais Scrope of Coddrington,
Lincolnshire. Was made KB after the
Restoration.
The Duke of Buccleuch and Queensberry

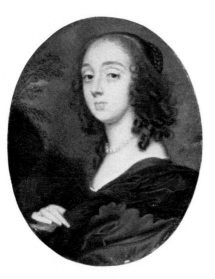

53

ANNE, COUNTESS OF MORTON
(d. 1654)

Watercolour on vellum, oval:
2 5/8 × 2 1/4 in.

Signed, probably in a later hand: *S*

The sitter has been identified for some years
as Anne, daughter of Sir Edward Villiers
(1585–1626), half-brother of the 1st Duke
of Buckingham. Anne married Robert,
Lord Dalkeith, later 9th Earl of Morton
(d. 1649). She was governess to Henrietta,
daughter of Charles I.
The miniature was formerly in the de la Hey
collection, sold at Sotheby's, 27 May 1968.

E. Grosvenor Paine, Esq, Oxford, Mississippi

54

SIR JOHN LEWIS, Bart (*c.*1615–71)

Watercolour on vellum, oval: 2 × 1 3/4 in.

The frame of the miniature is enamelled on
the reverse and bears the coat of arms of
six quarterings, that of Lewis being in the
first quarter. Sir John, who came from
Ledston, Co York, married Sarah Foote.
His elder daughter and co-heiress married
Theophilus Hastings, 7th Earl of
Huntingdon.

The Hon Felicity Samuel

55

PORTRAIT OF A LADY *called*
DOROTHY SIDNEY, COUNTESS OF
SUNDERLAND (1617–84)

Watercolour on vellum, oval: 2 1/2 × 2 in.

Signed in monogram: *SC*

The identification of the sitter as Lady
Dorothy Sidney seems improbable. She
married as her first husband, Henry, 1st
Earl of Sunderland, in 1639; he was killed
in 1643, and in 1652 she married Sir Robert
Smyth. A replica of this miniature, signed
and dated 1653, is in the Starr collection,
Kansas City.

The Duke of Buccleuch and Queensberry

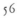

56

SIR THOMAS HANMER (1612–78)
Watercolour on vellum, oval:
2 7/8 × 2 1/4 in.

Sir Thomas Hanmer was noted as a man of taste and as an authority on horticulture. His wife was the sister of Thomas Baker (1606–58) of Whittingham Hall, Suffolk, whose bust by Bernini is in the Victoria and Albert Museum. A portrait of Sir Thomas by Cornelius Johnson, signed and dated 1631, is in the National Museum of Wales, Cardiff, and an imposing one of him by Van Dyck, probably painted in 1638, is in the collection of the Earl of Bradford (no. 243). His daughter, Trevor, later Lady Warner, was also painted by Cooper. The miniature is by family descent.

Lt-Col R. G. Hanmer

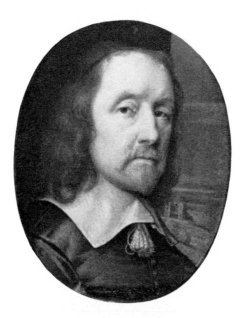

57

PORTRAIT OF AN UNKNOWN MAN
called INIGO JONES
Watercolour on vellum, oval:
2 7/8 × 2 3/8 in.

Although this miniature has in the past been thought to represent Inigo Jones, it is not now considered to be like him.

Robert Bayne-Powell, Esq

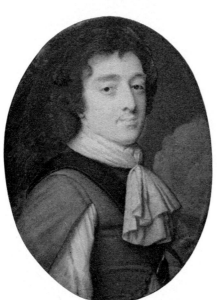

58

PORTRAIT OF AN UNKNOWN MAN
Watercolour on vellum, oval: 3 × 2 1/2 in.
The Duke of Rutland

59

THE DUCHESS OF BOLTON (d. 1680)

Watercolour on vellum, oval: 3 × 2 1/2 in.

Signed in monogram: *SC*.

The sitter was presumably Mary, widow of Henry Carey, and second wife of Charles Paulet or Powlett, 1st Duke of Bolton (1625?–99).

E. Grosvenor Paine, Esq, Oxford, Mississippi

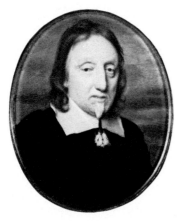

60

WILLIAM LENTHALL (1591–1662)

Watercolour on vellum, oval: 2 1/8 × 1 3/4 in.

Signed and dated: *S.C. | 1652*

The sitter was a successful lawyer and was elected Speaker (1640) of the Long Parliament; often yielded to pressure, but showed both dignity and resource in certain crises. Gave advice to Charles II before his return, but was not appointed to any office at the Restoration.

National Portrait Gallery

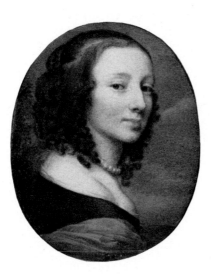

61

PORTRAIT OF AN UNKNOWN LADY

Watercolour on vellum, oval: 2 1/2 × 2 in.

This miniature was formerly in the Sotheby collection, Ecton Hall, Northampton, and was sold at Sotheby's, 11 October 1955 (lot 39). The sitter has been erroneously identified as Lucy, Countess of Carlisle (1599–1660).

The Fondation Custodia (collection F. Lugt), Institut Néerlandais, Paris

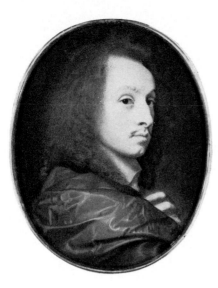

62

HUGH MAY (1622–84)

Watercolour on vellum, oval:
2 5/8 × 2 1/8 in.

Signed and dated: *SC / 1653*

The sitter was an architect, and brother of
Baptist May, Keeper of the Privy Purse to
Charles II. Hugh May was an active
Royalist and a friend of Sir Peter Lely, with
whom he was closely associated in a variety
of projects. A portrait of Lely and May,
painted *c.*1675 by Lely, is at Audley End.
May was appointed Controller of the Works
at Windsor Castle in 1673 and was in
charge of extensive rebuilding and
redecorating under Charles II. The
miniature was formerly in the collection of
Edward Knight, and was sold at Christie's,
3 July 1958 (lot 6), from whence it passed
to the Royal Collection.

Her Majesty The Queen

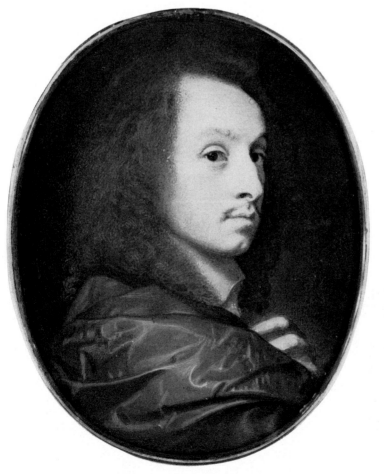

62 (*enlarged*)

63

SIR JUSTINIAN ISHAM, 2nd Bart
(1611–75)

Watercolour on vellum, oval: 2 1/2 × 2 in.

Signed and dated: *S.C. | 1653*

Son of Sir John Isham (1582–1651) by his
wife, Judith, daughter of William Lewin
DCL of Otterden, Kent. Royalist who
suffered severely for his loyalty to Charles I,
being fined and imprisoned several times.
Admitted as Fellow-Commoner at Christ's
College, Cambridge, 1627. Married twice,
his first wife, Jane, having died in
childbirth. Elected Member of Parliament
for Northamptonshire, 1661, and held the
seat until his death. Became one of the
unsuccessful suitors of Dorothy Osborne,
who nicknamed him 'the Emperor'.
Founded Lamport Hall Library. The
miniature is by family descent.

Sir Gyles Isham, Bart

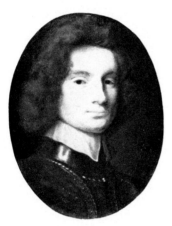

64

WILLIAM DORMER
(*c*.1631–83)

Watercolour on vellum, oval:
2 1/4 × 1 7/8 in.

Signed and dated: *SC. | 1653*

Of Ascot, Oxon. Married Annamara,
daughter of Edmund Waller, the poet; was
High Sheriff of Oxfordshire. Died at about
52 years of age. The miniature is by family
descent.

Private Collection

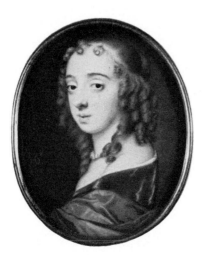

65

PORTRAIT OF AN UNKNOWN LADY

Watercolour on vellum, oval: 2 1/4 × 2 in.

Signed in monogram: *SC.* and dated: *| 1655*

The Duke of Buccleuch and Queensberry

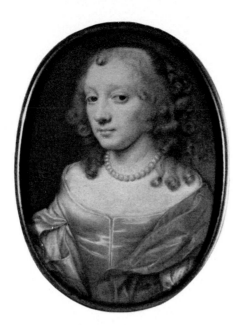

66

LADY FRANCES COOPER

Watercolour on vellum, oval:
2 7/8 × 2 1/4 in.

Lady Frances was the eldest daughter of
David Cecil, 3rd Earl of Exeter. In 1650
she married, as his second wife, Sir Anthony
Ashley Cooper (1621–83), later 1st Earl of
Shaftesbury.

Private Collection

67

JOHN MANNERS, 8th EARL OF
RUTLAND (1604–79)

Watercolour on vellum, oval: 2 × 1 3/4 in.

Signed and dated: *S.C. | 1656*

Eldest son of Sir George Manners;
succeeded to the title on the death of his
cousin, George, 7th Earl of Rutland.
Moderate Parliamentarian; at the
Restoration rebuilt Belvoir, which had
been dismantled.

The Duke of Rutland

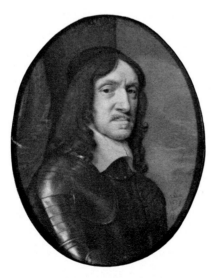

JOHN HOLLES, 2nd EARL OF CLARE
(1595–1666)

Watercolour on vellum, oval:
2 9/16 × 2 1/16 in.

Signed in monogram: *SC.* and dated: *| 1656*

John Holles succeeded to the earldom on
the death of his father in 1637. In 1626 he
married Elizabeth Vere, daughter and
co-heiress of Horace Lord Vere of Tilbury.
Mrs Lucy Hutchinson, in *Life of Colonel
Hutchinson*, 1806, p. 96, says that in the
Civil War Holles 'was very often of both
parties, and I think never advantaged either'.
The miniature is of outstanding merit, and
the portrait closely resembles the large
portrait of the Earl also in the Welbeck
collection.

*Reproduced by kind permission of the Duke
of Portland, KG*

[*Not in the exhibition*]

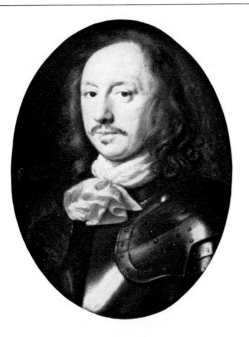

68

MONTAGUE BERTIE, 2nd EARL OF
LINDSEY (*c.* 1608–66)

Watercolour on vellum, oval:
3 1/8 × 2 3/8 in.

Signed in monogram: *SC* and dated: *1657*

Mary, the Earl's daughter by his second
wife, Bridget, married Charles Dormer,
2nd Earl of Carnarvon, whose family were
also painted by Cooper. See also no. 33.

The Fitzwilliam Museum, Cambridge

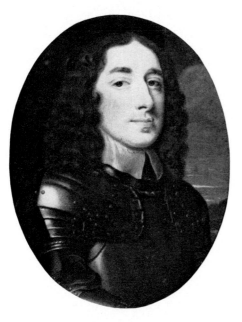

69

EDWARD NOEL, 1st EARL OF
GAINSBOROUGH (1641–89)

Watercolour on vellum, oval:
3 1/8 × 2 3/8 in.

Signed and dated: *SC/1657*

Served as Lord Lieutenant of the County of
Southampton, Warden of the New Forest
and Governor of Portsmouth. Married as
his first wife, Lady Elizabeth Wriothesley,
daughter and co-heir of Thomas, 4th Earl
of Southampton; and secondly, in 1683,
Mary, widow of Sir Robert Worseley of
the Isle of Wight.

The Fitzwilliam Museum, Cambridge

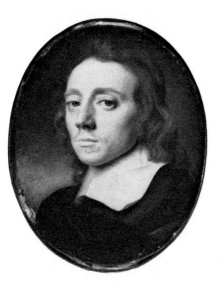

70

THE REVEREND THOMAS
STAIRSMORE (d. 1706)

Watercolour on vellum, oval: 2 1/2 × 2 in.

Signed in monogram: *SC* and dated: / *1657*

The Revd Thomas Staresmore or
Stairsmore became vicar of Edmonton in
1680 and died there in 1706. The
portrait was bequeathed to the Fitzwilliam
Museum in 1878 by the Revd C.
Lesingham Smith.

The Fitzwilliam Museum, Cambridge

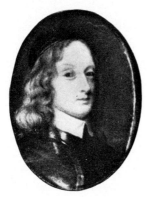

71

CHARLES, VISCOUNT CRANBORNE
(d. 1659)

Watercolour on vellum, oval:
1 7/8 × 1 1/4 in.

Charles was the second son of William, 2nd
Earl of Salisbury, and his wife, Catherine,
youngest daughter of Thomas Howard, 1st
Earl of Suffolk. Charles married, 2 April
1639, Lady Diana Maxwell (d. 1675),
younger daughter and co-heir of James,
Earl of Dirletoun. The miniature is by
family descent.

The Marquess of Salisbury

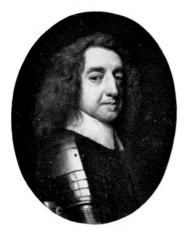

72

SIR WILLIAM PALMER (*c*.1605–82)

Watercolour on vellum, oval:
2 1/4 × 1 3/4 in.

Signed in monogram: *SC*. and dated: *1657*

Inscribed above the signature and date:
Æt. 52

Sir William Palmer of Warden,
Bedfordshire, was knighted on 18 April
1641. The miniature is by family descent,
and was purchased by the Victoria and
Albert Museum in 1956.

The Victoria and Albert Museum

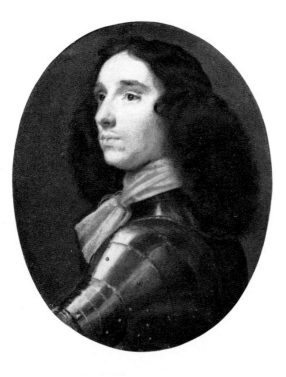

73

SIR JOHN CAREW (d. 1660)

Watercolour on vellum, oval:
3 1/2 × 2 1/2 in.

Of Antony, Cornwall. Regicide; sat as
judge on Charles I, and signed the King's
death warrant; served in the Common-
wealth Parliament of 1651 and 1654;
imprisoned by Cromwell, 1655; imprisoned
again in 1658. Tried at London as a
regicide in 1660 and executed at Charing
Cross.

Colonel Sir John Carew Pole, Bart

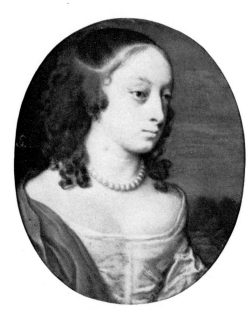

74

LADY CAREW

Watercolour on vellum, oval: 3 × 2 in.

Signed in monogram: *SC*.

Wife of Sir John Carew (d. 1660).

Colonel Sir John Carew Pole, Bart

75

PORTRAIT OF AN UNKNOWN LADY

Watercolour on vellum, oval: 3 × 2 1/2 in.

Signed: *S.C.*

This miniature came from the collection of
the Earls of Dysart, and was purchased
with the contents of Ham House.

The Victoria and Albert Museum
(*Ham House*)

76

SIR SAMUEL MORLAND (1625–95)

Watercolour on vellum, oval: 2 1/2 × 2 in.

The sitter was a diplomat, mathematician
and inventor. He invented two arithmetical
machines and a speaking trumpet. By his
invention of the 'plunge-pump' he raised
water to the top of Windsor Castle in 1675.
Created Baronet and Gentleman of the
Privy Chamber in 1660. Became blind in
1692.

The Victoria and Albert Museum

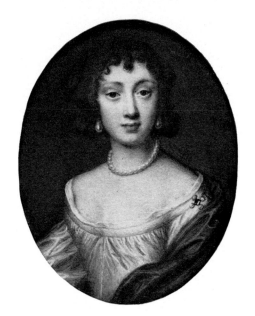

77
PORTRAIT OF AN UNKNOWN LADY
Watercolour on vellum, oval: 3 × 2 3/8 in.

The sitter has been wrongly identified as Princess Elizabeth (1635–50), Charles I's second daughter, who died a prisoner in Carisbrooke Castle in 1650.

The Earl Beauchamp

78
JAMES SCOTT, DUKE OF MONMOUTH AND BUCCLEUCH, KG (1649–85)
Watercolour on vellum, oval: 4 7/8 × 3 7/8 in. Unfinished sketch, painted *c.* 1664.

James Scott (known as Fitzroy and as Crofts) was the natural son of Charles II by Lucy Walter, daughter of Richard Walter of Haverfordwest. Born at The Hague; entrusted on his mother's death to the care of Lord Crofts; acknowledged by Charles II as his son in 1663 and made Baron Tyndale, Earl of Doncaster, Duke of Monmouth and KG. Married in 1663 Lady Anne Scott, only daughter of Francis, Earl of Buccleuch, and took the surname of Scott. Hoped to obtain legitimate and legal rights to the Crown. Executed in the Tower of London, 15 July 1685, after the failure of his insurrection against James II.
This miniature is presumed to be one of those bought by Charles II from the artist's widow, and for which he gave her a pension.
A copy attributed to S. P. Rosse is in the collection of the Duke of Buccleuch and Queensberry (no. 190).

Her Majesty The Queen

78 (enlarged)

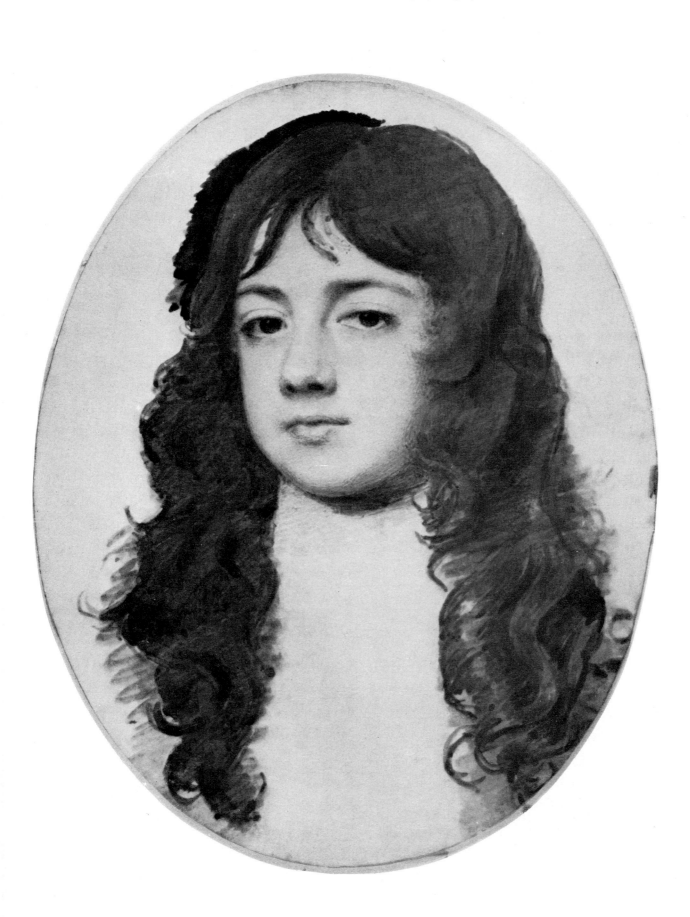

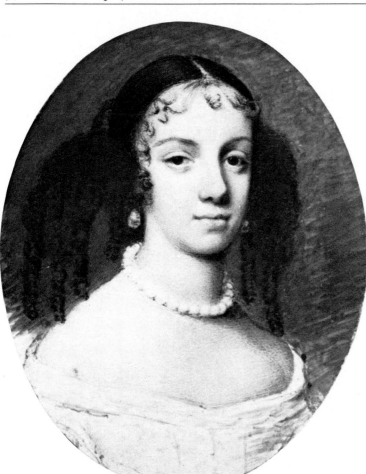

79

CATHERINE OF BRAGANZA
(1638–1705)

Watercolour on vellum, oval:
4 7/8 × 3 7/8 in. Unfinished sketch.

Queen of Charles II; daughter of King
John IV of Portugal and his wife, Louisa
de Gusman; born in November 1638, and
married Charles II on 21 May 1662. The
portrait is presumably one of the five
sketches which were listed as being in Mrs
Cooper's possession after the artist's death
and which were offered to Cosimo III in
1677; it is thought to have been among
those bought by Charles II.

Her Majesty The Queen

80

GEORGE MONCK, 1st DUKE OF
ALBEMARLE, KG (1608–70)

Watercolour on vellum, oval:
4 7/8 × 3 7/8 in. Unfinished sketch.

Served in the Royalist army during the
early stages of the Civil War; went with
Cromwell to Scotland and in 1651 became
Commander-in-Chief in Scotland. After
Cromwell's death Monck eventually
exercised his influence to bring about the
return of Charles II, and after the
Restoration was knighted and made KG.
This unfinished sketch was probably the
one which Cosimo III remembered seeing
in the artist's studio, and which he was
anxious to obtain after Cooper's death. But
for the advice given by his London agent
against purchasing these miniatures, the
five large sketches would probably now be
in the Uffizi.

Her Majesty The Queen

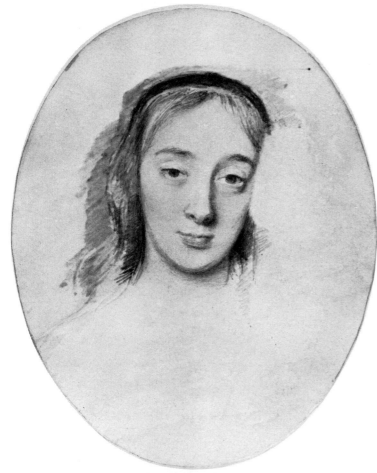

81

BARBARA VILLIERS, COUNTESS
OF CASTLEMAINE, and DUCHESS
OF CLEVELAND (1641–1709)

Watercolour on vellum, oval:
4 7/8 × 3 7/8 in. Unfinished sketch.

Daughter of William Villiers, 2nd Viscount
Grandison; married Roger Palmer (d. 1705)
in 1659; became the mistress of Charles II
in 1660; a London beauty; her
husband was created Earl of Castlemaine
in 1661, and in 1670 she was created
Duchess of Cleveland. Of her children,
Charles II acknowledged the paternity of
five.
A finished miniature of the sitter, signed
in monogram: *SC* and dated:/ *1661*, is also in
the Royal Collection.

Her Majesty The Queen

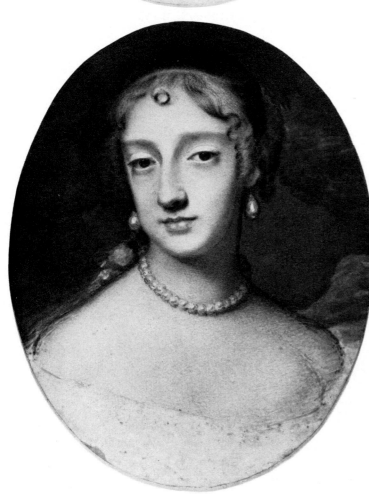

82

FRANCES TERESA STUART,
DUCHESS OF RICHMOND AND
LENNOX (1647–1702)

Watercolour on vellum, oval:
4 7/8 × 3 7/8 in. Unfinished sketch, probably
painted *c.*1663–4.

Frances Teresa Stuart married Charles
Stuart, 3rd Duke of Richmond, in 1667.
The elder daughter of Walter Stewart, MD;
known as 'La Belle Stuart'; believed to
have been the model for the figure of
Britannia on the copper coinage. Became
mistress of Charles II, who, according to
Pepys, 'became besotted with Miss
Stewart'.
This portrait is one of five large unfinished
sketches executed as prototypes from which
Cooper could make finished versions. It
was probably one of the works bought by
Charles II from Cooper's widow, and on
the list of works in her possession which
were offered for sale to Cosimo III. It was
in Queen Caroline's collection at St James's
Palace, 1743.

Her Majesty The Queen

83
THOMAS HOBBES (1588–1679)

Watercolour sketch on vellum, oval:
2 5/8 × 2 1/4 in. Painted *c*.1660.

Thomas Hobbes was a philosopher and for
twenty years tutor and secretary to William
Cavendish, 2nd Earl of Devonshire
(1591 ?–1628). He was the second son of
Thomas Hobbes, vicar of Charlton and
Westport (now part of Malmesbury). His
mother is said to have given birth to
Thomas prematurely owing to her agitation
at the reports of the Armada. After the
death of his patron, Hobbes travelled
abroad, returning to England in 1631 to
become tutor to William Cavendish, 3rd
Earl of Devonshire. Was mathematical
tutor to Charles II, from whom he received
a pension. Was a friend of Samuel Cooper
and of John Aubrey, who advised him of
the King's return and suggested that he
should seek an early interview with the
Monarch. According to Aubrey 'when
Hobbes laughed and was merry one could
scarce see his eyes'.

This unfinished portrait is supposedly the
one which Charles II purchased, and the
one referred to by Aubrey as 'one of the
best pieces that ever he did'.

The Cleveland Museum of Art
(Edward B. Greene Collection)

84
CHARLES II (1630–85)

Watercolour on vellum, oval: 3 5/8 × 3 in.
Unfinished.

This unfinished sketch from life is a good
representation of the King. Several
finished versions of the portrait exist,
including a small signed one in the
collection of the Duke of Portland.

Denys Eyre Bower Collection,
Chiddingstone Castle

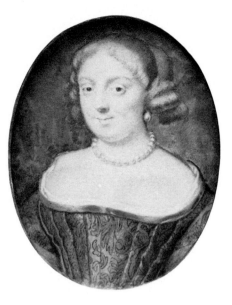

85

JANE PENRUDDOCK or PEN-
RUDDOCKE (b. *c.* 1618)

Watercolour on vellum, oval:
2 13/16 × 2 5/16 in. Unfinished.

The sitter, whose name is scratched on the
reverse of the locket, was presumably Jane
Penruddocke of Compton Chamberlain,
Wiltshire. She was the daughter of Sir John
Penruddocke (d. 1648) by his wife, Joane,
daughter of Sir John Meade. The family
were descended from Thomas
Penruddocke of Cumberland, and his wife,
Agnes, *née* Lowther, of Westmorland. Jane
married, in 1647, John Young, Esq, of
New Sarum. The family were Royalists, and
her brother, John (1619–55), fought for
Charles I, being taken captive after an
unsuccessful attempt to proclaim Charles II
king at Salisbury, and was beheaded at
Exeter in May 1655.

Mrs Daphne Foskett

86

RICHARD WISEMAN (1622 ?–76)

Watercolour on vellum, oval

Signed in monogram: *SC.* and dated: *1660*

The sitter was surgeon to Charles II and
Master of the Barber Surgeon's Company,
1665. Published works on surgery.

The Duke of Rutland

87

ANNE DIGBY, COUNTESS OF
SUNDERLAND (1646–1715)

Watercolour on vellum, oval:
3 1/16 × 2 1/2 in.

Signed in monogram: *SC* and dated: / *1660*

The sitter was the daughter of George
Digby, Earl of Bristol; married, on 10 June
1665, Robert, 2nd Earl of Sunderland, KG
(1640–1702).

The Earl Beauchamp

88

A MEMBER OF THE FAUCONBERG FAMILY

Watercolour on vellum, oval:
3 1/8 × 2 7/16 in.

Signed in monogram: *SC*

The Cleveland Museum of Art
(*Edward B. Greene Collection*)

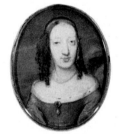

89

PORTRAIT OF AN UNKNOWN LADY

Watercolour on vellum, oval : 1 1/4 × 1 in.
Philadelphia Museum of Art

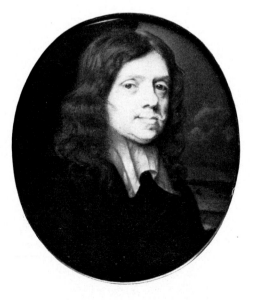

90

SIR DANIEL HARVEY (d. 1674)

Watercolour on vellum, oval:
2 3/4 × 2 1/2 in.

Signed in monogram: *SC* and dated: */1660*

The sitter was the son of a London
merchant, whose sister, Elizabeth, married
Henage Finch, 1st Earl of Nottingham
(1621–82). Sir Daniel Harvey succeeded
his brother-in-law, Henage Finch, 2nd Earl
of Winchelsea (d. 1689), as ambassador in
Constantinople, 1667–8. He arrived in
Smyrna in November 1668, and died there
in 1674. Harvey is mentioned in the Finch
MS, vol. I, *Historical Manuscript
Commission*, 1913.

Private Collection

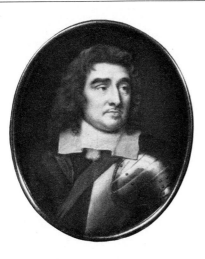

91

GEORGE MONCK, 1st DUKE OF ALBEMARLE, KG (1608–70)

Watercolour on vellum, oval:
2 1/4 × 1 7/8 in.

Signed in monogram: *SC*.

Cooper's unfinished sketch of the sitter is in the collection of HM The Queen (no. 80).

The Duke of Buccleuch and Queensberry

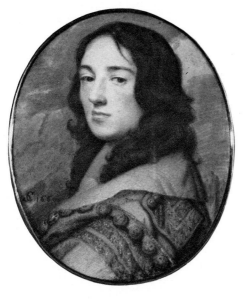

92

GEORGE VERNON (1635–1702)

Watercolour on vellum, oval: 2 3/4 × 2 in.

Signed in monogram: *SC* and dated: *1660*.

Son of Sir Henry Vernon (1615–58), George Vernon of Sudbury married three times: firstly, Margaret, daughter of Edwin Olney of Catesby, Northampton; secondly, Dorothy Shirley, sister of Robert, Earl Ferrers; and thirdly, Catherine, daughter of Sir Thomas Vernon of London. He devoted much of his energy to the rebuilding and redecorating of Sudbury Hall, Derbyshire.

The Lord Vernon

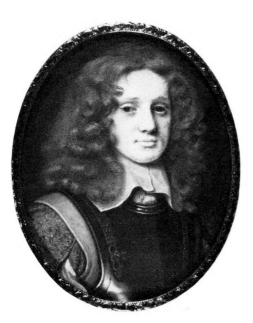

93

PORTRAIT OF AN UNKNOWN MAN IN ARMOUR

Watercolour on vellum, oval:
2 15/16 × 2 5/16 in.

This miniature was at one time attributed to Thomas Flatman but is undoubtedly the work of Samuel Cooper.

The Visitors of the Ashmolean Museum, Oxford

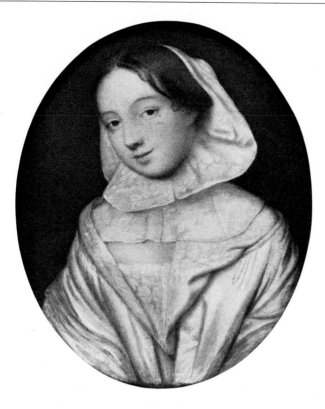

94
JANE MYDDELTON or
MYDDLETON (1645–92)
Watercolour on vellum, oval:
3 7/8 × 2 1/4 in.
Signed in monogram: *SC*

Daughter of Sir Robert Needham. 'The great beauty of Charles II's time.' Married to Charles Myddelton in 1660; attracted many lovers, including the Chevalier de Gramont, the Duke of York, and Edmund Waller. Received a pension from James II. This attractive miniature is a good example of Cooper's expertise in the use of subtle colours.

The Earl Beauchamp

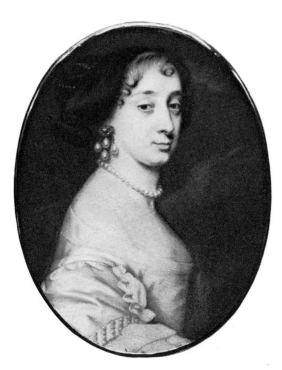

95
BARBARA VILLIERS, DUCHESS OF
CLEVELAND (1641–1709)
Watercolour on vellum, oval:
3 1/2 × 2 3/4 in.
Signed in monogram: *SC* and dated:
| *166–*(?—the last numeral is truncated)

By family descent from Robert Spencer, 2nd Earl of Sunderland.

The Earl Spencer

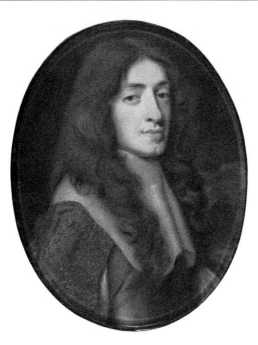

96
JAMES II, as DUKE OF YORK
(1633–1701)
Watercolour on vellum, oval:
3 1/4 × 2 1/2 in.
Signed in monogram: *SC* and dated:
/ [16]61
King of England; second son of Charles I.
Married as his first wife, Anne Hyde
(1637–71), and secondly, in 1673, Mary
Beatrice of Modena, by whom he had
James Francis Edward Stuart (1688–1766),
'the Old Pretender'.
This fine miniature, of which there are
several replicas and copies, was bought by
James Sotheby, 6 March 1711. His account
book records the purchase as follows:
'Pd for K.J. 2ds Picture when Duke of York
Aetat 28. A Half length painted by Sam
Cooper in water colours & set in a gilt
metal frame; bought at Mr. Graham's
Auction for me by Mr. James Seamer,
twenty guineas £21.10.0.'
James Seamer (Seymour) was a goldsmith
of Flower-de Luce, Fleet Street, who acted
for James Sotheby on other occasions and
is thought to have made all the characteristic
miniature frames with the monogram of
James Sotheby engraved on them. The
miniature was sold at Sotheby's, 11 October
1955, from the collection of Major General
Frederick Sotheby of Ecton Hall,
Northampton, when it was purchased by
the Victoria and Albert Museum.

The Victoria and Albert Museum

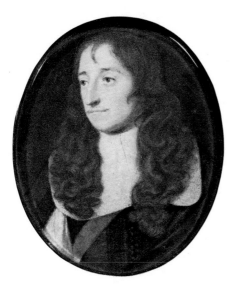

97
SIR HUGH SMYTH (1632–80)
Watercolour on vellum, oval:
2 3/4 × 2 1/4 in.
Signed in monogram: *SC*
Of Ashton Court, Bristol. Married Anne,
daughter of John Ashburnham. This
miniature and no. 98 were presumably
painted at the same time. They are by
family descent to the present owner from
the Hon Mrs Smyth.

Private Collection

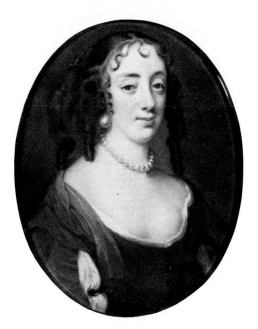

98

LADY SMYTH, *née* ANNE
ASHBURNHAM

Watercolour on vellum, oval:
3 1/8 × 2 5/8 in.

Signed in monogram: *SC*

Anne Ashburnham became the wife of Sir
Hugh Smyth (1632–80) of Ashton Court,
Bristol.

Private Collection

99

THOMAS WRIOTHESLEY, 4th EARL
OF SOUTHAMPTON (1608–67)

Watercolour on vellum, oval:
3 1/4 × 2 1/2 in.

Signed in monogram: *SC* and dated: / *1661*.

Son of Henry Wriothesley, 3rd Earl of
Southampton; succeeded to the earldom in
1624. He married three times, his first wife
being Rachel, eldest daughter of Daniel
de Massue, Seigneur de Ruvigny (d. 1640).
Burnet describes him as 'a man of great
virtue and of very good parts; he had a
lively apprehension and a good
judgement'.

The identification of the sitter as
Wriothesley has been questioned both as a
likeness and from the fact that he is not
shown wearing the Garter ribbon. The
miniature was in the collection of Horace
Walpole at Strawberry Hill, and was sold
for £10.10.0. in 1842.

*The Duke of Bedford and The Trustees of the
Bedford Estates*

100

LADY HARDINGE

Watercolour on vellum, oval:
3 1/2 × 2 3/4 in. Unfinished.

Signed in monogram: *SC* and dated: | *1664.*

The name of the sitter is inscribed on the reverse in a later hand. She may have been Anne, wife of Sir Robert Hardinge (d. 1679).
This miniature is previously unrecorded, and is another rare example of the artist painting the sitter's hands.

T. R. Fetherstonhaugh, Esq

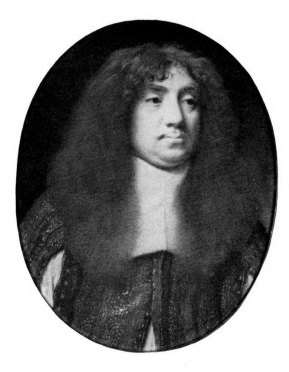

101

JOHN MAITLAND, 2nd EARL and 1st DUKE OF LAUDERDALE (1616–82)

Watercolour on vellum, oval:
3 1/2 × 2 3/4 in.

Signed in monogram: *SC* and dated: | *1664.*

The sitter was the grandson of Sir John Maitland (1545 ?–95), Lord High Chancellor of Scotland. A Covenanter; imprisoned 1651–60; later supported the King, and had great influence over Charles II, who created him Duke of Lauderdale and Marquess of March in 1672.
This portrait was sold at Christie's, 21 February 1961 (lot 88), and was purchased later for the National Portrait Gallery. Another version of this miniature (unsigned), and possibly after Cooper, is in the Buccleuch collection (no. 226).

National Portrait Gallery

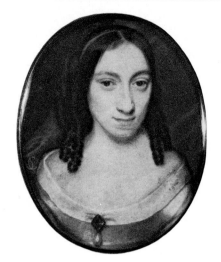

102

MARY FAIRFAX, DUCHESS OF
BUCKINGHAM (1638–1704) (?)

Watercolour on vellum, oval: 2 1/2 × 2 in.

Signed in monogram: *SC*

Mary Fairfax was the only daughter of
Thomas, Lord Fairfax, and the wife of
George Villiers, 2nd Duke of Buckingham
(1628–87), whom she married in 1657.
The miniature was in Horace Walpole's
collection at Strawberry Hill when it was
engraved.

The Duke of Buccleuch and Queensberry

103

BAPTIST MAY (1629–98)

Watercolour on vellum, oval:
4 1/2 × 2 1/2 in.

The sitter was probably educated in France;
was Keeper of the Privy Purse to Charles
II; registrar in chancery court, 1660. Was
a frequent and lavish entertainer of the
King and his friends; developed a taste for
collecting valuable pictures, and kept a fine
stud of horses; Member of Parliament for
Midhurst, 1670; Clerk of the Works at
Windsor Castle, 1671, under Sir
Christopher Wren; a friend of John
Evelyn, and supported Evelyn's and
Lely's recommendation of Grindling
Gibbons to the King. Member of
Parliament for Thetford, 1690. Died in
London, 2 May 1698.

The Lord de Saumarez

104

HENRY FREDERICK HOWARD, 3rd
EARL OF ARUNDEL (1608–52) (?)

Watercolour on vellum, oval:
2 3/4 × 2 1/4 in.

Signed: *S.C.*

Henry Frederick Howard was the son of
Thomas, 2nd Earl of Arundel. Created
Baron Mowbray, 1640; fought as a
Royalist in the Civil War; succeeded his
father as 3rd Earl and Earl Marshal, 1646.
The fact that the sitter is wearing a scarf
tied with a ribbon, rather than a plain linen
collar, would suggest a date of *c.*1663, in
which case the identification of the sitter
as Arundel is incorrect.

*Nelson Gallery-Atkins Museum (Gift of Mr
and Mrs John W. Starr), Kansas City, Missouri*

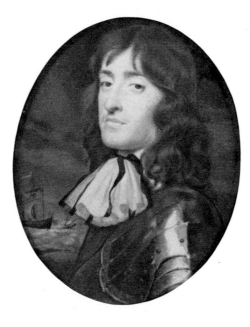

105

JAMES II, as DUKE OF YORK
(1633–1701)

Watercolour on vellum, oval: 3 × 2 1/2 in.

Signed in monogram: *SC.*

The Hon Felicity Samuel

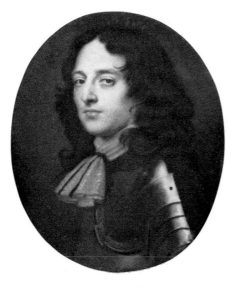

106

PORTRAIT OF AN UNKNOWN
MAN IN ARMOUR

Watercolour on vellum, oval:
2 3/4 × 2 1/4 in.

Private Collection

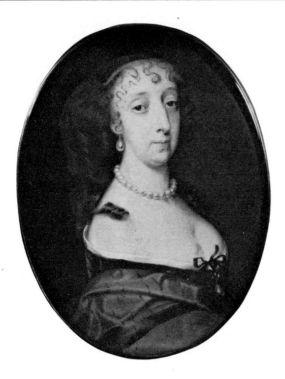

107

PENELOPE COMPTON, LADY
NICHOLAS(?), or ALICE FANSHAWE,
LADY BEDELL(?)

Watercolour on vellum, oval:
3 1/2 × 2 3/4 in.

Signed in monogram: *SC*

The true identity of the sitter is still
uncertain. Lady Penelope Compton was
the wife of Sir John Nicholas, KB; Alice
Fanshawe (1602–66) married, as her first
husband, Sir Christopher Hatton, and
secondly, Sir Capel Bedell.

The Duke of Buccleuch and Queensberry

108

SIR JOHN ROBARTES, 1st EARL OF
RADNOR and 2nd BARON ROBARTES
(1606–85)

Watercolour on vellum, oval:
3 1/4 × 2 1/2 in.

Signed in monogram: *SC*.

Son of Richard Robartes and his wife,
Frances, *née* Hender of Botreux Castle,
Cornwall. The family acquired great wealht
through trading in wool and tin. John
Robartes married Lucy, second daughter
of Robert Rich, 2nd Earl of Warwick. He
was a staunch Presbyterian; voted with the
popular party during the Long Parliament;
took no part in public affairs after the
death of Charles I. Created Earl of Radnor,
1679.

This miniature has had a certain amount of
restoration and, although it bears Cooper's
signature, may possibly be by one of his
followers. It has not been previously
recorded, although Cooper is known to
have painted the Robartes family, and a
miniature, possibly of this sitter, was in the
list of miniatures in the possession of Mrs
Cooper after her husband's death.

T. R. Fetherstonhaugh, Esq

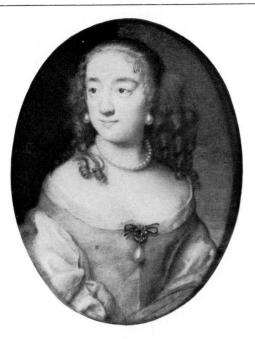

109

CHARLOTTE PASTON, COUNTESS
OF YARMOUTH (*c.*1650–84)

Watercolour on vellum, oval:
3 1/4 × 2 3/4 in.

Signed in monogram: *SC* and inscribed on
the reverse in a seventeenth-century hand:
Lady Paston by Sam: Cooper.

The sitter was the illegitimate daughter of
Charles II by Elizabeth, Lady Shannon.
She married firstly, James Howard (d.
1669) and secondly, in 1672, William
Paston, Earl of Yarmouth.

The Duke of Buccleuch and Queensberry

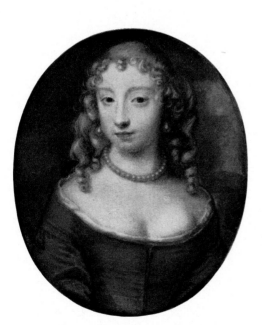

110

FRANCES JENNINGS, DUCHESS OF
TYRCONNEL (*c.* 1647/9–1730/1)

Watercolour on vellum, oval: 3 × 2 1/2 in.
Painted *c.*1665.

Signed in monogram: *SC*

The sitter was called 'La Belle Jennings';
she was the eldest daughter and co-heir of
Richard Jennings, of Sandridge, Herts,
and sister to Sarah, Duchess of
Marlborough. She married as his second
wife, in 1681, Richard Talbot de Malahide,
Earl and titular Duke of Tyrconnel. Frances
was Maid of Honour at the court of Charles
II. Her first husband was Sir George
Hamilton. According to Anthony Hamilton
(1646?–1720):

'Miss Jennings, arrayed in all the splendour
of her first youth had a complexion more
dazzling fair than had ever yet been seen.
Her tresses were a perfect blonde; but
there was something about her so vivid and
animated that it guaranteed her general
colouring against that sort of insipidity
which is usually associated with extreme
fairness . . . her eyes were comparatively
merciful, whilst her lips and the remainder
of her attractions were shooting a thousand
arrows straight into the centre of the heart.'

The Hon Rose Talbot

III

CHARLES II (1630–85)
Watercolour on vellum, rectangular:
7 1/2 × 6 3/8 in.
Signed in monogram: *SC* and dated: / *1665*

This miniature was given by Charles II to
Louise de Keroualle, Duchess of
Portsmouth, mother of Charles Lennox,
Duke of Richmond. It is one of the most
important miniatures of the King that
Cooper painted, and shows him in his
robes, wearing the sash and Order of the
Garter. An oval version, also by Cooper
and painted in the same year, is at the
Mauritshuis, The Hague (no. 112).

The Trustees of the Goodwood Collection

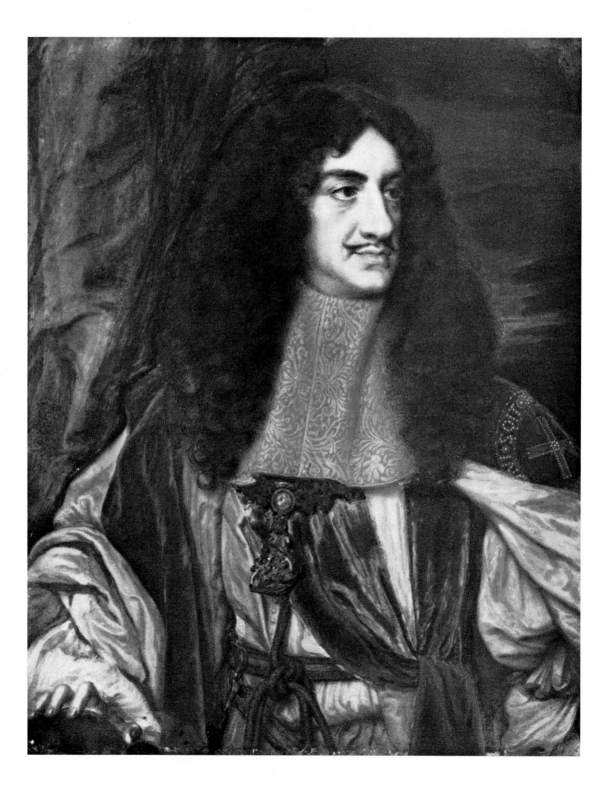

112

CHARLES II (1630–85)

Watercolour on vellum, oval:
6 1/2 × 5 1/4 in.

Signed in monogram: *SC* and dated: */ 1665*

This miniature is one of the finest of Cooper's portraits of the King. A larger version is in the collection of the Earl of March and Kinrara, Goodwood (no. 111). Both miniatures show the Monarch wearing the sash and Order of the Garter.

The Mauritshuis, The Hague

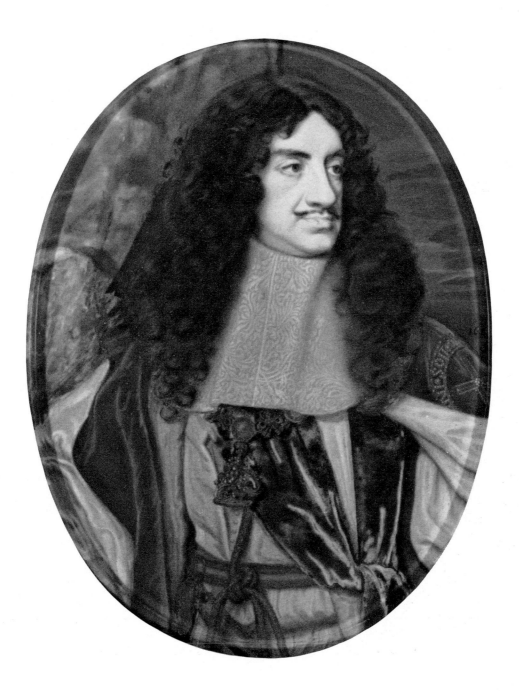

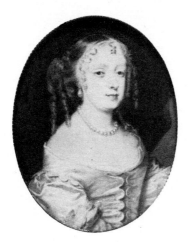

113
ANNE HYDE, DUCHESS OF YORK
(1637–71)
Watercolour on vellum, oval:
2 1/4 × 1 7/8 in.

Eldest daughter of Edward Hyde,
afterwards Earl of Clarendon. Maid of
Honour to the Princess of Orange, 1654;
became engaged to James, Duke of York,
at Breda, in 1659, and was privately
married to him in London in 1660. Only
two of their children survived childhood:
Mary (wife of William III) and Anne
(Queen Anne). The Duchess was secretly
received into the Roman Church in 1670.

The Earl Beauchamp

114
BARBARA VILLIERS, COUNTESS OF
CASTLEMAINE, and afterwards,
DUCHESS OF CLEVELAND
(1641–1709)(?)
Watercolour on vellum, oval:
3 3/8 × 2 3/4 in.
Signed in monogram: *SC*

Although this miniature has for some
years been said to represent Barbara Villiers,
the identification has been disputed. It is a
particularly attractive portrait and very
colourful.

The Duke of Buccleuch and Queensberry

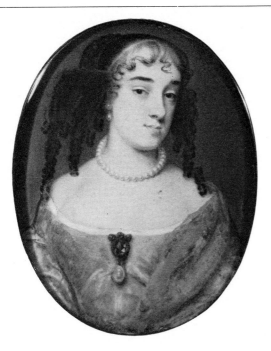

115

MARGARET BROOKE, LADY
DENHAM (*c*.1647–66/7)

Watercolour on vellum, oval:
3 5/16 × 2 3/4 in.

Signed in monogram: *SC*

The sitter was at one time identified as
Lady Heydon (d. 1642), but the date of her
death makes this impossible as the coiffure
is *c*.1660–5. Margaret Brooke was the
second wife of Sir John Denham (1615–69),
author of *Cooper's Hill*. He became mad for
a short period in 1666 in consequence of his
wife's suspected infidelity with the Duke of
York.

The Duke of Buccleuch and Queensberry

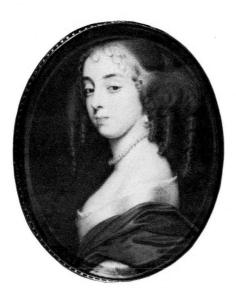

116

PORTRAIT OF AN UNKNOWN
LADY

Watercolour on vellum, oval:
2 5/8 × 2 1/4 in.

Signed in monogram: *SC*

The sitter was formerly erroneously
identified as Lady Lucy Percy, second wife
of the 1st Earl of Carlisle.

The Fitzwilliam Museum, Cambridge

117

NOAH BRIDGES

Watercolour on vellum, oval: 3 × 2 1/2 in.

Signed in monogram: *SC* and dated: */ 1666.*

The sitter, a stenographer and
mathematician, was educated at Balliol
College, Oxford. He was Clerk of the
Parliaments at Oxford in 1643 and 1644.
Kept a school at Putney and published
works on arithmetic, stenography and
cryptography.
The miniature was formerly in the Sotheby
collection at Ecton Hall, Northampton,
and was sold at Sotheby's, 11 October 1955.

The Fondation Custodia (collection F. Lugt),
Institut Néerlandais, Paris

118

A MAN *called* JOHN MAITLAND,
DUKE OF LAUDERDALE

Watercolour on vellum, oval:
3 1/2 × 2 3/4 in.

Signed in monogram: *SC* and dated: */ 1666.*

The Earl of Jersey

119

FRANCES TERESA STUART,
DUCHESS OF RICHMOND (1647–1702)

Watercolour on vellum, oval: 3 1/2 × 3 in.

Signed in monogram: *SC* and dated: | *1666*.

Another miniature of Frances Stuart in male attire, but without a hat, is in the collection of HM The Queen.

The Mauritshuis, The Hague

120

PORTRAIT OF AN UNKNOWN MAN

Watercolour on vellum, oval: 3 × 2 1/2 in.

Signed in monogram: *SC* and dated: *1667*

The sitter was once erroneously identified as Henry Jermyn, Lord Dover.

The Visitors of the Ashmolean Museum, Oxford

121

AMELIA ANN SOPHIA STANLEY,
MARCHIONESS OF ATHOLL

Watercolour on vellum, oval: 2 3/4 × 2 3/16 in.

Signed and dated: *SC | 1667*.

Lady Amelia was the daughter of James, 7th Earl of Derby, KG (1607–51). In 1659 she married John Murray, 1st Marquess of Atholl (d. 1703).

This attractive miniature is in superb condition, and the deep red dress the sitter is wearing has retained its brilliance.

The Duke of Atholl

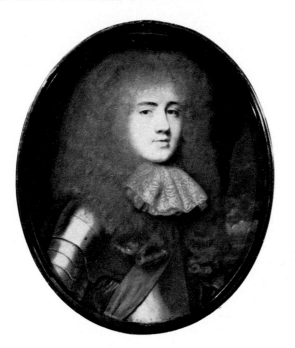

122

JAMES SCOTT, DUKE OF
MONMOUTH AND BUCCLEUCH, KG
(1649–85)

Watercolour on vellum, oval: 3 × 2 1/8 in.

Signed in monogram: *SC* and dated: | *1667*

The sitter was once called Philip Stanhope,
Earl of Chesterfield, but the miniature is
now thought to represent the Duke of
Monmouth.

The Duke of Buccleuch and Queensberry

123

PORTRAIT OF AN UNKNOWN MAN

Watercolour on vellum, oval:
3 1/4 × 2 1/2 in.

The sitter was once erroneously identified
as John Wilmot, Earl of Rochester.

*The Visitors of the Ashmolean Museum,
Oxford*

122 (*enlarged*)

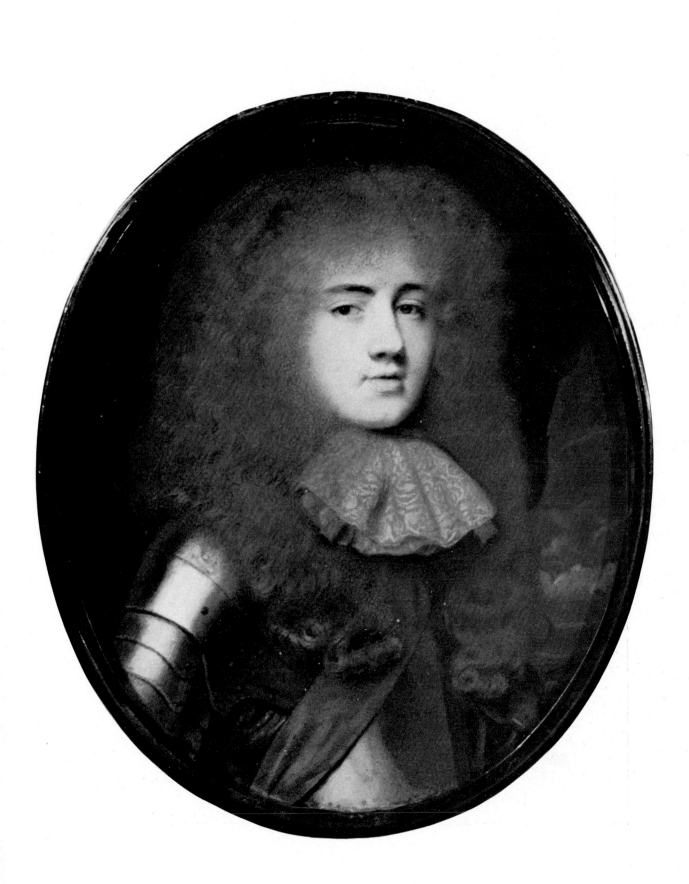

124

GILBERT SHELDON, ARCHBISHOP OF CANTERBURY (1598–1677)

Watercolour on vellum, rectangular: 4 1/4 × 3 1/4 in.

Signed in monogram: *SC* and dated: | *1667* and inscribed on the right of the portrait: *Æ 69*.

Sheldon became Bishop of London and Dean of the Chapel Royal, 1660, and Archbishop of Canterbury, 1663–77. Remained in London during the plague; built the Sheldonian Theatre, Oxford (1669), at his own expense.
This portrait is one of the rare examples of Cooper inscribing a portrait with the sitter's age. A second version of this miniature, but unsigned, is in the collection of the Duke of Portland, KG. Vertue records seeing both miniatures: *a fine limning set in a philetgris gold frame. of Gilbert Sheldon Arch Bp Cant. Æta. 69 1667. By S. Cooper one d^{ito} in silver Philettgris-Erl Oxford.* (*Walpole Society*, Vertue IV, p. 50)

Walters Art Gallery, Baltimore

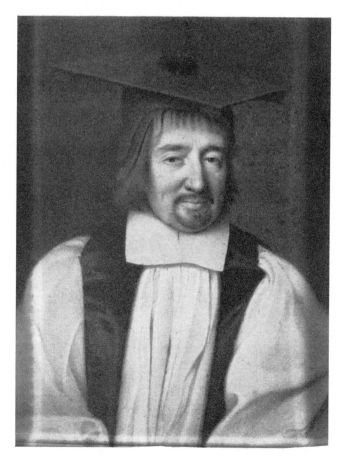

GILBERT SHELDON, ARCHBISHOP OF CANTERBURY (1598–1677)

Watercolour on vellum, rectangular, 4 1/2 × 3 3/8 in.

Set in contemporary silver filigree frame, with a mitre and monogram *GC* on the reverse.

Acquired by Edward Harley, 2nd Earl of Oxford in 1726. In his *Memoranda* the Earl notes: '1726 March – paid 25 G^s for the picture of ABp Sheldon.'
A replica of this miniature, signed and dated 1667, is in the Walters Art Gallery, Baltimore (no. 124).

Reproduced by kind permission of the Duke of Portland, KG

[*Not in the exhibition*]

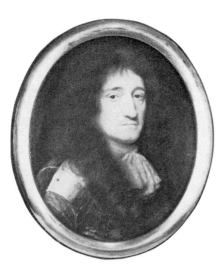

125

PRINCE RUPERT, COUNT PALATINE, KG (1619–82)

Watercolour on vellum, oval:
2 1/8 × 1 3/4 in.

This miniature was formerly in the collection of the Duke of Buccleuch and Queensberry, and was purchased from him in 1941.

National Maritime Museum, Greenwich

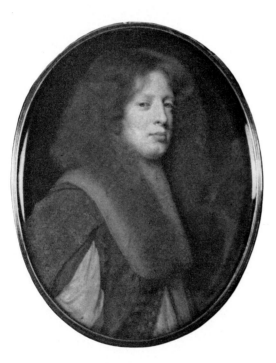

126

ANTHONY ASHLEY, 2nd EARL OF SHAFTESBURY (1652–99)

Watercolour on vellum, oval:
3 1/4 × 2 5/8 in. Probably painted *c*.1665–70.

Son of Anthony Ashley Cooper, 1st Earl of Shaftesbury, by his second wife, Frances, daughter of David Cecil, Earl of Exeter. He suffered from ill health, and was described as 'a man of feeble constitution, and understanding'. When only a boy of seventeen, his marriage was arranged to Lady Dorothy Manners, daughter of John, Earl of Rutland. Succeeded his father as earl in 1683.

This miniature was for many years thought to represent James Scott, Duke of Monmouth, and as such was bought by the late Queen Mary at the Pierpont Morgan sale, 24 June 1935, and given by her to King George V. The sitter was later identified as Shaftesbury by Oliver Millar, and was acquired by the Victoria and Albert Museum.

It was probably painted *c*.1665–70; the year of his marriage, 1669, is a possibility. The miniature is of exceptionally fine quality and comparable to the one of Frances Teresa Stuart in male attire, in the Royal Collection. The miniature of Shaftesbury shows clearly the change of fashion that came after 1660, with the open sleeve allowing the shirt to balloon out, and the introduction of the vest or waistcoat.

The Victoria and Albert Museum

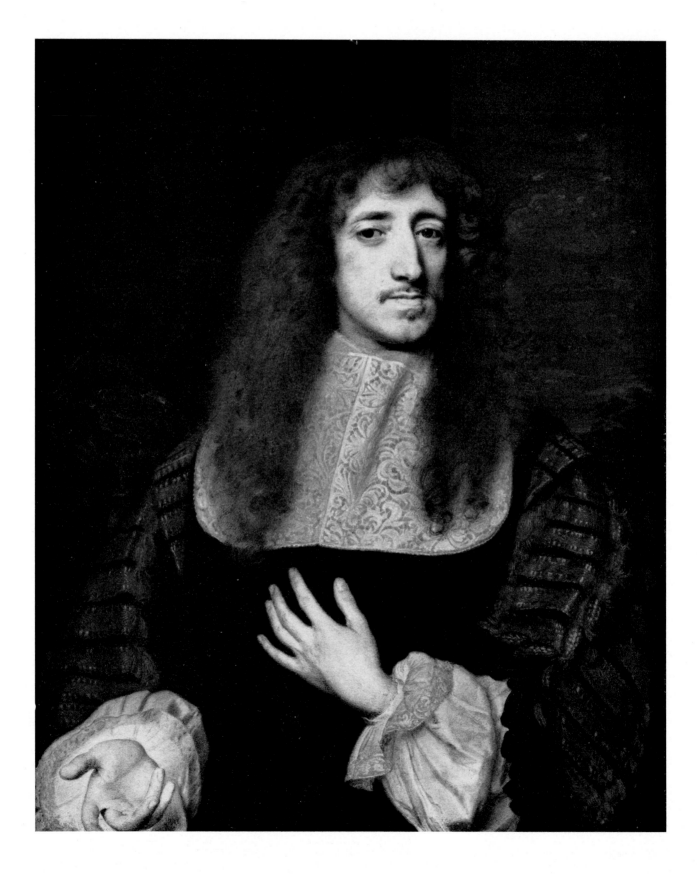

127

ANTHONY ASHLEY COOPER,
1st BARON ASHLEY and 1st EARL
OF SHAFTESBURY (1621–83)

Watercolour on vellum, rectangular:
8 1/4 × 6 5/8 in.

Signed in monogram: *SC*

The sitter inherited large estates including
Wimborne St Giles, Dorset; immortalized
by Dryden in *Absolom and Achitophel* and
The Modal. A man of great ambition and a
complex character, he joined the Parliamen-
tarians in the Civil War; created Baron
Ashley, 1661; Under Treasurer, 1661–7;
Chancellor of the Exchequer, 1661–72;
Earl of Shaftesbury, 1672; and Lord
Chancellor, 1672–3. Changed sides several
times: served as a member of the Cabal
Ministry, led the opposition to the Royal
party, championed the Duke of Monmouth,
and strongly opposed the Duke of York.
Sailed for Holland, 1682, and died in
Amsterdam, 1683.

This important miniature is one of the few
painted by Cooper showing the sitter's
hands. The robes the Earl is wearing are
generally considered to be those of the
Lord Chancellor, an office not held by
Shaftesbury before November 1672.
Unless the robes were finished by another
hand after Cooper's death, it is presumed
that they were worn in his office as
Chancellor of the Exchequer.

Vertue records seeing this miniature and
gives details: ⟨*Anthony Ashley Cooper.*⟩ ⟨*in
a square*⟩ *a large Curious limning of Ld
Shaftesbury. when lord chancellor* ⟨*one year,
from 72. to 73.*⟩ *in the habit of that office &
the seals by him a half length. painted by
Cooper, and now sent to Mr Rysbrack* [John
Michael Rysbrack (1693 ?–1770)] *to Moddel
a head for his Mon^t. after it—this is one of the
largest limnings of Cooper. and probably one of
the last. Cooper dyd 1672 May—see his Mon^t.*
(*Walpole Society*, Vertue IV, p. 14)

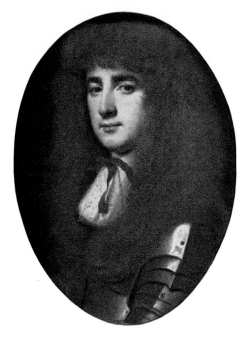

HENRY SIDNEY, EARL OF ROMNEY (1641–1704)

Watercolour on vellum, oval:
3 1/4 × 2 1/2 in.

Signed in monogram: *SC* and dated: / *1669*

The sitter held a number of important posts, including those of Secretary of State, Lord Lieutenant of Ireland and Master of the Ordinance, but according to Bishop Burnet (*History of His Own Time*, 1734), 'he was so set on pleasure that he was not able to follow business with due application'.

Reproduced by kind permission of the Duke of Portland, KG

[*Not in the exhibition*]

128

COSIMO III (1642–1723)

Watercolour on vellum, rectangular:
8 1/4 × 6 5/8 in.

Signed in monogram as if incised: *SC*.

Cosimo de' Medici, later Cosimo III of Tuscany, visited England in 1669, and among those who came to pay their respects to him in London was Samuel Cooper. Cosimo had heard of Cooper's ability and had been told that 'no person of quality visits that city without endeavouring to obtain some of his performances to take out of the Kingdom'.

The Prince had his first sitting on 1 June 1669, followed by several others; he described Cooper as 'a tiny man, all wit and courtesy as well housed as Lely, with his table covered with velvet'.

The miniature was not finished when Cosimo left England and was not delivered until the following year, by which time Cosimo had succeeded his father as Grand Duke of Tuscany. Lord Philip Howard paid Cooper £150 for the miniature on the Grand Duke's behalf. The portrait had been thought lost for many years until in 1965 it was identified in the Uffizi by Oliver Millar. It is of the utmost historic importance, and it is from letters discovered in the Medici archives, by Professor A. Crinò, that much valuable information regarding Cooper's miniatures has come to light.

Uffizi, Florence

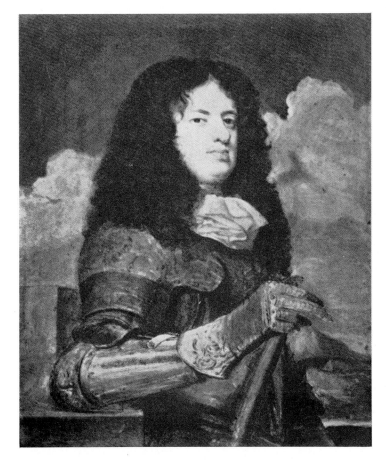

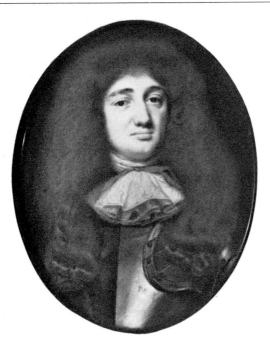

SIR FRESCHEVILLE HOLLES
(1641–72)

Watercolour on vellum, oval:
3 1/16 × 2 9/16 in.

Signed in monogram: *SC* and dated: | *1669*

The sitter was the son of Gervase Holles,
the antiquary. He became a captain in the
navy and lost his life at the battle of Solebay.
The miniature was purchased by Edward
Lord Harley for £15 at the L. Crosse sale,
5 December 1722.
A double portrait representing Sir
Frescheville Holles and Sir Robert Holmes,
by Lely, is in the National Maritime
Museum (no. 238).

*Reproduced by kind permission of the Duke
of Portland, KG*

[*Not in the exhibition*]

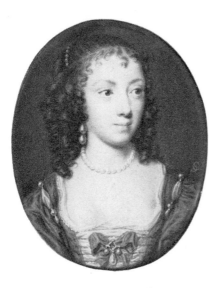

129

PORTRAIT OF AN UNKNOWN
YOUNG LADY IN A BLUE DRESS

Watercolour on vellum, oval:
2 5/8 × 2 1/4 in.

Signed in monogram: *SC.*

The Hon K. R. Thomson

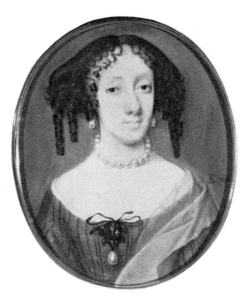

130

HENRIETTA, DUCHESS OF
ORLEANS (1644–70)

Watercolour on vellum, oval:
2 3/4 × 2 1/4 in.

Signed in monogram: *SC* and dated: | *1670.*

Sister of Charles II and fifth daughter of
Charles I. Married Philippe Duc d'Orleans
in 1661. This miniature of 'Minette' is
identifiable as such by comparison with the
full-length portrait of her by Sir Peter Lely,
given by Charles II to the City of Exeter in
1672, and now in the Guildhall, Exeter.
The Duchess, who was described as '. . . the
centre of a thousand fêtes and Madam of
France', is said to have been poisoned with
the connivance of her jealous husband.
She died 30 June 1670.

The Mauritshuis, The Hague

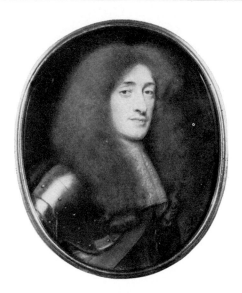

131

JAMES II, as DUKE OF YORK
(1633–1701)

Watercolour on vellum, oval:
2 1/2 × 2 1/8 in.

Signed in monogram: *SC* and dated:
/ *167–* (the last numeral is trimmed away)

This miniature was formerly in the collection
of the Duke of Buccleuch and Queensberry,
and was purchased from him in 1941.

National Maritime Museum, Greenwich

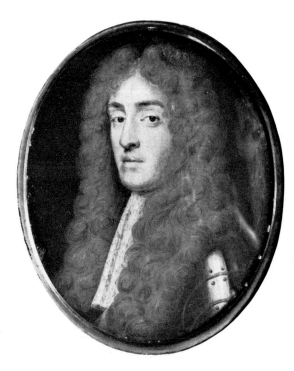

132

JAMES II, as DUKE OF YORK
(1633–1701)

Watercolour on vellum, oval:
3 1/4 × 2 3/4 in.

Inscribed on the reverse in an early
eighteenth-century hand: *Jas 2d when D.
of York by Couper*.

This miniature was formerly in the
collections of the Earls of Dudley, and was
purchased by the present owner from
Gertrude, Countess of Dudley, wife of
William, 2nd Earl of Dudley (1867–1932).
Cooper painted several miniatures of the
Duke of York, all of which vary in their
composition.

*Denys Eyre Bower Collection,
Chiddingstone Castle*

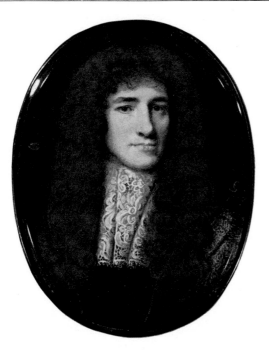

133

ANTHONY ASHLEY COOPER, 1st
EARL OF SHAFTESBURY (1621–83)(?)

Watercolour on vellum, oval:
3 1/8 × 2 1/2 in.

Signed in monogram: *SC.* and dated: | *1670*

The identification of the portrait is uncertain.

Philadelphia Museum of Art

134

PORTRAIT OF AN UNKNOWN
LADY

Watercolour on vellum, oval: 3 × 2 1/2 in.

Signed in monogram: *SC.* and dated: |*1671*

The identity of the sitter has not been
established: she has been called variously
Charlotte de la Tremouille, Countess of
Derby, and Margaret Leslie, Lady Balgony.
The work is of importance as it was painted
in the last year of the artist's life.

The Duke of Buccleuch and Queensberry

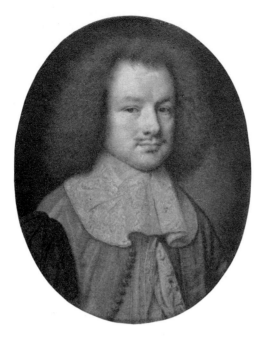

135
LORD CLIFFORD OF CHUDLEIGH
(1630–73)

Watercolour on vellum, oval:
3 1/4 × 2 5/8 in.

Signed in monogram: *SC* and inscribed on
the reverse by the artist: *Sr Thomas
Clifford 1672. Æta: 42 Sam: Cooper fecit.*

Thomas Clifford of Ugbrooke, Devonshire,
suspected of being a concealed Romanist;
entered Exeter College, Oxford, 1647, and
the Middle Temple, 1648; trustee for the
Duke of Monmouth and confidant of
Arlington; held numerous important
offices; was granted estates by Charles II.
Acting Secretary of State, 1672, in which
year he was created Baron Clifford and
Lord High Treasurer; resigned, 1673, the
year of his death. This miniature passed to
the sitter's granddaughter, Anne Clifford,
and by family descent to John Gage in 1818.
The quality of the miniature, painted in the
year of Cooper's death, shows that there
was no deterioration in his work up to the
end of his life; the portrait is therefore of
great documentary importance.

The Lord Clifford of Chudleigh

Samuel Cooper
Drawings

136

Mrs JOHN HOSKINS (d. after 1665)

Black chalk on paper, heightened with blue, rectangular: 11 × 9 in.

Signed with the monogram: *SC* and inscribed: *SC*

The identification of the sitter as Mrs Hoskins is based on an inscription on the reverse of the drawing written in the same hand as the inscription on the drawing of the *Dead Child* (no. 137): *Mrs Hoskins*. This portrait, which presumably represents Sarah, wife of John Hoskins (d. 1665), is almost certainly the same sitter as the lady in the miniature by Hoskins (no. 153) in the collection of Her Majesty The Queen. Samuel and Alexander Cooper were 'bred up under the care and discipline' of Hoskins and his wife, and this drawing is therefore of great historic interest, as well as being a fine example of Cooper's draughtsmanship.

A. H. Harford, Esq

137

A DEAD CHILD

Black chalk heightened with white and greyish blue, on tinted paper, rectangular: 7 × 5 in.

On the reverse of this drawing is one of a man thought to be Hoskins, Junior (no. 138), part of the man's hat having been cut away. The identity of the child is uncertain, but it is probably the son of John Hoskins, Junior, as the inscription on the side bearing the drawing of the man reads, bottom left: *Dead Child*, and underneath, in another hand: *Mr S:C: child done by him*; and on the right side, bottom, in the same hand as the latter inscription: *N.B. Ye son of: Old Mr Hoskins' son*.

This drawing is in my opinion one of the finest that Cooper ever executed. The modelling is superb, and the subject most moving.

A. H. Harford, Esq.

138

JOHN HOSKINS, JUNIOR (?)

Black chalk on paper, rectangular:
7 × 5 in.

This drawing is on the reverse of the *Dead
Child* (no. 137) and is thought to be of
Samuel Cooper's cousin, the younger
Hoskins. The features are not inconsistent
with those on the miniature in the collection
of the Duke of Buccleuch and Queensberry
which, if the inscription *IPSE* is to be
believed, must represent Hoskins, Junior.

A. H. Harford, Esq

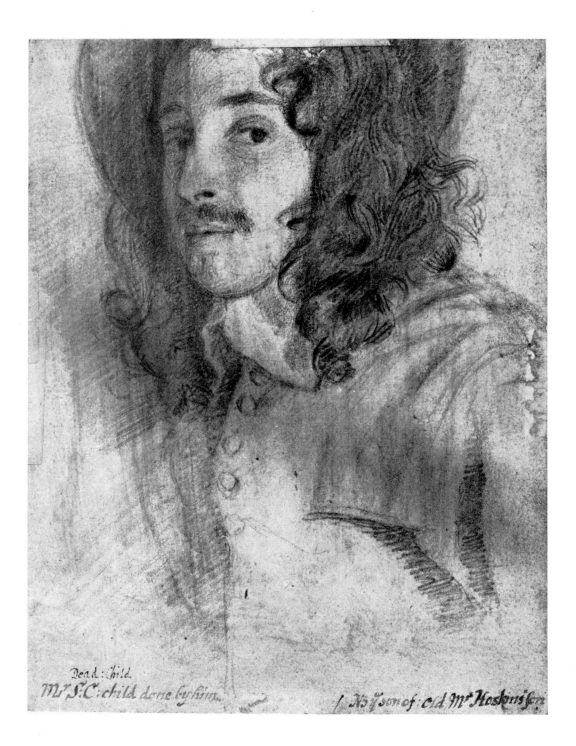

139

Mrs JOHN HOSKINS (d. after 1665)

Black chalk on tinted paper, rectangular:
11 × 9 in.

This unsigned portrait of Sarah Hoskins
comes from the same collection as no. 136.

A. H. Harford, Esq

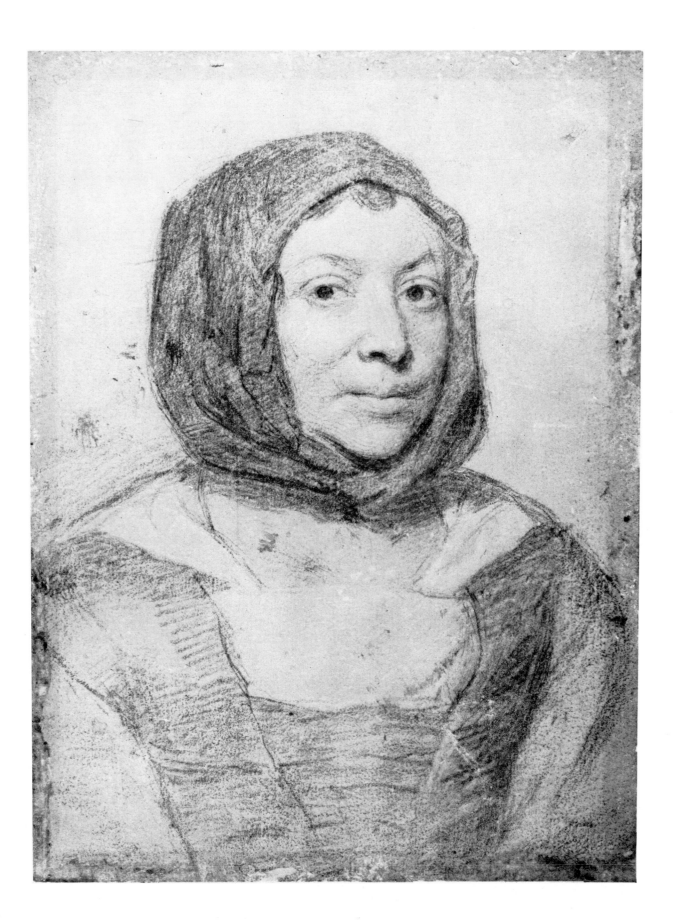

140
CHARLES II (1630–85)
Red and black chalk on brown paper,
rectangular: 6 7/8 × 5 1/2 in.

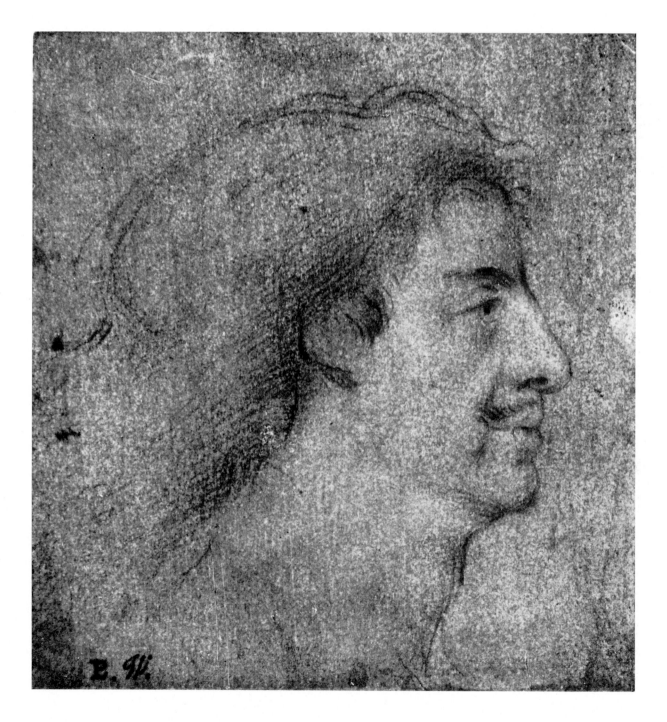

140
CHARLES II (1630–85)

Head in profile (framed with a similar drawing, slightly smaller).

On the reverse of the mount is a note written by the younger Richardson, which reads:

'This Drawing is the portrait of K Charles II*d* for his Inauguration Medal; and for which he sate (as I have heard my Father say) the very same day that He made his Publick Entry, through London; to Loose no time in making the Dye.'

This is taken to mean the dye for the two medals by John Roettier of 1661.

Further mention of this drawing is made by John Evelyn in his *Diary*, 10 January 1662: 'Being call'd into his Ma*tys* closet when Mr. Cooper, y*e* rare limner, was crayoning of the King's face and head, to make the stamps for the new mill'd money now contriving, I had the honour to hold the candle whilst it was doing, he choosing the night and candle-light for y*e* better finding out the shadows.'

The drawing was given to George III on 29 May, the anniversary of the Restoration, by 'his dutiful Son George P', later George IV.

Her Majesty The Queen

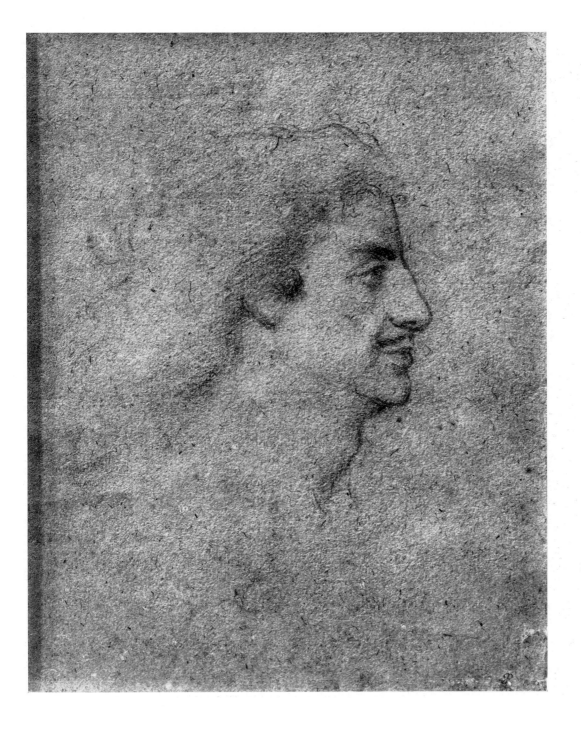

141

THOMAS ALCOCK

Black chalk on paper, rectangular:
7 × 4 1/2 in. Probably drawn *c*.1655.

Inscribed on the back board of the frame:
*This Picture was drawne for mee at the Earle
of Westmorelands house Apethorpe . . . by the
Greate tho' little Limner, the then famous Mr.
Cooper of Covent Garden: when I was eighteen
years of age Thomas Alcock preceptor.*

Apart from the fact that the sitter was
probably tutor to the Westmoreland family,
nothing further is known about him. The
drawing was bequeathed to Oxford
University by Dr Rawlinson in 1755 and
transferred to the Ashmolean Museum in
1897.

Until the portraits in the Harford collection
were identified as by Cooper, this portrait
and the crayon drawing of Charles II were
the only known examples of his work in
this medium, and as such of great
importance.

*The Visitors of the Ashmolean Museum,
Oxford*

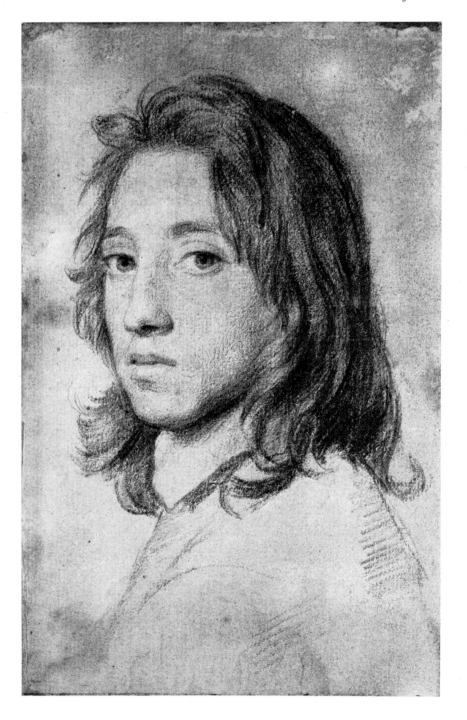

John Hoskins
(*c.* 1595–1665)

In spite of years of research, little knowledge is available about the life and family of John Hoskins. He is known to have had a son of the same name, who apparently followed his father's profession and possibly helped him in the studio. It is still not possible to distinguish between the works executed by the two Hoskinses, and for the present, with the exception of the miniature supposedly by the younger John Hoskins in the Buccleuch collection, all works attributed to Hoskins are taken to refer to the elder man. Hoskins's earliest known works date from about 1620, and a number of his miniatures were in the collection of Charles I. De Piles, in *The Art of Painting*, published in 1706, refers to Hoskins as 'a very eminent limner in the reign of King Charles I, whom he drew with his Queen, and most of his court. He was bred a face-painter in oil, but afterwards taking to miniature he far exceeded what he did before.'

For reasons which are not explained, Alexander and Samuel Cooper were brought up by their uncle, John Hoskins, and his wife, Sarah, and both boys must have had their initial training under him. Charles I appointed Hoskins his 'limner' on 20 April 1640, with a life annuity of £200, which soon fell into arrears.

Hoskins was a considerable artist and bridged the gap between Hilliard and his followers, and the rise to fame of his nephew, Samuel Cooper. Like his predecessors, he painted his portraits on parchment stuck on to card, and favoured a subdued colouring, which rendered his portraits simple and dignified. Like other artists of the period he came under the influence of Van Dyck, whose works he often copied. He died in Bedford Street, Covent Garden, on 22 February 1664/5, and was survived by his wife.

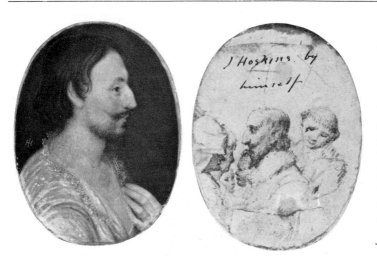

142

SELF-PORTRAIT (?)

Watercolour on vellum, oval:
2 3/8 × 1 3/4 in.

Signed in monogram: *IH*

This profile portrait is said to represent the
artist himself. On the reverse of the
miniature is a drawing of what is taken to
be a family group, composed of Hoskins,
his wife and four children. It is tempting
to consider the possibility of two of the
children being Alexander and Samuel
Cooper. The group bears an inscription:
J. Hoskins | by himself.

The Duke of Buccleuch and Queensberry

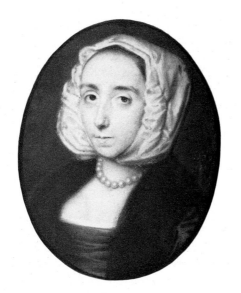

143

PORTRAIT OF AN UNKNOWN LADY
called ELIZABETH VERNON,
COUNTESS OF SOUTHAMPTON
(d. after 1625)

Watercolour on vellum, oval: 2 3/4 × 2 in.

Signed and dated: *1620 | IH*

This miniature was for many years thought
to represent Elizabeth Vernon, but this is
now considered unlikely. The date has also
been given as 1650, but this has been
misread, and the date of 1620 as given above
is correct.

The Duke of Buccleuch and Queensberry

144 (*opposite*)

CHARLES I (1600–49)

Watercolour on vellum, rectangular:
8 1/2 × 6 in.

Signed and dated beneath the crowned
cypher: *CR | 1632 | IH f*

King of Great Britain and Ireland, second
son of James VI and I and Anne of
Denmark. Betrothed to Princess Henrietta
Maria of France, December 1624. Succeeded
to the throne, 27 March 1625; married
Henrietta Maria by proxy, May 1625.
Condemned to death on 27 January and
executed on 30 January 1649.
This miniature is a superb example of
Hoskins's work and one of the most
impressive and human representations of
the King. The painting of the lace and
costume is brilliant. It was formerly in the
collection of Henry J. Pfungst, Esq.

The Earl Beauchamp

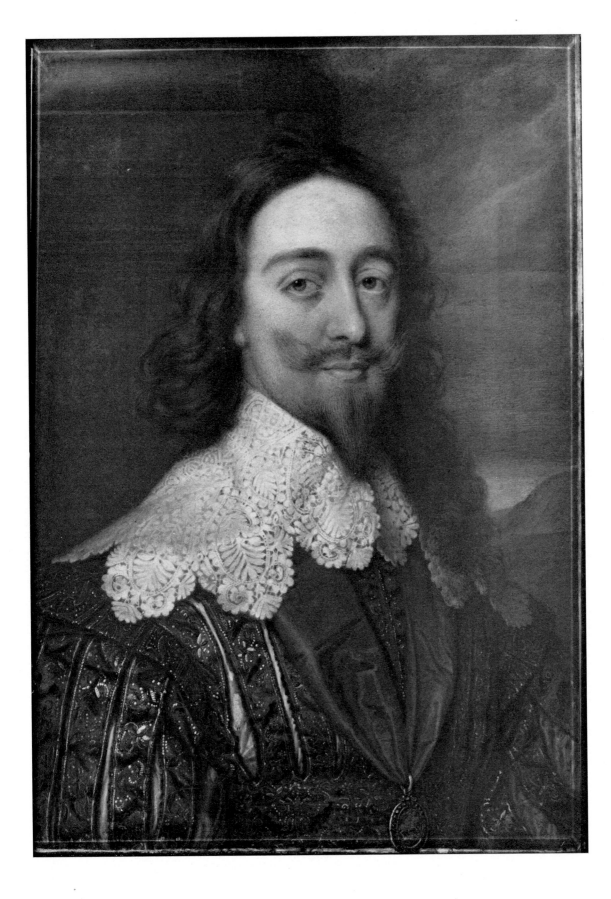

145
HENRIETTA MARIA (1609–69)
Watercolour on vellum, circular: 7 in.

Signed and dated: *1632 / I.H.*, above which
is the Queen's monogram, *HMR*,
surmounted by a crown

Set in an attractive blue and white enamel
frame.
This miniature is almost certainly
identifiable with the miniature of the
Queen listed by Van der Doort in the
catalogue of Charles I's collection. (See
Walpole Society, XXXVII, 1958–60, ed.
Oliver Millar, p. 105.)

The Mauritshuis, The Hague

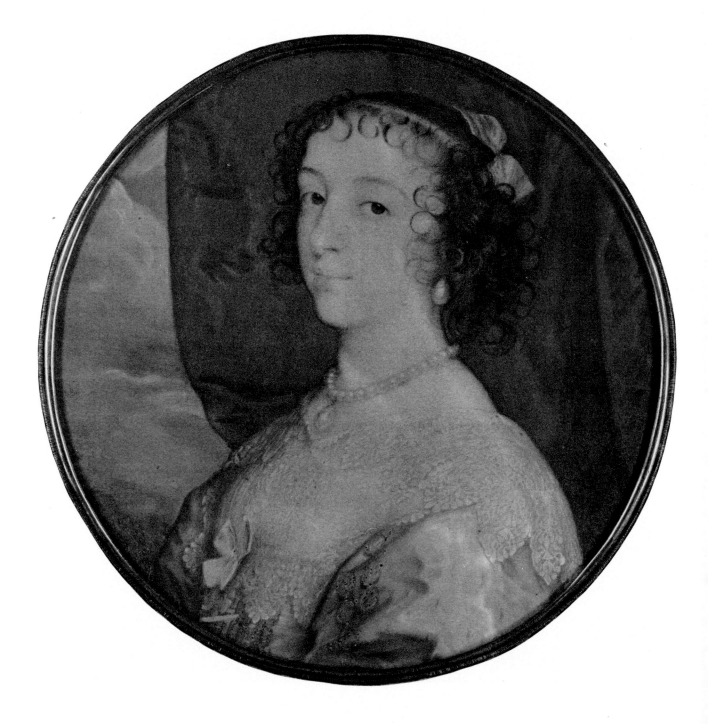

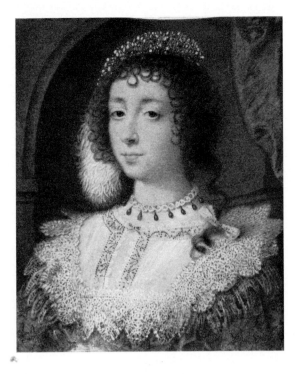

146
HENRIETTA MARIA (1609–69)
Watercolour on vellum, rectangular:
3 1/2 × 3 in.

Signed on the reverse in monogram: *SC*.

Queen of Charles I; youngest daughter of
Henri IV and Marie de' Medici; married
Charles I by proxy, and came to England in
1625.

The miniature was painted for the King in
*c.*1632, and said to be the one recorded by
Van der Doort: 'Don by the life by
Haskins'.

This miniature was for many years in the
de la Hey collection which was sold at
Sotheby's in 1968, when this portrait was
acquired for the Royal Collection.

The late Basil Long considered that the
pencil monogram *SC*, which the miniature
bears, was an authentic signature by
Samuel Cooper, but when the portrait was
exhibited at the R.A. in 1960–1, it was
attributed to Hoskins. The miniature is of
exceptionally high quality, and although
the style is close to that of Hoskins, Cooper
was probably still working with his uncle
at the time it was painted; there is the
possibility that it was the combined work
of both men.

The Queen has been said to be wearing a
dress designed for her by Inigo Jones,
when she appeared in the masque *Tempe
Restor'd* in 1632. The design for this dress
survives and is not the same. Dr Roy Strong
considers that the Queen is wearing court
dress.

Her Majesty The Queen

147

CHARLES I (1600–49) and QUEEN
HENRIETTA MARIA (1609–69)

Watercolour on vellum, oblong:
2 3/4 × 4 1/2 in.

Inscribed between the two figures with the
initials *CMR* in monogram, surmounted
by a crown, and dated in the bottom
left-hand corner: *1636* (not 1626 as
previously stated, the 3 having been
obscured by the frame). The reverse of the
miniature bears a cypher *CR* surmounted
by a crown.

This superb miniature after Van Dyck is
presumably the one mentioned by Van
der Doort as in the collection of Charles I
(See *Walpole Society*, XXXVII, p. 106):
'Item your Ma*tie* and the Queenes Picture
togeither in one peece, yo*r* Ma*tie* in
Carnacon and y*e* Queene in a white habbitt
shee presenting yo*r* Ma*tie* with her right
hand a Garland of Lawrell, and in her left
hand, holding an Ollive Braunch in a little
black ebbone frame, and a Cristall over it
w*th* a shiver, Coppied by Haskins after S*r*
Anthony Vandikes picture w*ch* is now at
Denmarke-house above the Chimney in
oyle Cullors.'

The Duke of Northumberland

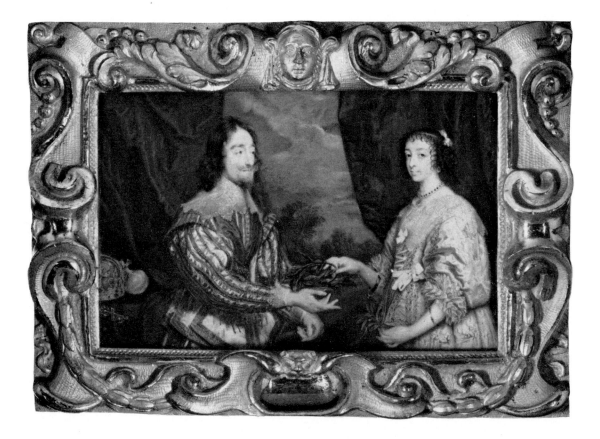

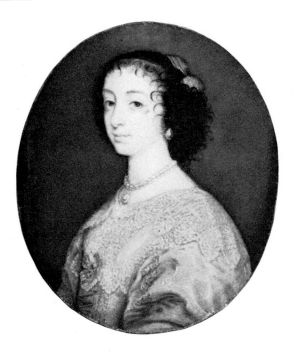

148

HENRIETTA MARIA (1609–69)

Watercolour on vellum, oval:
2 5/8 × 2 1/4 in.

Hoskins painted a number of portraits of
the Queen, both from life and from
portraits by Van Dyck. This miniature
appears to be after the half-length portrait
by Van Dyck in the Royal Collection, no.
147 in *Tudor, Stuart and Early Georgian
Pictures in the Collection of Her Majesty The
Queen*, by Oliver Millar.

*The Marquess of Exeter,
Burghley House Collection*

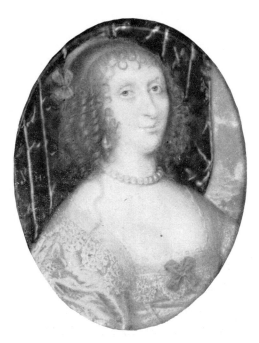

149

LADY CATHERINE ERSKINE
(d. 1635)

Watercolour on vellum, oval: 2 5/8 × 2 in.

Signed in monogram: *IH*.

The sitter was the fourth daughter of John,
Earl of Marr, and married, as his first wife,
Thomas, 2nd Earl of Haddington
(1600–40), by whom she had four sons
and a daughter.

The Earl of Haddington, KT

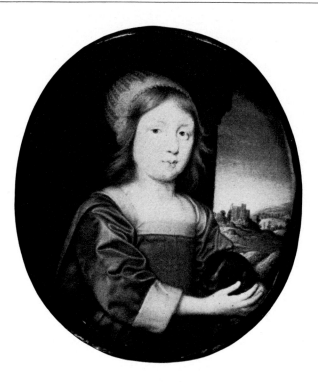

150

WILLIAM CAVENDISH, 4th EARL
and 1st DUKE OF DEVONSHIRE
(1640–1707)

Watercolour on vellum, oval: 3 1/2 × 3 in.

Signed and dated: *IH | 1644*

Son of William, 3rd Earl of Devonshire
and his wife, Lady Elizabeth Cecil (d. 1689).
Married on 26 October 1662, Mary Butler
(1646–1710), 2nd daughter of James, Duke
of Ormonde. William was responsible for
building Chatsworth. A miniature of
'My-lady Cavendish' by Cooper was
purchased by Cosimo III in 1674; it
presumably represented Mary Butler.
This miniature showing William as a child
is thought to be identifiable with one of
those left to his sister Anne, wife of the 5th
Earl of Exeter. Details of these bequests are
given in an Indenture dated 18 April 1690,
including one which reads: *A picture of the
p^{re} sent Earle of Devonshire when a Child by
Hoskins.* The date of the will has frequently
been given erroneously as 1692.
The miniature is a good example of
Hoskins's work at this period of his career.

The Marquess of Exeter,
Burghley House Collection

151

PORTRAIT OF A BOY
('MASTER CECIL')

Watercolour on vellum, oval:
2 3/8 × 2 4/5 in.

This miniature is possibly identifiable as
that of 'A picture of a Boy playeing on
Castinetts by Hoskins', mentioned in the
Countess of Devonshire's will. Were it not
for this, the breadth of modelling and
delicacy of flesh tones might have led one
to suggest a tentative attribution to Cooper.

The Marquess of Exeter,
Burghley House Collection

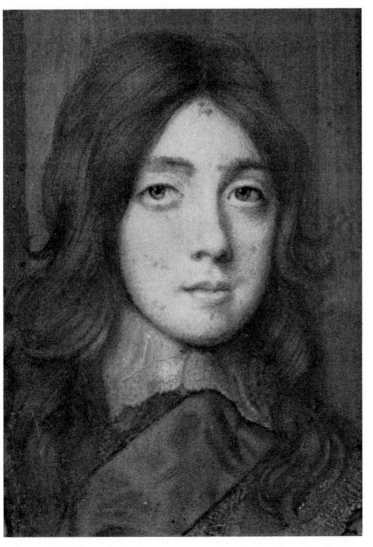

152 (*detail*)

152

THE THREE CHILDREN OF
CHARLES I

Watercolour on vellum, oblong:
3 1/4 × 4 13/16 in. Probably painted *c*.1647.

The miniature was formerly attributed to
Peter Oliver (*c*.1594–1647), but the style and
treatment of the painting seem closer to
the work of John Hoskins, to whom it is
now attributed. The children, James, Duke
of York, Princess Elizabeth and Prince
Henry, were probably painted when they
were in the custody of the Earl of
Northumberland.

The Fitzwilliam Museum, Cambridge

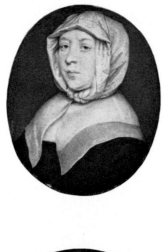

153

THE ARTIST'S WIFE (?)

Watercolour on vellum, oval: 2 × 1 5/8 in.
Probably painted *c.* 1645.

Signed: *IH*

The sitter appears identical with the woman identified as Sarah Hoskins (nos. 136, 139), drawn by Samuel Cooper, who was her nephew.

Her Majesty The Queen

154

WILLIAM, 2nd DUKE OF HAMILTON, KG (1616–51)

Watercolour on vellum, oval:
2 3/4 × 2 1/4 in.

Signed and dated: *IH | 1647.*

The sitter was created Earl of Lanark, Lord Mackanshire and Polmont, 31 March 1639. Succeeded his brother, James, 1st Duke of Hamilton, in 1648/9. Married Elizabeth, daughter and co-heir of James, Earl of Dirleton, 26 May 1638.
The miniature is a fine example of the artist's work, and is set in the original enamel locket.

The Earl of Haddington, KT

John Hoskins, Junior

Little is known about the above artist other than the fact that he was the son of John and Sarah Hoskins. It is thought that he followed his father's profession, and was presumably taught by him. In the past, numerous miniatures have been attributed to the younger man on the basis of different signatures, but in the absence of any documentary evidence it is not possible to make any definite attributions. The only portrait thought to be by him is the one in the collection of the Duke of Buccleuch which is signed and dated: *1656 | iH | IPSE*. The portrait is not totally inconsistent with the drawing, also thought to represent Hoskins, Junior, by Samuel Cooper (no. 138).

155

SELF-PORTRAIT (?)

Watercolour on vellum, oval: 3 × 2 1/4 in.

Signed and dated: *1656 | iH | IPSE*

Because of the lack of any documentary evidence, the problem of differentiating between the work of John Hoskins, Senior, and that of his son has never been resolved. This miniature represents a younger man than 'Old Hoskins' would have been at the date it was painted, and even allowing for some overpainting it is executed in a totally different style. The features of the sitter in this miniature are not unlike those in the drawing of a man, supposedly John Hoskins, Junior, by Samuel Cooper (no. 138).

The Duke of Buccleuch and Queensberry

Alexander Cooper
(d. 1660)

Elder brother of Samuel Cooper and nephew of John Hoskins, by whom the two boys were brought up and taught painting. Alexander Cooper is said to have been a pupil of Peter Oliver. His date of birth is unknown, but about 1605 has been suggested. He was in Holland by about 1631, and appears to have remained on the Continent for the rest of his life. He painted a series of portraits of the Bohemian royal family and in 1644–6 was in The Hague and from 1647 to 1657 in Sweden, where he held the office of Court Painter. In about 1655 he was working for the King of Denmark, probably in Copenhagen; six miniatures of the royal family are in the Rosenborg Castle, Copenhagen, all of them painted against blue backgrounds and set in rich enamel lockets, on the reverse of which are monograms and the date 1656. Only a small number of miniatures authenticated by his signature – *AC* – are known, but other works are attributed to him from time to time on the basis of style and technique. The majority of his works are probably still on the Continent. He is said to have died in Stockholm in 1660.

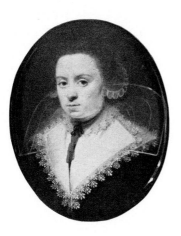

156

PORTRAIT OF AN UNKNOWN LADY

Watercolour on vellum, oval:
2 1/4 × 1 7/8 in.

Signed in monogram: *AC*

Only a small number of signed miniatures
by Alexander Cooper have been discovered.

Her Majesty The Queen of The Netherlands

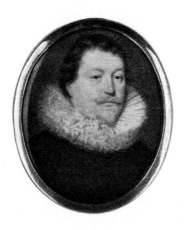

157

PORTRAIT OF AN UNKNOWN LADY

Watercolour on vellum, oval:
1 7/8 × 1 1/2 in.

Signed: *A.C.*

Her Majesty The Queen of The Netherlands

158

PORTRAIT OF AN UNKNOWN MAN

Watercolour on vellum, oval:
1 7/8 × 1 1/2 in.

Signed: *A.C.*

Her Majesty The Queen of The Netherlands

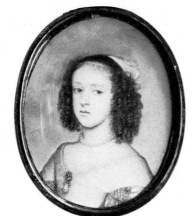

159

PRINCESS ANNA SOPHIA, OF DENMARK (1647–1717)

Watercolour on vellum, oval: 2 × 1 1/2 in.

Probably painted in 1656; set in a gold and enamel locket similar to the other miniatures of the family, and dated 1656 on the reverse.

The Princess was the daughter of Frederik III and Queen Sophie Amalie. She married John George, Elector of Saxony.

Rosenborg Castle, Copenhagen

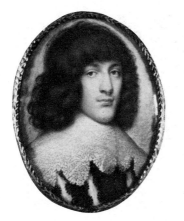

160

PRINCESS FREDERIKKE AMALIE, OF DENMARK (1649–1704)

Watercolour on vellum, oval: 2 × 1 1/2 in.

Probably painted in 1656; set in a gold and enamel locket similar to the other miniatures of her family, and dated 1656 on the reverse.

The Princess married Christian Albert of Holstein-Gottorp.

Rosenborg Castle, Copenhagen

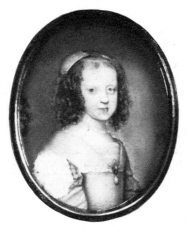

161

CHARLES LOUIS, COUNT PALATINE (1617–80)

Watercolour on vellum, oval: 2 × 1 9/16 in.

Although this miniature is unsigned, it has been accepted as the work of Alexander Cooper for some years. Examples of this artist's works are rare.

The Duke of Buccleuch and Queensberry

162

A PAIR OF MINIATURES OF UNKNOWN CHILDREN

Watercolour on vellum, oval: 1 1/8 × 1 in.

These attractive miniatures set in a double locket are attributed with some degree of confidence to Alexander Cooper, and are close in style to those in the Rosenborg Castle, Copenhagen. Both miniatures are painted against a blue background.

Robert Bayne-Powell, Esq

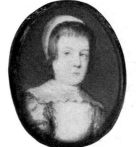

Thomas Flatman
(1635–1688)

Born in London in 1635, son of a clerk in Chancery, Thomas Flatman was educated at Winchester and New College, Oxford, where he was elected a Fellow in 1656. He was admitted to the Inner Temple, 31 May 1655, and called to the Bar, 11 May 1662. He was a member of a small religious and æsthetic circle which included the Beale family, Dean Sancroft, later Archbishop of Canterbury, and the Revd Samuel Woodford. Flatman was a man of many parts and had a reputation as a melancholic, religious poet. Dated miniatures by him exist between the years 1661 and 1683. He based his early works on the style of Samuel Cooper, and is considered second only to Cooper as a seventeenth-century miniaturist. Many of his early works have a brownish flesh colour which is unattractive; often his miniatures have a sky background, the blue being harsher than any colour used by Cooper. Many of Flatman's miniatures have been and still are attributed to Cooper, and several portraits have had a false Cooper signature added to them. In maturity Flatman painted with assurance and brilliance, and was one of the few artists besides Cooper who highlighted the sitter's coat with pure gold. His self-portrait is in the Victoria and Albert Museum.

163

PORTRAIT OF AN UNKNOWN MAN

Watercolour on vellum, oval:
2 3/4 × 2 1/8 in.

This miniature is an interesting example of
a portrait by Flatman which has had a false
signature added. When it was sold at
Christie's, 6 July 1965 (lot 41), it was
signed and dated: *SC | 1662*. The present
owner has had the false inscription
removed. It is undoubtedly by Flatman. It
has been suggested by Graham Reynolds
that this may well be a self-portrait,
executed a few years earlier than the one in
the Victoria and Albert Museum.

E. Hawtin, Esq

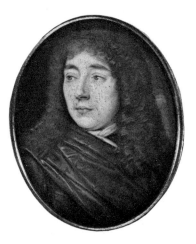

164

SIR THOMAS LANGTON (1632–1701)

Watercolour on vellum, oval:
2 1/8 × 1 3/4 in.

Signed with a gold monogram: *TF*

Sir Thomas Langton, of Brislington,
Somerset, married as his first wife, Hester,
daughter of William Cann of Bristol, and
secondly, Elizabeth Gunning. Mentioned
in the Bristol Civic Records, 1659–73, when
he was Alderman, Sheriff, Mayor (1666),
and Master Merchant Venturer.
Two miniatures of the sitter by Flatman
are at Corsham; in this one he is wearing a
brown wig.

The Lord Methuen

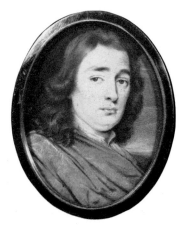

165

SIR THOMAS LANGTON (1632–1701)

Watercolour on vellum, oval:
2 1/8 × 1 3/4 in.

Signed with a gold monogram: *TF*.

Companion to no. 164, where the sitter is
wearing a wig.

The Lord Methuen

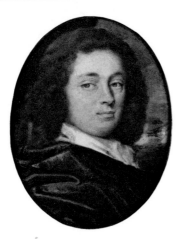

166

THOMAS OTWAY, BISHOP OF
OSSORY (1616–93) (?)

Watercolour on vellum, oval:
2 1/4 × 1 3/4 in.

This miniature has been previously
unattributed, but is clearly in the style of
Flatman.

The Duke of Buccleuch and Queensberry

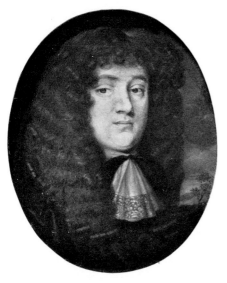

167

THOMAS BUTLER, EARL OF
OSSORY (1634–80)

Watercolour on vellum, oval;
2 3/4 × 2 1/8 in.

Signed in monogram: *TF*

Eldest son of James Butler, 1st Duke of
Ormonde; lived in Kilkenny Castle from
birth till 1647. Educated in a French
Protestant school at Caen. In London,
1652–5; imprisoned as a political suspect,
went to Holland, 1656; married, 1659,
Emilia, a relative of the Prince of Orange.
Created Baron Butler, 1666. Sent to offer
the Prince of Orange marriage with
Princess Mary, 1674. Took command at
Tangiers, 1680.

The Earl Beauchamp

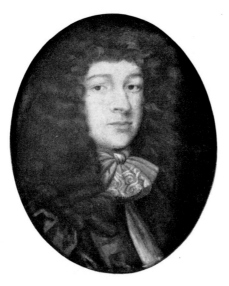

168

JOHN HOPE, of HOPETOUN
(1652–82)

Watercolour on vellum, oval:
2 7/8 × 2 3/8 in.

The sitter was the father of the 1st Earl of
Hopetoun. He married Margaret, eldest
daughter of John, 4th Earl of Haddington.
Lost his life in a shipwreck whilst on his
way to Scotland, 5 May 1682. His son,
Charles, was created Earl of Hopetoun,
15 April 1703.

The Earl of Haddington, KT

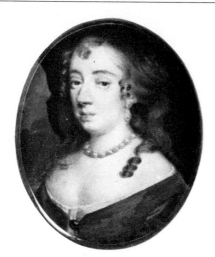

169

A LADY *called* ELIZABETH
CLAYPOLE (1629–58)

Watercolour on vellum, oval:
2 1/4 × 1 7/8 in.

Signed: *F.*

*Nelson Gallery-Atkins Museum (Gift of Mr
and Mrs John W. Starr), Kansas City,
Missouri*

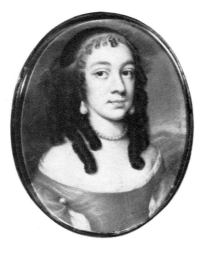

170

LADY LANGLEY *née* ELIZABETH
HEWET (d. 1702)

Watercolour on vellum, oval:
2 5/16 × 1 5/8 in.

Signed: *TF*

The sitter was the second wife of Sir Henry
Langley (d. 1688) of The Abbey,
Shrewsbury.
This miniature and the companion one
of her husband (no. 171) are of particularly
fine quality.

V. M. E. Holt, Esq

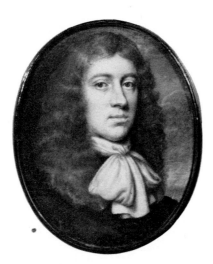

171

SIR HENRY LANGLEY (d. 1688)

Watercolour on vellum, oval:
2 5/16 × 1 5/8 in.

Signed: *TF*

Sir Henry lived at The Abbey, Shrewsbury,
and was the son of Jonathan Langley, Esq.
Knighted in 1680. Married as his first wife,
Jane, daughter of William Strode, DD (d.
1669), and secondly, Elizabeth Hewet, who
survived him.

V. M. E. Holt, Esq

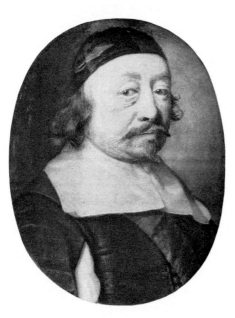

172

PORTRAIT OF AN UNKNOWN LADY

Watercolour on vellum, oval: 3 × 2 1/2 in.

Signed in monogram: *TF.* and dated: *1661*.

The sitter was formerly said to be the
artist's wife. This miniature is a fine
example of Flatman's work.

The Victoria and Albert Museum

173

PORTRAIT OF AN UNKNOWN MAN

Watercolour on vellum, oval:
2 1/2 × 2 1/8 in.

Signed and dated: *F. | 1661*

The sitter was once erroneously identified
as Sir Henry Vane (1613–62).

The Duke of Buccleuch and Queensberry

174

MILDMAY FANE, 2nd EARL OF
WESTMORLAND (d. 1666)

Watercolour on vellum, oval: 3 × 2 1/4 in.

This miniature has been attributed to
Cooper and Flatman, but the work seems
close to that of Flatman, and the brilliant
condition of the portrait and the manner
in which the jacket is shaded with gold are
reminiscent of Flatman's miniature of
John Lee Warner (no. 181).
The sitter was made KB in 1625, and
appears to be wearing the sash of that
Order.

Walters Art Gallery, Baltimore

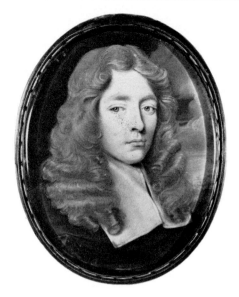

175

PORTRAIT OF AN UNKNOWN MAN

Watercolour on vellum, oval: 2 1/2 × 2 in.

This miniature was once in the collection of the late J. J. Foster, and illustrated on pl. LXXI in his work, *Samuel Cooper and the English Miniature Painters of the XVII Century*.

Kenneth Guichard, Esq

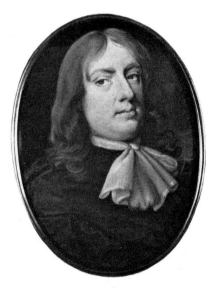

176

PORTRAIT OF AN UNKNOWN MAN

Watercolour on vellum, oval: 2 1/2 × 2 in.

Signed in monogram: *TF*

The Duke of Buccleuch and Queensberry

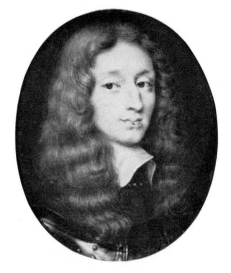

177

SIR PHILIP TYRWHITT, BART (1611–88)

Watercolour on vellum, oval: 2 5/8 × 2 1/8 in.

The sitter was High Sheriff of Lincolnshire, 1660–1, and Member of Parliament for Grimsby until 1667. Married, in or before 1663, Penelope, daughter of Sir Erasmus de la Fountain of Kirby Pelham, Leicestershire.

Private Collection

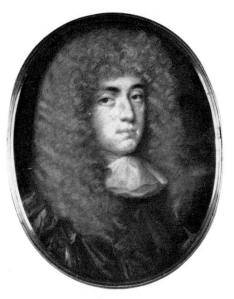

178

PORTRAIT OF AN UNKNOWN MAN
Watercolour on vellum, oval:
2 3/4 × 2 1/4 in.
Signed in monogram: *TF*
Mrs Daphne Foskett

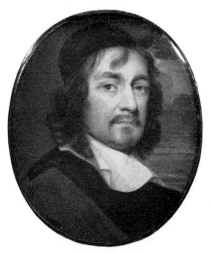

179

PORTRAIT OF A MAN *called* Sir
JOHN MAYNARD (1602–90)
Watercolour on vellum, oval: 2 3/8 × 2 in.
Attributed to Flatman.

The features of the sitter do not resemble
those of the portrait of Sir John by an
unknown artist. This miniature has
hitherto been attributed to Samuel Cooper,
but the late Basil Long tentatively suggested
that it was by Flatman, and the style seems
closer to his work than that of Cooper.

The Duke of Buccleuch and Queensberry

180

PORTRAIT OF AN UNKNOWN MAN
Watercolour on vellum, oval:
2 5/8 × 2 1/8 in.
Signed in monogram: *TF.*
*Nelson Gallery-Atkins Museum (Gift of Mr
and Mrs John W. Starr), Kansas City,
Missouri*

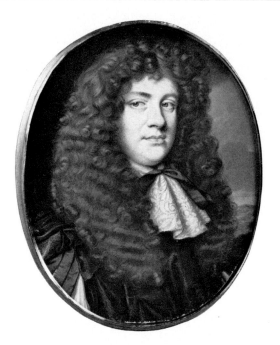

181

JOHN LEE WARNER

Watercolour on vellum, oval:
3 1/8 × 2 1/2 in.

Signed in monogram: *TF*.

This superb miniature is one of Flatman's finest works. The brown robes shaded with pure gold, and the touches of green on the ribbon and sleeves, are all details painted with meticulous care, and place the artist on a very high level.

Walters Art Gallery, Baltimore

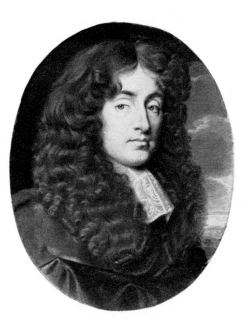

182

PORTRAIT OF AN UNKNOWN MAN

Watercolour on vellum, oval: 3 × 2 1/2 in.

Signed in monogram: *TF* and dated: | *1675*

The Visitors of the Ashmolean Museum, Oxford

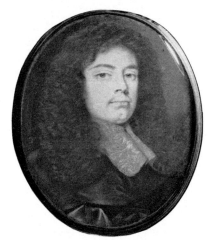

183

PORTRAIT OF AN UNKNOWN MAN

Watercolour on vellum, oval:
2 1/4 × 1 7/8 in.

Signed with a monogram in gold: *TF*

This miniature is in fine condition and is contained in a simple gold frame; it is still in its original sealskin box.

The Fondation Custodia (collection F. Lugt), Institut Néerlandais, Paris

Richard Gibson
(1615–1690)

Born in 1615, perhaps in Cumberland, Richard Gibson was called 'the dwarf'. He became a page to a lady in Mortlake, and having shown aptitude for art, was supposedly instructed by F. Cleyn. He later studied Lely's work and was influenced by him. He was noticed at court and appointed a page to Charles I; he attracted the attention of Queen Henrietta Maria, and a bride was found for him of his own height (3 feet 10 inches). By his wife, Anna Shepherd, he had nine children, the five who survived all being of normal size. His daughter, Susan Penelope, also became a miniaturist, and was a follower of Cooper. Gibson was a good draughtsman, and his miniatures are well painted. He was patronized by the Earl of Pembroke, and spent a lot of time in Holland, where he taught Princess Mary of Orange. A miniature of Louise de Keroualle, Duchess of Portsmouth, signed and dated on the reverse, *R. Gibson fecit 1673*, is in the Uffizi in Florence. He died in London, 23 July 1690

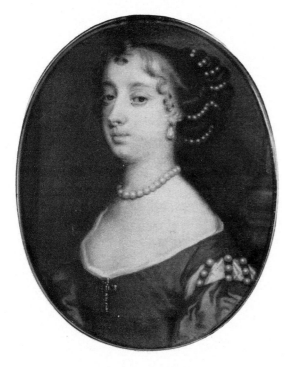

184

BARBARA VILLIERS, DUCHESS OF CLEVELAND (1641–1709)

Watercolour on vellum, oval:
3 3/8 × 2 1/2 in.

This miniature is by family descent from Robert, 2nd Earl of Sunderland.

The Earl Spencer

185

A CHILD IN A BLUE DRESS

Watercolour on vellum, oval, 2 × 1 5/8 in.

By family descent, probably from Sarah, Duchess of Marlborough (d. 1744).

The Earl Spencer

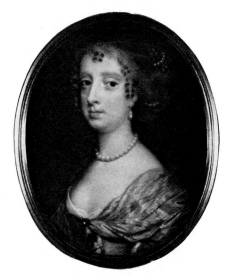

186

ELIZABETH WRIOTHESLEY, COUNTESS OF NORTHUMBERLAND (1646–90)

Watercolour on vellum, oval: 2 1/2 × 2 1/8 in. Attributed to Gibson.

This miniature is close in style to the known works of Richard Gibson.

The Duke of Buccleuch and Queensberry

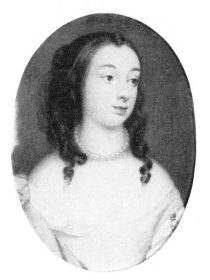

187

LADY FRANKLIN

Watercolour on vellum, oval: 2 3/4 × 2 1/4 in.

Inscribed on the reverse of the miniature: *My Lady Franklin*

This miniature was once in the collection of the Earl of Wharncliffe and was exhibited at the South Kensington Museum in June 1865.

Mrs Daphne Foskett

Susan Penelope Rosse
née Gibson (1652?–1700)

Born *c.*1652, daughter of Richard Gibson and his wife, Anna Shepherd, Susan followed her father's profession and was his pupil; she studied and frequently copied miniatures by Samuel Cooper, and may well have worked in his studio. She married a jeweller named Michael Rose or Rosse, from whom George Vertue obtained much of his information about her and who showed Vertue portraits of the Gibson family. A pocket-book containing fourteen unframed and sometimes unfinished miniatures, including the artist's self-portrait and some of the artist's family, is in the Victoria and Albert Museum. Many of her miniatures are small, and are sometimes signed *SR* or *SPR*. Her husband sold a large collection of miniatures and pictures in 1723; the catalogue contains numerous portraits by Mrs Rosse after Cooper as well as some from life. Identification is difficult as only a few of her works are signed, but it is more than probable that a number of miniatures formerly attributed to Cooper are copies by Mrs Rosse. She died in Covent Garden in 1700, aged 48, and was buried in the church there.

188

PORTRAIT OF AN UNKNOWN LADY

Watercolour on vellum, oval:
1 1/16 × 15/16 in.

Signed in gold: *S P*
 R.

Signed miniatures by this artist are rare; in consequence, identification is difficult and many of her works probably pass unrecognized.

The Victoria and Albert Museum

189
JAMES II (1633–1701)
Watercolour on vellum, oval: 1 1/8 × 1 in.
Signed: *S.R.*
Her Majesty The Queen

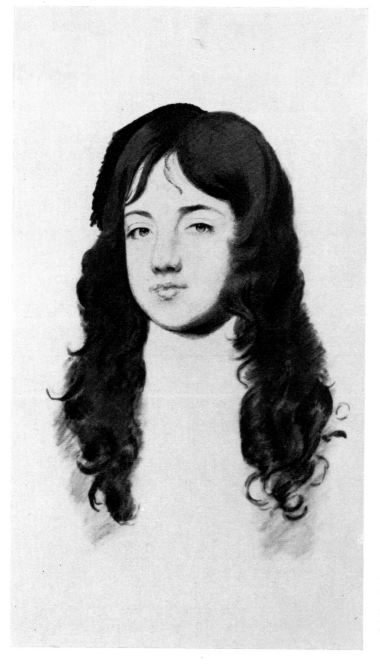

190 (*detail, showing head, actual size*)
JAMES SCOTT, DUKE OF
MONMOUTH AND BUCCLEUCH, KG
(1649–85)
Watercolour on vellum, rectangular:
8 1/2 × 6 3/4 in.

This portrait is a copy of Cooper's
unfinished miniature (no. 78) in the
Royal Collection. The copy has for some
time been attributed to Susan Rosse, who
copied so many of Cooper's works,
although there has been a difference of
opinion as to the age of the vellum on
which it is painted.
The draughtsmanship, although good, has
not the quality of the master's hand, and
lacks Cooper's effortless modelling.
The Duke of Buccleuch and Queensberry

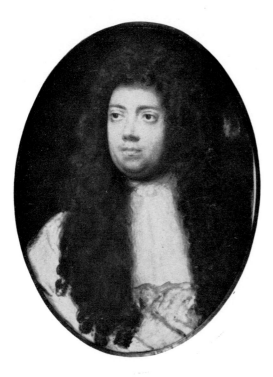

191
PORTRAIT OF AN UNKNOWN MAN
Watercolour on vellum, oval:
3 1/2 × 2 5/8 in.
The Fitzwilliam Museum, Cambridge

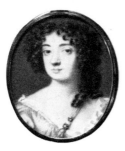

192 (*enlarged*)
LOUISE RENÉE DE KEROUALLE,
DUCHESS OF PORTSMOUTH AND
AUBIGNY (1649–1734)
Watercolour on vellum, oval:
15/16 × 3/4 in.
The sitter's name is scratched on the
reverse of the locket.
Mrs Daphne Foskett

193
BARBARA VILLIERS, DUCHESS OF
CLEVELAND (1641–1709)
Watercolour on vellum, oval: 1 × 13/16 in.
The sitter's name is scratched on the
reverse of the locket.
Mrs Daphne Foskett

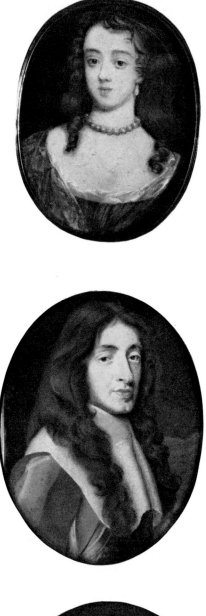

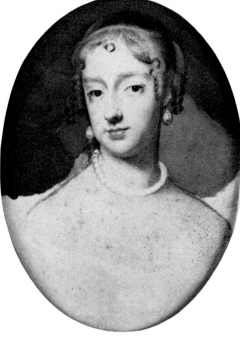

194

ELIZABETH, COUNTESS OF
NORTHUMBERLAND (d. 1704/5) (?)

Watercolour on vellum, oval: 2 1/2 × 2 in.

Inscribed in pencil on the reverse of the
gesso base: *Elizabeth | Countess of |
Northumberland | no 1006 | 5.*

This miniature is attributed to Susan Rosse.
The identification of the sitter is not
certain. Lady Elizabeth Howard, second
daughter of Theophilus, 2nd Earl of
Suffolk, and his wife, Elizabeth (d. 1633),
married as his second wife, 1 October 1642,
Algernon, 10th Earl of Northumberland, KG
(1602–68)

Mrs Daphne Foskett

195

JAMES II, as DUKE OF YORK
(1633–1701)

Watercolour on vellum, oval: 3 × 2 1/2 in.

On the reverse of the miniature is an
inscription: *The Duke of York, drawn
1660 | after the decease of Car 2 | Jac 2.*

This miniature, of which other versions
exist, has for many years been attributed to
Cooper, and as such was illustrated by the
late J. J. Foster in *Samuel Cooper and the
English Miniature Painters of the XVII
Century*, pl. L, no. 125. It is a replica of the
miniature of the Duke of York in the
Victoria and Albert Museum (no. 96),
signed and dated 1661. It may well be a
copy by Susan Penelope Rosse.

The Duke of Beaufort

196

FRANCES TERESA STUART,
DUCHESS OF RICHMOND (1647–1702)

Watercolour on vellum, oval:
3 1/2 × 2 3/4 in.

The miniature is inscribed on the reverse:
*Miss Stewart the favourite Mistress | of
Car 2. Married the Duke of Richmond &
Lenox.*

This miniature, together with nos. 195 and
197, was illustrated by the late J. J. Foster
as being by Cooper. As in the case of the
other miniatures, it is possibly by Susan
Penelope Rosse after Cooper.
The original unfinished version from which
this is taken is in the collection of Her
Majesty The Queen (no. 82), one of five
important sketches made by Cooper from
which finished miniatures could be made.

The Duke of Beaufort

197

MISS KIRCKE, KIRKE or KIRK

Watercolour on vellum, oval: 3 × 2 1/4 in.

Inscribed on the reverse: *Miss Kirk niece of / General Kirk.*

This miniature has for many years been attributed to Samuel Cooper, and was illustrated by J. J. Foster in *Samuel Cooper and the English Miniature Painters of the XVII Century* (pl. L, no. 129), where the sitter was said to be the daughter of General Percy Kirke (1646–91) and Maid of Honour to the Queen. The style of painting is close to the work of S. P. Rosse.

The Duke of Beaufort

198

ELEANOR (NELL) GWYN (1650–87)

Watercolour on vellum, oval: 1 5/8 × 1 1/8 in.

Signed: *SR.*

Nell Gwyn, who was probably the most popular of Charles II's mistresses, started life selling oranges at the Theatre Royal, Drury Lane. Her career as an actress began in 1665, when she appeared at Drury Lane as Cydaria, and continued as an actress up to 1682. Described by Pepys as 'pretty witty Nell'. She had two sons by Charles II: Charles Beauclerk, b. 1670, later created Duke of St Albans, and James, b. 1671. The above miniature is traditionally said to represent Nell, and to have been left by her to her son, the Duke of St Albans, and to have passed to the Drummond family through her great granddaughter, Charlotte Beauclerk, who married John Drummond (1723–74), son of the founder of Drummonds Bank. The miniature, together with one of Charles II by Cooper, was sold at Christies, 20 February 1973 (lot 131).

Charles Fleischmann, Esq, Cincinnati, Ohio

D. Gibson (fl. 1656–1658)

The existence of a seventeenth-century miniaturist who signed his works *D. Gibson* in full or *D.G.* has been established for some time, but so far nothing of importance is known about him, or his relationship if any to the three other artists of that name: R. Gibson, E. Gibson and W. Gibson. Richard Gibson, the dwarf, and his wife, Anna, had nine children, of whom a son Dirck is recorded as a sculptor in the Hague, *c.*1690–1712. The miniatures painted by D. Gibson are very close in style to the works of Richard Gibson, and identification is difficult. Key pieces by him are the miniatures of Lady Catherine Dormer in the Victoria and Albert Museum and those of the Earl and Countess of Carnarvon, both signed in monogram, *DG*, in the collection of the Duke of Beaufort.

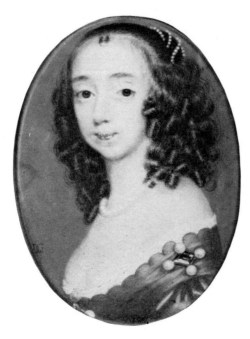

199

ELIZABETH CAPEL, COUNTESS OF CARNARVON or CAENARVON

Watercolour on vellum, oval:
3 1/4 × 2 1/2 in.

Signed in monogram: *DG*

The sitter was the wife of Charles Dormer, 2nd Earl of Carnarvon (1632–1709).
The miniature is of importance as it is one of the few signed examples of this artist's work.

The Duke of Beaufort

200

CHARLES, 2nd EARL OF
CARNARVON (1632–1709)

Watercolour on vellum, oval:
3 1/4 × 2 1/2 in.

Signed in monogram: *DG*

Son of Robert, 1st Earl (d. 1643), who fell
at the first battle of Newbury. His family
were among Lely's most influential patrons
before the Restoration. Signed examples of
this artist's work are rare.

The Duke of Beaufort

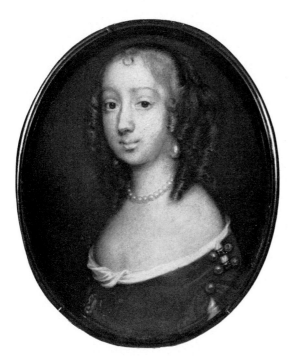

201

LADY CATHERINE DORMER
(d. 1659)

Watercolour on vellum, oval:
3 3/16 × 2 5/16 in.

Inscribed on the reverse: *my Lady K.
Dormer | picter done by mr | Gibsone.*

The sitter was the daughter of Montague
Bertie, 2nd Earl of Lindsey, and sister of
the Hon Peregrine Bertie (d. 1700), who
was also painted by Gibson. Lady Catherine
was the first wife of Robert Dormer of
Dorton, Bucks, whose family were painted
in miniature by Samuel Cooper.

The Victoria and Albert Museum

202

THE HON PEREGRINE BERTIE
(d. 1700)

Watercolour on vellum, oval:
2 3/4 × 2 3/8 in.

The sitter was the second son of Montague,
2nd Earl of Lindsey, and brother of Lady
Catherine Dormer (d. 1659), first wife of
Robert Dormer of Dorton, Bucks. A
miniature of Lady Catherine Dormer, also
by Gibson, is in the Victoria and Albert
Museum (no. 201).

Private Collection

203

ELIZABETH, COUNTESS OF ESSEX
(d. 1717)

Watercolour on vellum, oval: 2 1/4 × 2 in.

A smaller version of this miniature by the
same artist, in which the sitter is wearing
the same dress, is in the collection of Mr
George Howard, at Castle Howard, where
it is identified as Elizabeth, daughter of
Algernon Percy, 10th Earl of
Northumberland. Elizabeth married, 19
May 1653, Arthur, 1st Earl of Essex (d.
1683). The Earl, having been committed
to the Tower, was found there, 13 July
1683, with his throat cut. Their daughter,
Anne, married Charles, 3rd Earl of Carlisle.

Mrs Daphne Foskett

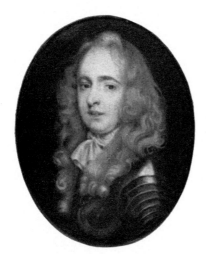

204

PORTRAIT OF AN UNKNOWN MAN
IN ARMOUR

Watercolour on vellum, oval: 2 3/8 × 2 in.

Mrs Daphne Foskett

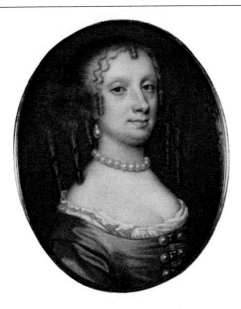

205

LADY RAWDON (d. 1636)

Watercolour on vellum, oval:

2 3/4 × 2 1/4 in.

The sitter was Ursula, widow of Francis Hill and daughter of Francis Stafford of Bradney, Salop. She married in 1635, as his first wife, Sir George Rawdon (1604–84), but she and her only child died in the following year. As Gibson is not known to have been working before *c.*1656, the miniature is presumably taken from an earlier portrait.

The Hon Felicity Samuel

William Claret (d. 1706)

Little is known about this artist, who is best known as a portrait painter in oil, but it is assumed that he was the miniaturist who signed *WC*. He is said to have been a pupil of Lely, whose style he imitated. Only two miniatures are at present attributed to him: one of the Duchess of Portsmouth, signed in monogram *WC*, and the other in a private collection, signed *WC*. According to George Vertue, Claret was a widower for many years, and at his death left all his possessions to an old housekeeper.

206

LOUISE RENÉE DE KEROUALLE, DUCHESS OF PORTSMOUTH AND AUBIGNY (1649–1734)

Watercolour on vellum, oval: 3 1/16 × 2 1/2 in.

Signed in monogram *WC*. Painted *c*.1670.

This miniature was once owned by Fanny Murray, mistress of the Hon John Spencer, and given by her husband, David Ross, the actor, to Georgiana, Countess Spencer, in 1778.

The Earl Spencer

David Des Granges
(1611/13–1675?)

The son of Samson Des Granges of Guernsey, David Des Granges was baptized in London as a Hugenot on 24 May 1611 or 20 January 1613. He subsequently became a Roman Catholic and was associated for a time with French Dominicans. He began his career as an engraver. He was given employment by Charles I, and in 1651 accompanied Charles II to Scotland, where he was appointed His Majesty's Limner in Scotland. He painted a large number of miniatures after the works of other artists, including a good copy of Titian's *Marquis del Guasto with his Mistress*. His usual signature is *DDG* formed in a triangle, sometimes followed by a date. His sight failed towards the end of his life and because of this and ill health he was obliged to rely on charity. He died *c.*1675.

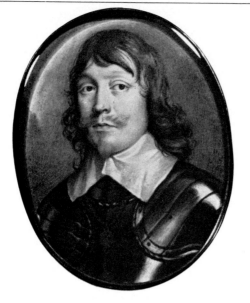

207

JAMES, 3rd MARQUESS and 1st
DUKE OF HAMILTON, KG (1606–49)
Watercolour on vellum, oval:
2 3/4 × 2 1/4 in.
Signed: *D*
D.G / 1650

Son of James, 2nd Marquess of Hamilton,
and his wife, Anne, daughter of James,
Earl of Glencairn; was created Duke of
Hamilton, Marquess of Clydesdale, Earl of
Cambridge and Lord Aven and Innerdale,
12 April 1643; married Margaret (d. 10
May 1638), daughter of the Earl of
Denbigh, in 1620. Beheaded on 9 March
1649, and succeeded by his brother,
William. The miniature is based on a
full-length portrait by Van Dyck in the
Hamilton collection.

The Earl of Haddington, KT

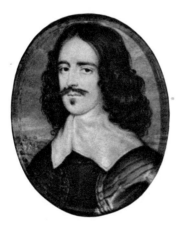

208

PORTRAIT OF A MAN *called* HENRY
IRETON (1611–51)
Watercolour on vellum, oval:
2 1/8 × 1 3/4 in.
Signed: *D*
D G

The identification of the sitter as Henry
Ireton is uncertain.

Mrs W. A. Rappolt

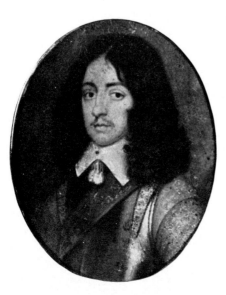

209

CHARLES II (1630–85)
Watercolour on vellum, oval:
2 3/4 × 2 1/4 in.
Painted in 1651, when the King was in
exile.

Several replicas of this miniature exist, one
of which is in the Portland collection.

The Earl Spencer

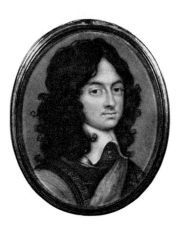

210

CHARLES II (1630–85)

Watercolour on vellum, oval:
1 7/8 × 1 1/2 in.

Signed and dated: *D*
 D G / 1651.

This miniature is probably one of those
listed by Des Granges, and referred to in
the Treasury Papers, 1556–1696, p. 23–6:
'one picture of Your Majesty in small,
delivered to the French Marquess who came
to Your Majesty at St. Johnston's in 1651
pretending raising a troop of horse for
your Majesty, whom Your Majesty
rewarded also with an 100*l*.1, and
recommended by a letter drawn Dr
Massinet.'
Several other replicas of this portrait exist
and were probably used as presentation
pieces to the King's followers.

Private Collection

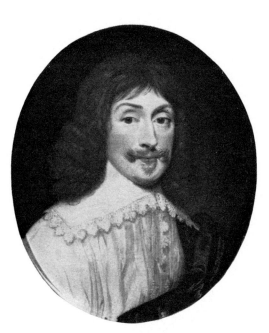

211

JAMES STUART, 4th DUKE OF
LENNOX (1612–55)

Watercolour on vellum, oval:
3 1/8 × 2 5/8 in.

The suggested identification of the sitter as
the Duke of Lennox has been confirmed
recently by Robin Hutchison at the Scottish
National Portrait Gallery after careful
comparison with known portraits. The
miniature was first identified as of the Duke
of Lennox when it was in the collection of
the late H. J. Pfungst and exhibited at the
Victoria and Albert Museum in 1914–15; it
thereafter lost its identity.
The sitter was the son of Esme, 3rd Duke
of Lennox. Studied at Cambridge; was a
staunch supporter of Charles I, whom he
granted large sums of money during the
Civil War; was created Duke of Richmond
in 1641.

Mrs Daphne Foskett

Franciszek Smiadecki (mid–17th century)

Little is known about this artist, who is thought to have been Polish or Russian. It has always been said that he was taught painting by either Alexander or Samuel Cooper. Miniatures of very high quality, signed *F.S.*, exist, and in recent years have become highly sought after. For the present all works signed *F.S.* are, in the absence of any documentary evidence to the contrary, attributed to the above artist.

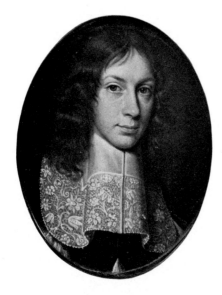

212

PORTRAIT OF AN UNKNOWN MAN

Oil on copper, oval: 2 3/4 × 2 1/4 in.

Signed: *F.S.*

The sitter has been erroneously identified as Andrew Marvell.

The Duke of Buccleuch and Queensberry

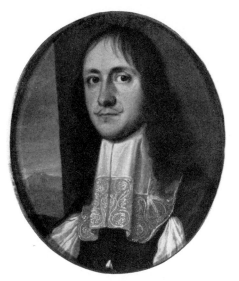

213

PORTRAIT OF AN UNKNOWN MAN
Oil on copper, oval: 2 3/4 × 2 3/8 in.
Signed: *F.S.*
The Duke of Buccleuch and Queensberry

214

PORTRAIT OF AN UNKNOWN MAN
Oil on copper, oval: 2 3/4 × 2 1/4 in.
The Earl Beauchamp

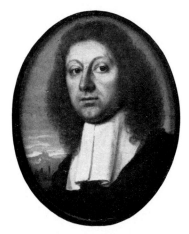

215

PORTRAIT OF AN UNKNOWN MAN
Watercolour on vellum, oval: 2 1/4 × 2 in.
Miniatures by the artist who sometimes
signed *FS* are at present identified with
the above artist, the majority of whose
works are in oil on copper. They are all of
outstanding quality and the few painted in
watercolour are of particular interest.
Mrs Daphne Foskett

Nicholas Dixon
(*fl.* 1660–1708)

Sometimes erroneously called Nathaniel Dixon, Nicholas practised in London and lived for some years in the parish of St Martin-in-the-Fields. He succeeded Cooper as 'Limner' to Charles II, and had a distinguished clientele. He was involved in a lottery which failed, and was obliged to mortgage 70 miniatures, 30 of which are now in the collection of the Duke of Portland. Little is known about him or by whom he was taught to paint, but his early works are reminiscent of those by Hoskins. The majority of his miniatures are signed in monogram, *ND*. One of his most outstanding works is the large cabinet miniature of Anne, Countess of Exeter, her brother, William, and a black page, signed and dated, *ND / 1668*. He used a reddish-brown flesh colour and painted the eyes of his sitters half closed and rather elongated. His works should not be confused with those of Cooper.

216
ANNE, COUNTESS OF EXETER,
her brother WILLIAM (1640/1–1707),
later 1st DUKE OF DEVONSHIRE,
and a BLACK PAGE BOY

Watercolour on vellum, oblong:
6 1/4 × 7 3/4 in.

Signed in monogram: *ND* and dated:
| *1668.*

Anne and William were the children of
Elizabeth Cecil and her husband, William,
3rd Earl of Devonshire. Anne became the
wife of John Cecil, 5th Earl of Exeter (d.
1700), and William succeeded to the title
as 1st Duke of Devonshire on the death of
his father. The miniature was left to Anne
by her mother.
The miniature is an exceptionally fine
example of the artist's work, especially on
such a large scale.

The Marquess of Exeter,
Burghley House Collection

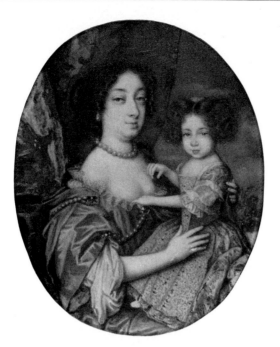

217

BARBARA VILLIERS, DUCHESS OF
CLEVELAND (1641–1709), with her
CHILD

Watercolour on vellum, oval:
3 1/4 × 2 3/4 in.

Signed in monogram: *ND*.

The miniature is by family descent through
Robert Spencer, 2nd Earl of Sunderland. It
closely resembles the painting by Henri
Gascars in the collection of Viscount Dillon.

The Earl Spencer

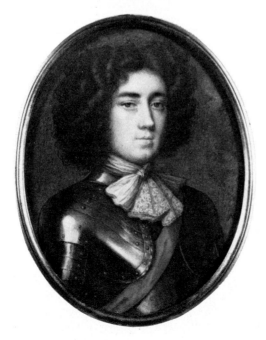

218

PORTRAIT OF AN UNKNOWN LADY

Watercolour on vellum, oval:
2 5/8 × 2 1/8 in.

Signed in monogram: *ND*

The Duke of Buccleuch and Queensberry

219

JAMES SCOTT, DUKE OF
MONMOUTH AND BUCCLEUCH, KG
(1649–85)

Watercolour on vellum, oval: 3 × 2 3/8 in.

Signed in monogram: *ND*

The sitter was the illegitimate son of Charles
II and Lucy Walter; he married Lady Anne
Scott, the only daughter of Francis, Earl of
Buccleuch, in 1663. Was beheaded after
the failure of his insurrection against
James II.

The Duke of Buccleuch and Queensberry

220

LUCY WALTER (1630?–58)

Watercolour on vellum, oval:
3 1/8 × 2 1/2 in.

Daughter of a Welsh Royalist; known also
as Mrs Barlow; mother of James Scott,
Duke of Monmouth and Buccleuch, KG.
Had several lovers and was mistress of
Charles II. Proof that she had been legally
married to the King was reported to be in
'a black box'; Charles II issued three
declarations denying any such marriage.

The Duke of Buccleuch and Queensberry

221

MARY II, as PRINCESS (1662–94) (?)

Watercolour on vellum, oval:
3 1/4 × 2 3/4 in.

This miniature is based on the portrait by
Sir Peter Lely, painted *c.* 1672, when the
Princess was about ten years of age. It
shows her walking in a landscape as Diana
the Huntress, wearing a crescent moon on
her brow, drawing a bow and followed by
a greyhound. The original, which for many
years was thought to represent Jane
Kellaway, is in the Royal Collection. The
features of the girl in this miniature do not
exactly conform to those of the Princess by
Lely, and it is possible that Dixon adapted
them to suit those of another sitter.

Mrs Daphne Foskett

Cornelius Johnson (1593–1661/2)

Baptized in London, 14 October 1593. His name has been spelt in various ways, the modern use being Johnson. His family came from Cologne, later settled in Antwerp, and from there came to England. He married Elizabeth Beck or Beke, in 1622. He is best known for his large oil portraits, but also executed miniatures in oil and in watercolour, although I have not traced any painted in the latter medium. He is said to have copied many large paintings in miniature. He signed *C.J.* in monogram, and charged five broad pieces for a head. A miniature of a man painted in oil on copper – signed, on the reverse, *C. Johnson, fecit 1639* – is in the collection of the Duke of Portland. He was supposedly ruined by the extravagance of his second wife and to have died a poor man in Utrecht, or Amsterdam, around 1661.

222

PETER VANDERPUT

Oil on copper, oval: 3 7/8 × 2 3/4 in.
A trace of a signature is visible.

Son of Giles Vanderput (d. 1646), merchant of London, and his wife, Sarah, daughter of John Janpine of Ypres. The founder of the English branch of the Vanderput family was Gillis van der Putte, born in Antwerp in 1576 and buried at St Margaret Pattens. Peter Vanderput was living at College Hill in the parish of St Margaret Pattens when he married Jane Hoste, daughter of a London merchant.

The Hon K. R. Thomson

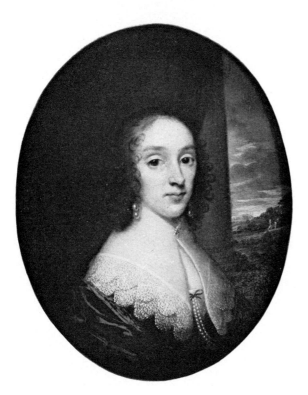

223

Mrs PETER VANDERPUT *née* HOSTE

Oil on copper, oval: 3 7/8 × 2 3/4 in.
A trace of a signature is visible.

Daughter of Dierick Hoste, a merchant, of London and Sandringham, Norfolk. Wife of Peter Vanderput of College Hill in the parish of St Margaret Pattens. This and the companion miniature of her husband (no. 222) are exceptionally fine examples of Johnson's work in miniature. They were sold at Sotheby's, 6 March 1967 (lot 75).

The Hon K. R. Thomson

Unknown Artists

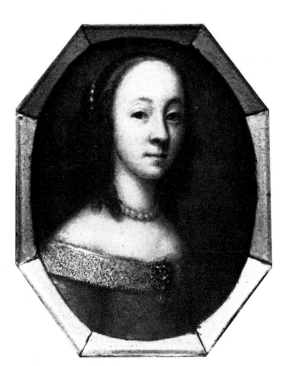

224

PORTRAIT OF AN UNKNOWN LADY

Oil on copper, oval: 3 1/8 × 2 3/8 in.
Painted *c.*1660.

In a contemporary carved wooden frame.

Mrs Daphne Foskett

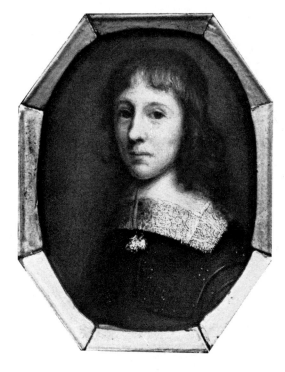

225

PORTRAIT OF AN UNKNOWN MAN

Oil on copper, oval: 3 1/8 × 2 3/8 in.
Painted *c.* 1660.

In a contemporary carved wooden frame.

Mrs Daphne Foskett

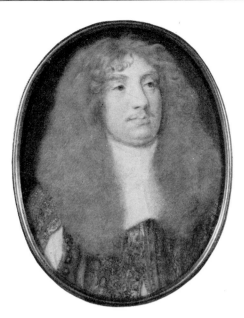

226

JOHN MAITLAND, 2nd EARL and
1st DUKE OF LAUDERDALE (1616–82)

Watercolour on vellum, oval: 3 × 2 3/8 in.

This miniature is a copy of the one by
Cooper in the National Portrait Gallery
(no. 101), which is signed, and dated *1664*.
This copy may well be another work by
Susan Penelope Rosse and not, as has been
suggested in the past, by Edmund Ashfield.

The Duke of Buccleuch and Queensberry

227

JOHN TURNER (?)

Watercolour on vellum, oval: 2 × 1 3/4 in.
Painted *c*.1653–6.

An inscription on the reverse in a later
hand states that the sitter is supposed to be
John Turner, merchant, brother of Leigh
Turner of Cold Overton, Leicestershire.
In spite of the undoubtedly high quality of
the painting it has not so far been possible
to attribute it with any certainty to an
artist.

Mrs Daphne Foskett

228

CHARLES II (1630–85)

Oil on copper, oval: 3 1/2 × 2 7/8 in.

Painted after Samuel Cooper. The King is
wearing armour and the sash of the Garter.

The Duke of Buccleuch and Queensberry

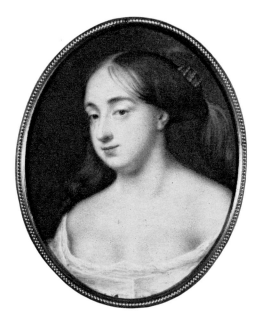

229

PORTRAIT OF AN UNKNOWN LADY

Watercolour on vellum, oval:
2 13/16 × 2 5/16 in.

Inscribed on the reverse in a later hand:
*Madam Eleanor Gwyn | S. Cooper pxt | from
the | late Th° Webb Coll. | To do likeness . . .*
(The latter part of the inscription is
indecipherable.)

The identification of the sitter as Nell
Gwyn, although possible, is open to some
doubt. The miniature may be the work of
Susan Penelope Rosse.

The Duke of Buccleuch and Queensberry

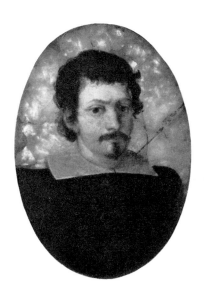

230

PORTRAIT OF AN UNKNOWN MAN

Oil on rock amethyst, oval: 2 3/4 × 2 in.
Painted *c.*1650.

This miniature is a rare example of an
artist painting on a semi-precious stone.
It has been suggested that the portrait
represents James Stanley, who succeeded
to the title as 7th Earl of Derby in 1642,
but this seems unlikely as the sitter's
costume indicates that he may have come
from the Continent.

Mrs Daphne Foskett

Large Portraits

231 MARY BEALE (1633–99)

CHARLES BEALE (?)

Oil on canvas, rectangular: 24 × 18 1/2 in.
Painted c.1680.

The sitter is identified as Charles Beale
(1660–1714), younger son of Charles and
Mary Beale. Charles assisted his mother
with her paintings and also painted
portraits and miniatures. Was a pupil of
Thomas Flatman, who painted his portrait.
His father kept notebooks, many of which
are preserved at the British Museum. It is
from his father's diary that the well-known
quotation occurs:

'Sunday, May 5, 1672. Mr Samuel Cooper,
the most famous limner of the world for a
face died.'

The Lord Ellenborough

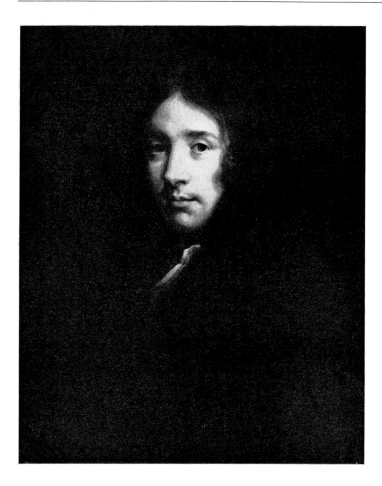

232 THOMAS FLATMAN (1635–88)

SELF-PORTRAIT (?)

Oil on canvas, rectangular:
22 1/2 × 18 1/4 in. Painted *c*.1660.

Miniature painter, and poet. Educated at
Winchester and New College, Oxford;
called to the Bar, 1662; a member of a
small religious and aesthetic circle. His
friends included Charles and Mary Beale,
Dean Sancroft and the Revd Samuel
Woodford. Flatman suffered from fits of
depression; he was of an earnestly religious
temperament and inclined to be morbid.
His earliest known miniatures date from
c.1661. His style was based on that of
Cooper, but he later developed a broader,
freer style of his own, as may be seen in the
self-portrait of 1673 in the Victoria and
Albert Museum. Many of his miniatures
have been attributed to Cooper and even
had false signatures added to them.
Artistically his miniatures justify the claim
made that he was second only to Cooper in
seventeenth-century miniature painting.
This portrait is traditionally believed to be
by Flatman; a comparison between this
and the 1673 self-portrait already mentioned
and the self-portrait at Knowle painted
c.1680, leads one to think that the features
here, when Flatman would have been much
younger, are not inconsistent with those
in the other two portraits.

National Portrait Gallery

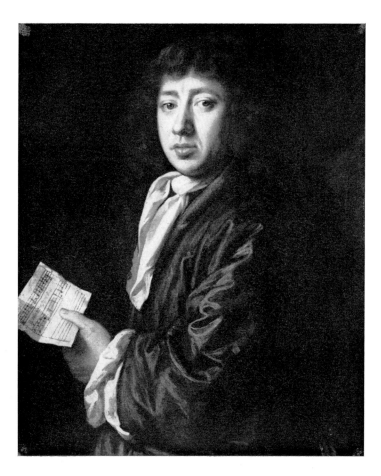

233 JOHN HAYLS (d. 1679)

SAMUEL PEPYS (1633–1703)

Oil on canvas, rectangular:
29 3/4 × 24 3/4 in. Painted in 1666.

Son of John Pepys, a London tailor.
Diarist and Naval administrator; educated
at St Paul's School and Magdalene College,
Cambridge. His *Diary*, written between
1660 and 1669, is a unique social document;
the most recent edition, edited by Robert
Latham and William Matthews, is in the
process of publication in eleven volumes.
Pepys became Clerk of the King's Ships
and Clerk of the Privy Seal, 1660; Surveyor
General, 1665; committed to the Tower
and relieved of his offices, 1679, but
released, 1680; Secretary to the Admiralty,
1686; deprived of his office at the

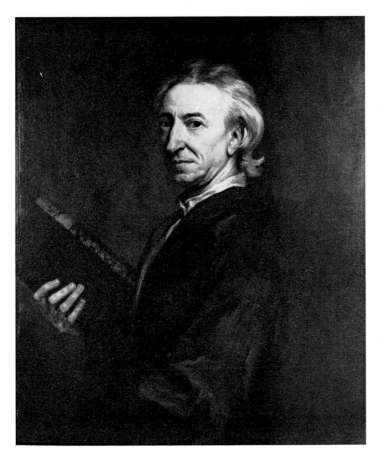

234 SIR GODFREY KNELLER (1646–1723)

JOHN EVELYN (1620–1706)

Oil on canvas, rectangular: 31 × 26 1/2 in.
Painted 1684.

Evelyn was the compiler of the celebrated
diary which is a unique record of events
from the assassination of the Duke of
Buckingham to the battle of Blenheim.
He was a keen collector, traveller and expert
on gardening, and took an interest in all
scientific and artistic movements of
importance. This portrait is recorded in
his *Diary*, 8 July 1689:
'I sat for my picture to Mr. Kneller, for Mr.
Pepys, late Secretary to the Admiralty,
holding my "sylva" in my right hand. It was
on his long and earnest request, and
plac'd in his library. Kneller never painted
in a more masterly manner'.
On 10 January 1662 Evelyn recorded in his
Diary that he had been in Cooper's studio
whilst he was drawing the King's head for
the coinage, and that he
'had the honour to hold the candle whilst it
was doing, he [Cooper] choosing the night
and candle-light for the better finding out
the shadows.'

*The Trustees of the will of J. H. C. Evelyn,
deceased*

revolution and lived in retirement, chiefly
at Clapham.
This portrait is fully documented in his
Diary. Hayls began a portrait of Mrs Pepys
(now missing) on 15 February 1666 and
one of Pepys on 17 March. On 16 May
Pepys paid Hayls £14 for the picture and
25 shillings for the frame, plus £7 for the
copy and 5 shillings for the frame. He
noted in his *Diary*: 'I am very well satisfied
in my pictures and so took them in another
coach home along with me, and there with
great pleasure my wife and I hung them up.'

National Portrait Gallery

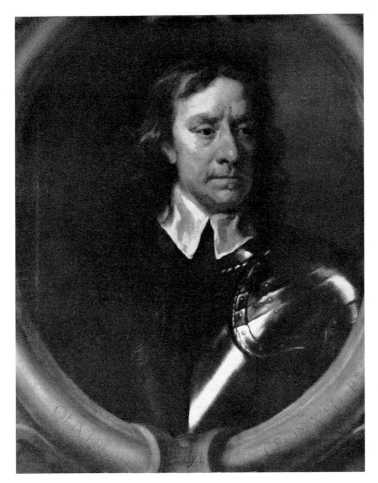

235 SIR PETER LELY (1618–80)

OLIVER CROMWELL (1599–1658)

Oil on canvas, rectangular:
30 1/2 × 24 3/4 in. Painted 1653/4.

This portrait, of which there are several
versions, was probably painted *c.*1653,
soon after Cromwell was proclaimed Lord
Protector. It seems to have been one from
which several official portraits were taken.
It is not certain that the portrait was from
life, and the suggestion has been put
forward that it might have been based on
the miniature by Cooper in the Buccleuch
collection (no. 36).

City Museum and Art Gallery, Birmingham

236 SIR PETER LELY

SELF-PORTRAIT

Oil on canvas, rectangular:
42 1/2 × 34 1/2 in. Painted *c.*1660.

Signed in monogram. Perhaps slightly cut
down; the beginning of a date (?) can be
discerned under the monogram, but is
indecipherable.

This famous portrait painter was of Dutch
extraction, born in Soest (Westphalia).
Studied in Haarlem under P. de Grebber;
came to London *c.* 1641–3. In 1647 he
painted Charles I with James, Duke of
York. Painted Cromwell. After the
Restoration in 1660 he was Principal
Painter and had a fashionable clientele.
Knighted, 1680. Died in December of that
year. Formed a large collection of drawings
and pictures. His 'Windsor Beauties' are at
Hampton Court.
Lely lived in 'The Great Piazza', Covent
Garden, near Samuel Cooper, and it is
interesting to note that in Mrs Cooper's
will she mentions 'Sir Peter Lilly's picture
in oyle' which she left to her cousin 'John
Hoskins'.

National Portrait Gallery

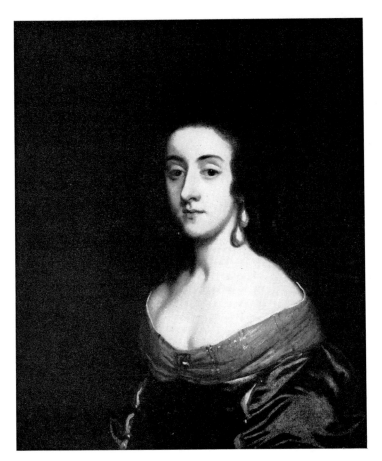

237 SIR PETER LELY

DOROTHY OSBORNE, afterwards
LADY TEMPLE (1627–95)

Oil on canvas, 28 × 24 in. Painted 1653.

Daughter of Sir Peter Osborne (1584–1653).
Married Sir William Temple, statesman
and author, in 1655. Dorothy's letters to
her lover were published in 1888. This
picture is mentioned in a letter to Sir
William in October 1653:
'Thinking of sending you my Picture till I
could come myself, but a picture is but dull
company and that you need not besyd's I
cannot tell whither it bee very like mee or
not, though tis the best I have ever had
drawne for mee, and Mr Lilly will have it
that hee never took more pain's to make a
good one in his life, and that it was I think
spoiled it: he was condemned for making
the first hee drew for mee a little worse
than I, and in makeing this better hee has
made it as unlike as tother.'
The portrait was evidently not liked, and
in the following year Dorothy wrote to Sir
William telling him that she hoped that
'Mr. Cooper will vouchsafe to take the
pains to draw it for you I have made him
twenty courtesys and promised him £15
to persuade him.'
The whereabouts of Cooper's miniature is
unfortunately unknown.

Private Collection

238 SIR PETER LELY

SIR FRESCHEVILLE HOLLES
(1641–72) and SIR ROBERT HOLMES
(1622–92)

Oil on canvas, oblong: 52 × 64 in.
Probably painted *c.* 1672.

Inscribed at a slightly later date with the
names of the sitters and artist. The painting
was probably executed to commemorate
their joint action against the Dutch convoy
of the Smyrna fleet. Holles was the son of
Gervase Holles, the antiquary. He lost his
life at the battle of Solebay on 28 May 1672.
Holmes served under Prince Rupert during
the Civil War and had a distinguished naval
career.
A fine miniature of Holles by Samuel
Cooper is in the collection of the Duke of
Portland.

National Maritime Museum, Greenwich

239 STUDIO OF LELY

CATHERINE SEDLEY, COUNTESS OF DORCHESTER (1657–1717)

Oil on canvas, rectangular:
49 1/2 × 39 1/2 in. Painted *c*. 1675.

The sitter was a vivacious, rich, young woman, who attended the court of Charles II and became the mistress of James, Duke of York. She was apparently astonished by his passion, saying 'It cannot be my beauty, for he must see I have none: and it cannot be my wit, for he has not enough to know that I have any!' Was made a countess after his accession to the throne; was a staunch Protestant, and became a political influence. In 1696 she married Sir David Colyear, later Lord Portmore.
The portrait was for many years thought to represent Nell Gwyn, by Lely, and was so catalogued until 1947, when it was identified as Catherine Sedley. Exact identification of sitters at this time is difficult, as the pose was a favourite one of Lely's, and many sitters were painted in the same way and with rather similar faces.

National Portrait Gallery

240 STUDIO OF LELY

ELEANOR (NELL) GWYN (1650–87)

Oil on canvas, rectangular: 50 × 40 in.
Painted *c*.1675.

Born at Hereford, Nell came to London, where she went on the stage at Drury Lane Theatre. Was a good comedy actress, and extremely popular. After becoming one of the mistresses of Charles II, she lived on the fringe of the court. Her great rival for the King's favour was the Duchess of Portsmouth, but she succeeded in retaining the King's affection to the end of his life, and his dying request to his brother was 'Let not poor Nelly starve.'
Because such a large number of late seventeenth-century portraits have been said to represent Nell Gwyn, correct identification is very difficult. The case for this portrait being identified as Nell Gwyn rests on another almost identical version in the de Saumarez collection.

National Portrait Gallery

241 I. THOMSON AFTER HAYLS

ELIZABETH PEPYS, wife of Samuel
Pepys

Engraving, after J. Hayls, rectangular,
5 × 3 3/4 in. Engraved *c.* 1828.

The original portrait by Hayls, painted in
1666, is reputed to have been destroyed,
but it is thought possible that it may have
been the one sold in the Pepys Cockerell sale
of 1848 (lot 110), when it was catalogued
as 'Rembrant School: Portrait of a Lady'.

National Portrait Gallery

242 SIR ANTHONY VAN DYCK (1599–1641)

MARGARET LEMON

Oil on canvas, rectangular:
36 3/4 × 30 5/8 in.

The sitter was Van Dyck's mistress and
said to have been very jealous of women
sitting to him. The portrait was presumably
painted before 1639, after which time the
artist was married to Lady Margaret
Ruthven.

The portrait is probably the one acquired
by Charles I, sold in 1650 to the painter
John Baptist Gaspars, and recovered for
the Royal Collection at the Restoration. It is
supposedly inspired by Titian's *Girl in a
Fur Wrap* in the Kunsthistorisches Museum,
Vienna.

It is interesting to compare this portrait
with Cooper's representation of the sitter
(no. 9).

Her Majesty The Queen

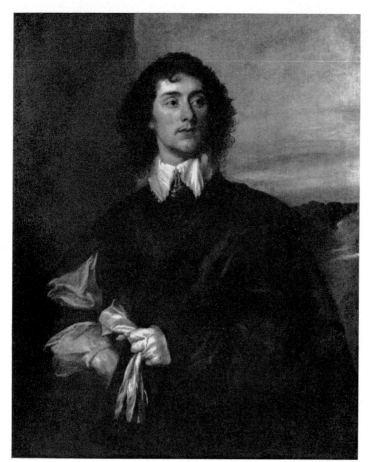

243 SIR ANTHONY VAN DYCK

SIR THOMAS HANMER (1612–78)

Oil on canvas, rectangular: 42 × 37 in.
Probably painted *c*.1638.

The sitter was a page and cup-bearer at
the court of Charles I; a man of taste and
an eminent horticulturist. In the autumn
of 1638 Sir Thomas set out for three years
of travel. He married the sister of Thomas
Baker of Whittingham Hall, Suffolk, whose
bust was executed in marble by Bernini.
The portrait of Sir Thomas was for many
years thought to be by Robert Walker; it
was later identified as the one mentioned by
John Evelyn on 24 January 1685: 'I din'd
at Lord Newport's, who has some excellent
pictures, especially that of *Sir Tho. Hanmer*,
by Van Dyke, one of the best he ever
painted.'
A fine miniature of Sir Thomas Hanmer
was painted by Samuel Cooper and remains
in the family. (no. 56).

The Earl of Bradford

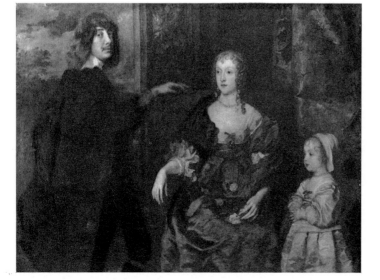

244 SIR ANTHONY VAN DYCK

ALGERNON, 10th EARL OF NORTHUMBERLAND, with his first wife, LADY ANN CECIL, and their DAUGHTER

Oil on canvas, oblong: 52 3/4 × 71 1/2 in.

It is interesting to compare the miniature
by Cooper of the 10th Earl of
Northumberland, in the Victoria and
Albert Museum, with this portrait, as it
would appear likely that Cooper based his
miniature on the painting by Van Dyck.

The National Trust, Petworth House

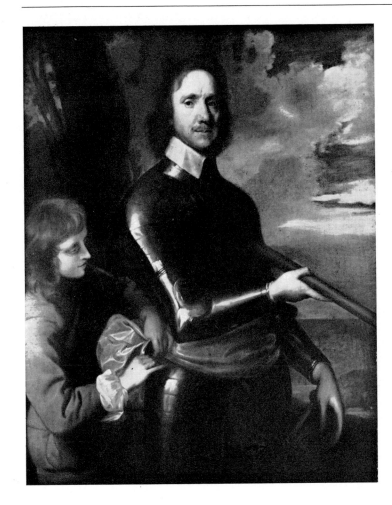

245 ROBERT WALKER (d. 1658)

OLIVER CROMWELL (1599–1658)

Oil on canvas, rectangular: 49 1/2 × 40 in.
Painted *c.*1649.

Soldier and statesman of Welsh descent;
born in Huntington, was educated there
and also at Sidney Sussex, Cambridge.
Installed as Protector and head of the
executive power, 1653. Died 3 September
1658.

This portrait is traditionally said to have
been given by Cromwell to Colonel
Nathaniel Rich, and was bequeathed by
the latter's great grandson to the British
Museum; it was transferred to the National
Portrait Gallery in June 1879.

A number of similar portraits exist, and
other versions with slight variations were
produced in Walker's studio for several
years.

It is interesting to compare this portrait
with the unfinished miniature of Cromwell
by Cooper in the Buccleuch collection,
which is considered the finest representation
of the Protector in existence (no. 36).

National Portrait Gallery

The famous Samuel Cooper Limner an Englishman of the most Eminent character

limning by himself

also a Crayon by himself of Kensington

246 UNKNOWN ARTIST

SAMUEL COOPER (1609–72)

Watercolour on paper, rectangular:
6 1/8 × 4 5/8 in.

This painting is a copy of the portrait in crayon in the Victoria and Albert Museum (no. 2), which is supposedly a self-portrait but about which there has always been some dispute. It has been suggested that the crayon was by Jackson, a relative of Cooper about whom nothing is known.

National Portrait Gallery

Coins

247 JOHN ROETTIER

THE RESTORATION: FELICITAS
BRITANNIAE

Silver

Recording the entry of Charles II into
London, 29 May 1660.

The profile drawing for this medal was
executed by Samuel Cooper soon after the
King's return. Evelyn records 'Being call'd
into his Ma^tys closet when Mr. Cooper,
y^e rare limner, was crayoning of the King's
face and head, to make the stamps for the
new mill'd money now contriving . . .'
The drawing is in the collection of Her
Majesty The Queen, and is framed with a
second version, slightly smaller (no. 140).

The British Museum

248 THOMAS SIMON

SILVER CROWN (Cromwell as Protector)
1658

It is generally believed that these crowns
were never issued for general circulation
because of Cromwell's death in 1658, but
were probably sold as souvenirs. The
Protector is portrayed draped and laureated
like a Roman emperor, and the reverse
inscription reads: OLIVAR D G RP ANG
SCO HIB & PRO.

The Duke of Buccleuch and Queensberry

249 THOMAS SIMON

GOLD BROAD 1656

As with the crown, this coin shows
Cromwell draped and laureated like a
Roman emperor. Examples in good
condition are rare.

The Duke of Buccleuch and Queensberry

250 THOMAS SIMON

SILVER BROAD 1658

This coin is similar to the silver broad.

The Duke of Buccleuch and Queensberry

List of sitters

Numbers refer to catalogue entries

(This list includes sitters whose identities are uncertain.)

List of lenders

Numbers refer to catalogue entries

Her Majesty The Queen, 5, 6, 11, 62, 78, 79, 80, 81, 82, 140, 146, 153, 189, 242

Her Majesty The Queen of The Netherlands, 15, 156, 157, 158

Anonymous, 48, 64, 66, 90, 97, 98, 106, 177, 202, 210, 237

The Visitors of the Ashmolean Museum, Oxford, 93, 120, 123, 141, 182

The Duke of Atholl, 121

Robert Bayne-Powell, Esq, 22, 57, 162

The Earl Beauchamp, 19, 77, 87, 94, 113, 144, 167, 214

The Duke of Beaufort, KG, 195, 196, 197, 199, 200

The Duke of Bedford and the Trustees of the Bedford Estates, 99

Denys Eyre Bower Collection, Chiddingstone Castle, 84, 132

The Earl of Bradford, 243

The British Museum, 247

The Duke of Buccleuch and Queensberry, 14, 20, 24, 26, 28, 36, 37, 40, 41, 45, 46, 52, 55, 65, 91, 102, 107, 109, 114, 115, 122, 134, 142, 143, 155, 161, 166, 173, 176, 179, 186, 190, 212, 213, 218, 219, 220, 226, 228, 229, 248, 249, 250

The Trustees of the Chatsworth Settlement (Devonshire Collection, Chatsworth), 38, 39, 42

The Administrative Trustees of the Chequers Trust, 16, 47

City Museum and Art Gallery, Birmingham, 235

The Cleveland Museum of Art, Ohio, 17, 83, 88

The Lord Clifford of Chudleigh, 135

The Lord de Saumerez, 103

The Lord Ellenborough, 231

The Trustees of the will of J. H. C. Evelyn, deceased, 234

The Marquess of Exeter, 12, 34, 35, 148, 150, 151, 216

T. R. Fetherstonhaugh, Esq, 100, 108

The Syndics of the Fitzwilliam Museum, Cambridge, 21, 31, 32, 33, 51, 68, 69, 70, 116, 152, 191

Charles Fleischmann, Esq, Cincinnati, Ohio, 198

Fondation Custodia (collection F. Lugt), Institut Néerlandais, Paris, 9, 18, 61, 117, 183

Mrs Daphne Foskett, 49, 85, 178, 187, 192, 193, 194, 203, 204, 211, 215, 221, 224, 225, 227, 230

The Trustees of the Goodwood Collection, 111

Kenneth Guichard, Esq, 175

The Earl of Haddington, KT, 3, 4, 149, 154, 168, 207

Lieutenant-Colonel R. G. Hanmer, 56

A. H. Harford, Esq, 136, 137, 138, 139

E. Hawtin, Esq, 163

V. M. E. Holt, Esq, 170, 171

Sir Gyles Isham, Bart, 63

The Earl of Jersey, 118

The Hon Mrs Johnston, 8

Mauritshuis (Royal Picture Gallery), The Hague, 10, 13, 112, 119, 130, 145

The Lord Methuen, 164, 165

National Maritime Museum, Greenwich, 125, 131, 238

National Portrait Gallery, 27, 43, 60, 101, 232, 233, 236, 239, 240, 241, 245, 246

The National Trust (Egremont Collection, Petworth), 244